Building Wellness
with
DMG

HOW A BREAKTHROUGH NUTRIENT GIVES
CANCER, AUTISM & CARDIOVASCULAR PATIENTS
A SECOND CHANCE AT HEALTH

Roger V. Kendall, Ph.D.
with Adena Therrien

Forewords by Bernard Rimland, Ph.D.
& Richard Passwater, Ph.D

ISBN 978-1-893910-31-7
ISBN 1893910-31-8
Second printing 2009
Printed in the United States
Published by Freedom Press
1861 North Topanga Canyon Boulevard
Topanga, CA 90290
Bulk Orders Available: (800) 959-9797
E-mail: info@freedompressonline.com

Advanced Praise

"It gives me great pleasure to endorse the excellent and carefully referenced compendium of information on DMG compiled by Dr. Kendall. DMG is today still an overlooked nutrient while the evidence regarding defective methylation contributing to a host of serious degenerative diseases continues to mount. Dr. Kendall's excellent, well written book will significantly solve that problem and help DMG gain its rightful place in the armamentarium of nutritional supplements we all need to combat the stress and pollution we face."

—*Garry Gordon, M.D, D.O., M.D.(H.), President of Gordon Research Institute*

"I have done research on DMG over the past 18 years, which has demonstrated the multifaceted benefits of DMG on health. Our studies have concentrated on the immune-enhancing and anti-cancer activity of this nutrient. DMG was found to enhance the immune response and lend protection against pathogens causing both chronic and infectious disease in test tubes and laboratory animals. In addition, DMG was shown in various laboratory models to have a direct anti-cancer effect. Dr. Kendall examines research from several sources and in layman's terms carefully explains the scientific basis for the use of DMG as a part of a healthy dietary regimen."

—*John Lawson, Ph.D., Dept. of Microbiology & Molecular Medicine
Clemson University*

"Natural therapies work remarkably in my veterinary practice for pets with seizures. Dr. Kendall's new book shares information on one of these supplements, DMG, and shows pet owners how they might be able to 'say no to drugs' for pets with seizures."

—*Shawn Messonnier, D.V.M., Author,* Eight Weeks to a Healthy Dog
and the award-winning The Natural Health Bible for Dogs & Cats

"Upon reviewing this book we know that Dr. Kendall had finally put into print an easy to read, yet thorough, work on this most amazing nutrient, DMG. In our practice we have used DMG for many years and in many different health conditions, from autism to cancer and most other chronic health conditions. We have always found DMG to provide many health improving benefits to any patients we used it on.

"In this book both the clinician and the lay public have a great source of information at their disposal. Any practicing physician will quickly understand the complex physiological influences DMG has on the body and will be able to design their own protocols for treatment. Likewise, the layperson can see the many benefits of the nutrient and how it may bring improved health into their lives.

"There has been a need for this type of book on DMG and no one is more qualified and respected than Dr. Roger Kendall to have performed this work. We are sure that reading this book will bring greater understanding of this amazing nutrient and will help many who are searching for better health and well-being."

—*Jim Fox, D.C. & Janine Fox, D.C., www.doctorsnutrition.com*

"I first became aware of DMG in 1974. As Chair of the Department of Clinical Nutrition at New York Chiropractic College I had assigned my 'Readings in Research' class the task of reviewing the literature for methyl donors in the management of mental and psychiatric disorders. To my surprise a number of students presented significant literature on the health benefits of DMG. Although most of the studies were done in the Soviet Union the one area of particular interest to me is that cardiovascular disease as well as cancer can result from deficient methylation and that adding dimethylglycine to the diet can increase methyl donation and improve the health and well-being for a wide range of patients.

"I took this information 'out of the classroom' and after further research began applying DMG in numerous clinical situations with excellent results at the Institute of Rehabilitative Nutrition, where I served as Clinical Director.

"After nearly 30 years of experiencing the benefits of DMG, I continue to incorporate DMG in my private practice and to discuss the many health benefits of this nutrient on my nationally syndicated radio program.

"This breakthrough book of the year profoundly describes in detail DMG as a healing nutrient for a wide range of conditions. Dr. Kendall has done an incredible service to the health conscious community in providing this profound and vital book."

—*Alan H. Pressman, D.C., F.A.C.C.N., D.A.C.B.N., C.C.N., Ph.D.,*
Author, The Complete Idiot's Guide to Vitamins and Minerals ,
WWRL Radio and Cable Radio Network, www.drpressman.com

"It is vitally important that consumers of dietary supplements learn as much about the supplements they consume as possible. Dr. Kendall has taken the time and effort to bring together a great deal of research on the safety and efficacy of DMG and other supplements. Not since DMG first became available in 1965 has anyone brought together such a wealth of information on this important nutrient. The author is to be commended for the amount of research he did to bring the history and science behind DMG's benefits to the public's attention."

—*Alexander G. Schauss, Ph.D.,*
Director, Natural and Medicinal Products Research,
Life Sciences Division, AIBMR, Inc., Tacoma, WA

"I have been using DMG for years and am pleased this book is full of good information for everyone interested in good health. They need to be aware of the many benefits that DMG has to offer. Thanks for putting it together in such an easy format for the layman and the professional!"

—*Phyllis A. Balch, C.N.C.,*
Author of the best-selling book
Prescription for Nutritional Healing

"This book offers new and important insights. It will be at the forefront of scientific-based health care for the concerned citizen."

—*Gary Null, Ph.D., noted national radio host on nutrition and healthy living,*
Author, The Complete Encyclopedia of Natural Healing

Acknowledgements

I would like to take the opportunity to thank all the many people who were involved and participated in this book project. This book has been a goal of mine for several years and I am appreciative of the time, support and individual expertise of those who have made this book a reality. A special thanks goes to my co-writer Adena Therrien who provided many hours of technical support in writing and skillfully organizing the vast amount of information on DMG into a concise and understandable format that brings the DMG story to life.

I am grateful to the professional guidance of David Steinman who has provided excellent editorial guidance and direction. His help is most appreciated especially in balancing the technical and scientific elements in the book with the practical applications of DMG. I'd also like to thank Jane Seymour, M.S., for her editorial support. Special thanks to our copy editor Cassandra Glickman; without her hard work this book would not have happened. Bonnie

Lambert labored relentlessly on book design, for which I am very grateful. Thanks go to Dick Passwater and Bernie Rimland for their kind and insightful forewords to the book. They both have had over 25 years of experience with DMG. I much appreciated those who reviewed the manuscript and gave positive comments for the book including Garry Gordon, M.D, D.O., M.D.(H.), John Lawson, Ph.D., Shawn Messonnier, D.V.M., Jim Fox, D.C., Janine Fox, D.C., Alan Pressman, D.C.P., Ph.D., Alex Schauss, Ph.D., Gary Null, Ph.D. and Phyllis Balch, C.N.C. I'd also like to thank Keli McBride, Tina Carroll, Alida White, and Lisa Gorman. Thanks to Nigel Yorwerth and his lovely wife Patricia Spadaro for their help with the book cover.

Special thanks go to Dom and Claudia Orlandi who gave me the opportunity to study and research DMG over the past 25 years and to FoodScience Corporation who funded most of the research studies reported for DMG. I wish to thank the many individuals who contributed their personal success stories on DMG for the book for which I am very appreciative.

Last of all, I would like to acknowledge the support and encouragement of my wonderful wife, Emy, who with her love and inspiration has brought greater meaning and purpose to my life.

Table of Contents

Foreword

I first learned about DMG in 1969 from a child psychiatrist, Alan Cott, M.D., who had just returned from a visit to Moscow. Dr. Cott, who shared my intense interest in autistic children, told me of his visit to an institution where Drs. M.G. Blyumina and T.L. Belyakova had discussed with him the remarkable improvement they had seen in the autistic children to whom they had given "calcium pangamate," which is now known as DMG. The Russian doctors provided him with a small supply of the tablets, which he tried on several of the autistic children in his practice in New York City, with equally remarkable results.

I had established the Autism Research Institute in 1967, as a center for conducting research and gathering and disseminating information on promising treatments for autism. I immediately began to investigate calcium pangamate. Most of the research had been done, and was still being done, by Russian scientists who were especially interested in its potential for improving the performance of athletes and

soldiers. I learned that, unlike harmful drugs that were, and still are, commonly given to autistic children, calcium pangamate was completely nontoxic, even in very large amounts. Not only was it nontoxic, it conferred remarkably important health benefits, as shown in a long series of human and animal studies. Dr. Roger Kendall has done an excellent job of summarizing a great deal of this work, and subsequent work, in the following chapters of this book.

I think you will be amazed, as I was, by the huge range of problems that are readily ameliorated by taking DMG. Dr. Harvey Ross was a partner with Dr. Cott in their psychiatry practice in New York City. Dr. Ross told me that during the spring and summer he had been having terrible problems with hay fever. As a physician, he of course had access to all the prescription drugs. None helped. "My nose was running so badly most of the time that I had to reach for Kleenex every few minutes, which was terribly disconcerting to my patients as well as distressing to me. I took some of the calcium pangamate (DMG) tablets that Alan had brought back from Moscow, and very quickly my hay fever was gone."

Of course most of my experience with DMG relates to its use with autistic children, where some truly quick and extraordinary improvement has been seen. A number of the cases we have reported are described in Chapter Seven of this book, and many more examples of the benefits of DMG for autistic children are reported in the recently-published book *Treating Autism: Parent Stories of Hope and Success* edited by Stephen M. Edelson, Ph.D., and myself. *Treating Autism* consists primarily of reports by parents of the success they have had with various treatments. DMG is mentioned repeatedly, and is listed in the index on some thirty pages.

One of the most spectacular incidents of improvement in autism was reported to me in a phone call from an east coast mother some years ago. She said that her six-year-old daughter, who had never spoken a word, was given a DMG tablet before she went to bed. The

next morning, when she awoke, rather than going to the living room and turning on the TV, she came into her mother's bedroom and said "Wake up, it's time to get up." The mother told me that she was so startled to hear her daughter speak that if she had not been lying in bed she would have fallen to the floor. She took her daughter to school and at the end of the day the teachers came to ask her what she had done to bring about the remarkable improvement in her daughter's speech.

I told the story a year or two later to a large group of parents in a hotel ballroom on Long Island. A number of women sitting towards the front of the auditorium began waving to me and pointing to one of the women in the group.

"Are you the one who called me?" I asked her.

"Yes," she said, "I am."

"Did I get the story right?" I asked her.

"Absolutely!" she replied.

You certainly can't expect that kind of a response from everyone who tries DMG, but there is no question that it can bring about remarkable benefits not only in autism but also in a very wide range of other disorders. It is indeed an extraordinary nutrient. Roger Kendall has done a wonderful service to all of us by presenting his vast knowledge of this safe and effective substance in this book.

—*Bernard Rimland, Ph.D., Director, Autism Research Institute,*
Founder, Autism Society of America,
Editor, Autism Research Review International
Author of the prize-winning book, Infantile Autism: The Syndrome and Its Implications for a Neural Theory of Behavior
Co-Author, Treating Autism: Parent Stories of Hope and Success
June 23, 2003

For updated information on DMG and other interventions for autism:
Autism Research Institute, 4182 Adams Avenue, San Diego, California 92116
www.autismresearchinstitute.com

Everyone should read Dr. Roger Kendall's book on DMG for at least two reasons. First of all, most people will be able to improve their health once they learn of the benefits of DMG. Secondly, no one is more qualified to write this book than Dr. Kendall. Please let me explain.

Many people will benefit from DMG. The major health benefits of DMG include improved immune function, enhanced cardiovascular function and improved mental and physical performance. Both types of immune function, humoral (antibody) and cellular-mediated immune response are improved, which translates into less risk of many types of diseases ranging from cancer to the common cold. Cardiovascular improvement includes improved coronary circulation, lower cholesterol and triglycerides, reduced angina and hypoxia. And, you don't have to be "old" or an athlete to appreciate the improvement in mental and physical performance.

Additionally, health benefits are brought about via DMG's role in producing SAMe (sulfur-adenosylmethionine) in the body and reducing homocysteine levels. SAMe is involved in many functions in cells and is important to mental and nerve function via the neurotransmitters norepinephrine and dopamine. Homocysteine is involved in cardiovascular disease and Alzheimer's disease.

Newer studies have also found that DMG is useful in reducing the problems associated wtih asthma, autism, seizures, lupus, and melanoma.

Dr. Kendall's experience with DMG is extensive. He has researched DMG since the 1970s both as a primary researcher and as a coordinator of most of the research done on DMG in other research centers. He is the author of several articles on DMG.

My personal experience with DMG began in the early 1970s when I became aware of the research done in the former USSR. When I visited the Moscow Health Institute in the 1970s, I was provided with many articles about B_{15}. At that time, it was incor-

rectly called vitamin B_{15}. I simply called it " B_{15}." Later Dr. Jerzy Meduski called it a metabolic enhancer, but an argument can still be made that DMG is a "conditionally essential" or a "conditional vitamin." There are indeed times when the body just can't make enough DMG to optimally meet its needs, and optimal health depends on getting additional DMG from the diet.

I was a nutritional consultant to several professional athletes and professional sports teams at that time and I advised them to use DMG as part of their training program because of its oxygen-sparing capability and stamina-enhancing power. Articles soon circulated in the media about the success that Muhammad Ali and Washington Redskins were having with their nutritional programs that included DMG.

Since that time, DMG has not received much notice in the health media and the millions of people who would otherwise benefit from DMG remain unaware of this important nutrient. I am pleased that the research has now been presented here by Dr. Kendall and that millions of people will become aware of the health benefits of DMG and how it will give them a better quality of life.

<div align="right">

—*Richard A. Passwater, Ph.D.*

Author, Supernutrition

Berlin, Maryland

July 20, 2003

</div>

Introduction

I first heard of vitamin B$_{15}$ in 1977 when I attended a nutritional conference. Dr. Richard Passwater, a noted nutritional biochemist, gave a lecture on vitamin B$_{15}$ and reported that it produced better performance in athletes, allowed cardiovascular patients to get more oxygen delivered to their tissues, and enhanced social skills and communication in children with autism. Other positive results were shown for liver disorders, allergies and skin conditions. I was fascinated with what I heard and little did I know then that I would spend the next quarter century researching the real nutrient behind vitamin B$_{15}$.

As it turned out, vitamin B$_{15}$, also known as pangamic acid or calcium pangamate, was not even the real factor responsible for these wonderful properties. In fact there is no such thing as vitamin B$_{15}$. My research over the next decade would prove that the active nutrient behind B$_{15}$ was, in fact, N,N-dimethylglycine (DMG).

I have followed the DMG research trail for most of my professional career and have been involved in extensive research that

shows that DMG without a doubt is the active component behind what was called pangamic acid or vitamin B_{15}.

I would like to have you become acquainted with five very important individuals who were very instrumental in my quest in discovering the real identity and benefit of the nutrient DMG. Each made significant contributions in their research on DMG and without them this book would never have been written.

Charles Graber, Ph.D., a microbiologist at the Medical University of South Carolina, started working with me in 1978. He had read about calcium pangamate in a Russian research paper and wanted to conduct his own immune studies. After hearing about my DMG research, he decided to use DMG instead. His research with DMG on the immune system showed DMG to be very effective in improving both humoral (antibody) and cellular immune response in both animals and people. His landmark research was published in 1981.

Jerzy Meduski, M.D., Ph.D., whom I first met in 1978, was then holding a research and teaching position at the University of Southern California School of Medicine. He was very familiar with the Russian work with adaptogens and their impact on stress. He found through his research that DMG fits the description of an adaptogen because of the way it aids the body in overcoming the stress response and maintaining homeostasis in the body. Dr. Meduski was the first to describe DMG as a metabolic enhancer in his 1979 Nutritional Biochemistry Lecture Guidelines. His contribution to DMG research on lactic acid and oxygen utilization was very important to understanding DMG's role in enhancing athletic performance. I had the great privilege of working with Dr. Meduski on establishing DMG's safety and its ability to help with hypoxia (low oxygen) and stress.

Mitchell Pries, M.D., with whom I began collaborating in 1979, helped me to answer an important question about DMG. When I first started to research the benefits of DMG for cardiovascular

health, I asked whether DMG supplementation could bring about the same benefits as reported by the Russians for calcium pangamate. Working out of his California clinic, Dr. Pries reported that DMG brought about at least five distinct improvements for cardiovascular patients that totally matched what was reported for calcium pangamate. His studies revealed that, without a doubt, DMG was the active nutrient behind calcium pangamate and what was erroneously called vitamin B_{15}. After his discovery, I found that the Russian research (over 200 studies) on calcium pangamate was a virtual goldmine in revealing other potential therapeutic and health-related benefits of DMG—as future research was to demonstrate.

Beginning in 1985, I had the opportunity to work with John Lawson, Ph.D., of Clemson University. Dr. Lawson became interested in doing research on DMG after reviewing Dr. Graber's ground-breaking research. Dr. Lawson's research over the last 18 years has clarified DMG's mechanism of action on immune system regulation and its potential anti-cancer properties. His discovery in 1986 showed that DMG was effective against melanoma and that DMG could prevent tumor cells from spreading to other parts of the body. His work with animal studies at Clemson University showed that DMG had anti-inflammatory effects in rheumatoid arthritis and was effective against other autoimmune diseases like lupus.

Finally, there is Bernard Rimland, Ph.D., who has been involved with DMG research since 1976 and who is the founder and president of the Autism Research Institute, in San Diego. His research has shown that DMG works in approximately 50 percent of all autistic individuals and improves communication, sleep patterns, and social interactions. He continues the battle to find the cause and cure of autism. It has been very rewarding to work with such a dedicated man who brought DMG to the attention of the autistic community and spread the word that DMG can help overcome some of the symptoms associated with autism.

Through the years, with the help of these associates, we have made many key discoveries about DMG's nutritional and therapeutic uses that have led to five U.S. patents, with more patents pending.

DMG has been around for over 30 years as a nutritional supplement, and it is time for the real DMG story to be told. This book may hold the key to a health problem for you or someone you know.

DMG has been overshadowed in recent years by many newly discovered nutritional products. This is unfortunate in one sense because this current health-conscious generation has lost the knowledge of the benefits of DMG that those in the eighties and early nineties had come to appreciate about this incredible nutrient.

That is why this book had to be written, to allow the new generation to rediscover DMG, to learn the incredible story of the wide variety of DMG benefits, a healing and health-building nutrient for the new millennium.

In my research, I have found that DMG can enable a person to function at a more optimal mental and physical level as it aids the body in overcoming a number of adverse health conditions. DMG seems to be one of those nutrients that is involved in almost every pathway of the body providing a way to "boost" each pathway and provide benefits to the body. Its positive effects are due to the many pathways it influences, cellular functions that it modifies, and the many building blocks it provides.

DMG helps the body to adapt positively to various forms of stress resulting in improved mental and physical performance. For the elderly, it provides more mental clarity and greater vitality. DMG can improve brain and sexual function as well as enhance athletic performance. DMG's ability to boost a person's immune response is critical in a world where many biological threats and infectious agents continue to challenge our body's ability to resist infection.

Over the years, I have been impressed with the wide therapeutic uses of DMG and the list of possible healing applications continues

to grow as more research and clinical studies are done on this amazing nutrient. In short, DMG should be part of everyone's total nutrition program.

I myself have been taking DMG for nearly 25 years to maintain high energy levels, to optimize my cardiovascular health, and strengthen my immune system. DMG is especially important when I travel overseas because it helps protect me against various foreign pathogens and especially from microbes in the recycled air of jet aircrafts. I have found that as an added benefit, it helps reduce the effects of jet lag.

As you read this book, you may be surprised at the many health benefits reported. You may not believe it is possible for DMG to do all these wonderful things and help so many conditions. But DMG holds a central position in building wellness and good health. Find out more about how DMG can help you to jump-start your life, protect you from infectious diseases and help you overcome life-threatening degenerative conditions. DMG is an important nutrient whose many critical positive effects on the human body can dramatically help you build wellness and improve your health.

—Roger V. Kendall, Ph.D.
Westford, Vermont
September 2003

DMG–A Nutrient for the New Millennium

Dear Dr. Kendall,
I am a 41-year-old recovering chronic alcoholic. After 28 days, my strong AA support, and DMG I've taken my last drink. *—Thanks from Washington*

Dear Dr. Kendall,
DMG is better than Viagra! *—Thanks from California*

Dear Dr. Kendall,
My daughter has used DMG to lessen the effects of asthma; she no longer needs an inhaler. *—Thanks from California*

Dear Dr. Kendall,
I am taking DMG for partial seizure syndrome, with success. Upon feeling a seizure about to take place, even if I am working with one of my patients, I can take a tablet and stop the seizure from happening. I am down to one seizure a day due to DMG. *—Thanks from Arizona*

Dear Dr. Kendall,
Greg has been plagued with all types of allergies since birth, and eczema so severe that he has been hospitalized several times. Since the age of 18 months he has been plagued with asthma. He has found breathing difficult and the prescribed medications have not helped. For the last two weeks of August he took three DMG tablets a day, then five pills a week. It is now November and it is just dawning on us that he is free of asthma! When he has trouble breathing, or he is wheezing or coughing he just takes extra DMG. I think these pills have helped his eczema also. —*God bless! from California*

Dear Dr. Kendall,
We would like to tell you about our experience with DMG. We started to use DMG approximately eight years ago, when we moved to North Carolina. I had a small growth that only showed up on ultrasound, not a mammogram. They watched it for years; twice a year, they would ultrasound. Last year when they ultrasounded my bust it was gone. I am not saying that DMG got rid of it, because I really don't know, but I believe it made me healthy enough for my body to fight this growth.

My husband Bill and I have not had the flu, sore throats or any type of sickness for over eight years. We do not take the flu shots. Even my doctor remarked how healthy we are. My husband had open-heart surgery seven years ago and he looks and feels wonderful.

My grandson who is 14 months old suffered from chronic ear infections. We put him on DMG and since he has not had any reoccurrence of this.

My sister Marcella is going under radiation, for cancer of the thyroid. She started taking the DMG and is feeling much better.

I try to tell everyone I know about DMG. I think it is a wonderful product. We must be doing something right that at 65 and 54 we can outdo our children.

We also have top show dogs that can run in any type of heat, and it does not bother them. They take DMG and they do not get sick. I was at a dog show a few years ago, where it was almost 100 degrees, and of course, my dogs were not bothered by the heat. A dog in the group fell down and I had my daughter get liquid DMG. I gave the dog six droppers-full and, within one half hour, the dog was up and doing fine.

My oldest son just had open-heart surgery, and he is also a diabetic. DMG has helped him tremendously with his circulation and energy levels. He has been able to reduce his use of insulin with the use of DMG.
—*Thanks from Dot & Bill Simberlund, North Carolina*

WHY IS DMG IMPORTANT?

What is DMG? Why is it so important to our health? Your body uses DMG every day even if you don't know it! Humans and animals produce DMG in small amounts, and it affects nearly every metabolic pathway within the cell. As a nutritional supplement, DMG has positive effects on your life from stress reduction to improved sexual function, cardiovascular health, immune function, and even overcoming cancer.

DMG aids the body in recovery from intense physical activity as well as degenerative diseases and surgery. Degenerative diseases like diabetes, cancer, arthritis, and heart disease are usually related to the body's inability to adapt to physical and mental stresses. DMG is an adaptogen that works with other cofactors in the body to counteract the negative effects of stress, to promote healing and to help prevent degenerative diseases. It decreases homocysteine levels (a risk factor for cardiovascular disease), increases oxygen utilization, modulates the immune response, aids in liver detoxification, regulates cholesterol and triglyceride levels, and increases energy levels. New research shows that DMG can function as an antioxidant, help the body cope with stress, and prevent free radical damage.

Because DMG is an anti-stress nutrient it impacts the function of several key metabolic pathways. It is beneficial to blood sugar and lipid metabolism as well as liver function. It's ideal for individuals under stress because its diverse functions affect almost every area of the body. Some professionals believe that many illnesses are due to free radical damage caused by stress, and that reduction of free radical damage improves health. DMG's ability to enhance immune competence and improve oxygen utilization are two key ways that DMG boosts wellness and optimizes health.

WHY SHOULD I TAKE DMG?

- DMG (N,N-Dimethylglycine) is a metabolic enhancer that can provide increased benefits when supplemented even if there isn't a deficiency.
- DMG makes the process of metabolism (breaking down or building up of compounds in the body) quicker and more efficient.
- DMG is a completely safe, hypoallergenic nutrient.
- We don't produce as much DMG as we grow older or if we are immune compromised, which leaves us more susceptible to stress and infection.
- DMG improves oxygen utilization, detoxification, cell protection, immune system modulation, and enhances the healing process.
- Extensive research with animals and in clinical testing shows that DMG is an adaptogen that helps maintain homeostasis.

Adaptogens like DMG normalize physiological functions and help maintain homeostasis within the body. These physiological functions include blood glucose levels, pH, blood pressure, hypoxic or low oxygen conditions, hormone levels, cholesterol levels, and levels of important biologically active nutrients. DMG has received a great deal of attention because it is beneficial in so many areas of human health and well-being. Research and clinical studies over the last 25 years demonstrate that DMG can help the body overcome a number of specific health problems. Since DMG is cost effective and results are usually seen fairly quickly, it should be relatively easy to determine if DMG is for you!

WHAT IS THIS THING CALLED DMG?

Sometimes nature packs big things in small packages. DMG is a small molecule with an amazing power to change and improve the health, well-being, and vitality of a person's life. I continue to be impressed

in my discussions with doctors and professional athletes regarding the profound differences that DMG can make in a person's healing potential and overall performance. It seems to act like a cellular catalyst that makes the whole body work better. DMG is a metabolic enhancer that can improve the efficiency of the major pathways of the cell.

DMG is a nutrient that prevents degeneration of the body. DMG is a natural substance found in low levels in the body and in certain foods like meat (liver), beans, seeds, and grains. DMG is not found in high levels in your body because it is an intermediary metabolite, meaning it is rapidly broken down into other substances that your body needs. The human body can produce small amounts of DMG from choline and betaine, but supplementation can provide increased levels of DMG resulting in many health benefits to the body.

DMG is built from the simplest amino acid, glycine, where two hydrogen atoms have been replaced with methyl (CH_3) groups on its nitrogen atom. Research shows it to be physiologically active and important to cell metabolism. DMG supplies essential methyl groups for modification, building, and detoxifying many components in the body.

N,N-Dimethylglycine

$$CH_3$$
$$|$$
$$CH_3-N\text{-}CH_2\text{-}C=O$$
$$|$$
$$OH$$

DMG BENEFITS FROM HEAD TO TOE

The list of areas of human health where DMG provides benefits is exhaustive. Biochemically it occupies a central position in the cell's metabolic pathway, and so it can produce a wide range of biological effects in the body.

DMG:
- Provides useful building units for the biosynthesis of vitamins, hormones, neurotransmitters, antibodies, nucleic acids and other metabolically active molecules.
- Improves oxygen utilization to reduce hypoxic (low oxygen) states in the body.
- Improves the immune response by increasing resistance to disease and infection.
- Has antiviral, antibacterial, and anti-tumor properties and modulates inflammation responses.
- Aids in cardiovascular functions by reducing elevated cholesterol, blood pressure, and triglyceride levels and improving circulation.
- Possesses anti-cancer activity, while preventing metastasis (the spread of cancer).
- Enhances energy levels, endurance, and muscle metabolism
- Improves physical and mental performance.
- Improves neurological function and mental clarity.
- Improves verbal communication and social interactions in autistic individuals.
- Reduces seizures.
- Improves glucose metabolism (storage and utilization) and can retard cataract development.
- Aids in detoxification and enhances liver function.

DMG detoxifies the blood and improves the function of the liver and other organs of the body. DMG helps enhance circulation, physical endurance, and energy production. It affects the efficiency of cellular reactions and improves the nutritional environment of the cell. DMG can help to prevent and relieve symptoms associated with headaches, migraines, insomnia, muscle pains, angina, arteriosclerosis, and shortness of breath.

Laboratory and clinical research indicates that DMG supplementation can be used effectively as a nutritional adjunct in a number of health-related areas including:

- Cardiovascular problems
- Glucose metabolism
- Autoimmune disorders
- Allergies
- Chronic fatigue
- Cancer/tumors
- Liver disorders
- Alcoholism and drug addiction
- Respiratory problems
- Immune response deficiencies
- Neurological disorders
- Autism
- Sports practice

BUILDING WELLNESS

You have heard the expression that an ounce of prevention is worth a pound of cure. When it comes to good health, it is actually easier to choose the path of prevention rather than having to treat a degenerative disease. Supplementation with DMG can be an important part of a preventative program that delays the aging process and reduces the occurrence of degenerative disease as a person gets older.

Health is not just the absence of disease but is better described as an optimal state that postpones age-related disease conditions allowing us to live healthier, happier, and longer lives. The difference between wellness and disease lies in the body's ability to adapt to stress and maintain homeostasis (balance within the body).

The body requires 50 or so essential nutrients including essential fatty acids, vitamins, minerals, and amino acids. Absence of these in the diet can produce a deficiency disease. Due to the change in definition of optimal health, physicians and nutritionists have expanded their research to include a second group of biologically active nutrients called *metabolic enhancers*. Metabolic enhancers improve the health, performance, adaptability, and function of the body when present in adequate amounts. Jerzy Meduski, M.D., Ph.D., was the

first to call DMG a metabolic enhancer. DMG fits the profile of a metabolic enhancer because it increases oxygen utilization, reduces lactic acid levels, improves metabolism, optimizes energy levels, and modulates the immune system for a healthier body. It works in a way that prevents stress from throwing the body out of balance.

BIOCHEMICAL INDIVIDUALITY: THE UNIQUENESS OF YOU

We don't all have "one size fits all" lives. Everyone is different. No one has the same genetics, stress or environment. We each have our own nutritional "fingerprint" or individuality. Along with biochemical differences, we have different lifestyles, nutritional needs, stress levels, and other health issues. There are so many factors that make up your individual health status; like a jigsaw puzzle—they all fit together, making up a picture of who you are and determining which specific nutritional needs you will have.

Good nutrition is the key to preventing deficiencies because nutrients work together to maintain optimal health and prevent the progression of disease. However, nutrition can also be used therapeutically to help the body heal itself and overcome serious health problems. The body will heal itself if given the proper environment and health building nutrients. The goal is to provide the body with the *right nutrients* at the *right time* and in the *proper form and amounts* so that the person's individual chemistry will be strengthened and enhanced to overcome the adverse health condition.

Any nutrient like DMG that is such an integral part of health is important to achieving a long and productive life, but no nutrient works alone in the body. Nutraceuticals work in teams since each one has a different function in the body, and your body requires all of them to stay healthy. This is probably because each biological pathway has its own components, cofactors, and limiting nutrients. Each pathway is regulated by feedback loops, and if there are any

factors missing the pathway shuts down. DMG works best in combination with other vitamins, minerals, and amino acids to energize and stimulate metabolism. Nutrients like vitamin B_6, vitamin B_{12}, and folic acid that are present in the biological pathways with DMG can potentiate DMG's effects due to synergy. Most nutrients do work synergistically to help the body regenerate and heal more efficiently. Synergy is when two or more nutrients together have a greater effect then the individual nutrients working separately. With nutraceuticals, results are synergistic where one plus one can equal three. A single supplement may not work with your biochemical individuality, but when taken in combination with other key nutrients better results are obtained. DMG along with a full spectrum of balanced nutrients can help build long-term good health and vitality.

The connection between diet or nutritional status and health is firmly established. Optimal health is obtained as a result of nutrients working in concert together, at proper levels for the given individual's lifestyle and genetic makeup. If you are a couch potato then your needs are much different from a marathon runner. These are very important things to keep in mind because they define your biochemical individuality. By providing a diverse but effective nutritional foundation, you can more effectively combat degenerative disease by supplying all the nutritional factors that the body needs. Years of clinical experience, patient surveys, case studies, and testimonials show that nutraceuticals work and are an important part of the holistic approach to health.

NUTRACEUTICALS VERSUS PHARMACEUTICALS

Nutraceuticals are nutritional supplements that build wellness. Pharmaceuticals are drugs used to treat disease. Nutraceuticals support and correct deficient metabolic pathways. Drugs block or interfere with the body's normal biological adaptation processes

related to the disease, and in most cases they come with side effects. Pharmaceuticals may treat the symptoms but can end up masking the disease. They cover up problems in a manner that over time may cause more damage than the original disease.

Many scientific and clinical studies over the years have demonstrated that nutraceuticals, herbs, and other natural products can be used effectively and safely to promote healing and restore health. Nutraceuticals support the body in multiple ways. They provide building blocks for the body to repair itself, activate biological pathways, and restore balance, and all without the side effects of most drugs. Although nutraceuticals may work more slowly than drugs, in the long run they are safer and can be used long-term for better results.

DMG USES

DMG has a wide variety of nutritional applications. According to James Balch, M.D., and Phyllis Balch, C.N.C., authors of *Prescription for Nutritional Healing*, DMG can be used for 48 condition-specific uses (see chart below). One of the reasons that DMG can affect so many areas in the body is because it "falls apart"… In other words, it is through donation of methyl groups that DMG provides some seemingly miraculous results (see Chapter 2).

Specific Conditions DMG Benefits—as Detailed in *Prescription for Nutritional Healing*, 3rd ed.

by James Balch, M.D. and Phyllis Balch, C.N.C.

Condition	Page #	Condition	Page #
Aging	133	Hepatitis	431
AIDS	141	Herpes Virus Infection	434
Alcoholism	150	Impotence	456
Arteriosclerosis	187	Infertility	463
Arthritis	190	Leg Ulcers	491
Asthma	197	Memory Improvement	507
Autism	206	Meningitis	510
Breast Cancer	223	Migraine	519
Bronchitis	223	Mononucleosis	522
Bruising	236	Muscle Cramps	531
Cancer	250	Muscle Injuries, Sprains, Strains	643
Cardiovascular Disease	270	Parkinson's Disease	559
Chronic Fatigue Syndrome	288	Prostate Cancer	592
Circulatory Problems	291	Raynaud's Disease	604
Cirrhosis of the Liver	293	Schizophrenia	613
Down Syndrome	333	Seborrhea	616
Emphysema	343	Senility	617
Epilepsy	343	Skin Cancer	629
Fibromyalgia Syndrome	375	Smoking Dependency	637
Gangrene	391	Spider Bite	642
Hair Loss	402	Sunburn	651
Headache	408	Varicose Veins	672
Heart Attack	419	Vertigo	675
Hemorrhoids	427	Weakened Immune System	682

DMG Falls Apart...So You Don't Have To—The Importance of Transmethylation

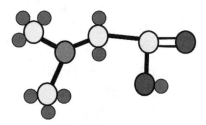

N,N-Dimethylglycine

HOW IS METHYLATION IMPORTANT TO YOUR HEALTH?

So, you're asking yourself why would I care about methylation...Good question. Actually, methylation is very important to your health and decreased methylation in the body is associated with many health conditions, including cardiovascular, brain, and liver disease, as well as cancer.

DMG HAS A JOB TO DO

DMG significantly contributes to methylation. DMG impacts most of the major cycles in the body. DMG works, because it falls apart, to provide what the body needs. The methyl (CH_3) groups donated by DMG are key players in the intricate network of methylation in the human body.

DMG affects so many areas in the body because it supports a biochemical process that is essential to life called transmethylation. The methyl-donating ability of DMG enhances many important reactions used in the body to modify, detoxify, and turn on or off cellular processes. As a methyl donor, DMG causes certain critical chemical reactions to proceed more smoothly. DMG donates methyl groups for the remethylation (recycling) of S-adenosylmethionine (SAMe), the major methyl donor in the body. DMG also functions as a mineral transporter, chelating agent, and cell communicator. Additionally, DMG helps detoxify toxic substances, and remove hazardous by-products from circulation.

TAKING THE MYSTERY OUT OF DMG

DMG is an intricate part of human metabolism that can enable an individual to function at a higher plane of mental and physical health and aid the body in overcoming a number of adverse health conditions. DMG's positive effects are due to its ability to provide many cellular building blocks, help in metabolic reactions through methyl donation (the ability to donate part of itself to another molecule), and improve cellular communication. As an intermediary metabolite, it can be rapidly converted into other compounds the body needs.

DMG is a non-fuel nutrient, which means it is not like a fat or sugar that the body uses for energy. But DMG is ergogenic, which means it makes the process of making energy more efficient and that helps improve physical stamina. In short, DMG is a metabolic enhancer that maximizes the amount of energy produced from each molecule of oxygen consumed in cellular respiration. Oxygen, when used more efficiently, benefits the body by preventing a buildup of toxins and disease-causing agents in the blood.

DMG supports methylation processes in the body. Transmethylation is an enzyme-controlled reaction where a methyl

group is given up by DMG in order to complete the synthesis of another molecule. It is a biochemical process that is essential to life and necessary for good health. It is a biochemical reaction that occurs a billion times a second. Methylation is needed to build many molecules in the body. DMG supplies methyl groups for many important reactions that modify, build, recycle, activate, protect, and change the structure and function of many components in the body. The two methyl groups of DMG can be easily removed when needed by other components in cellular reactions making DMG an effective methyl donor, and important for metabolism in almost every cell in the body.

When talking about the transmethylation pathway one usually starts with choline. (See chart called Methylation Pathways on page 32). Choline is sometimes included in the B vitamin complex. It is not, however, considered an essential nutrient because it can be synthesized in the body by the methylation of the amino acid serine. Choline is ingested in the diet in adequate amounts from foods like legumes, meat, milk, and whole-grain cereals. Ingested choline can be oxidized to become betaine, which then loses a methyl group to become DMG. DMG in turn gives up its methyl groups to a methyl reserve in a process called oxidative demethylation that takes place mainly in the liver. DMG is converted to many useful metabolites by enzyme-controlled reactions, as seen in the chart called Methylation Pathways on page 32. Nutrients that are important for DMG metabolism are vitamin B_2 (riboflavin), vitamin B_6 (pyridoxine), vitamin B_{12}, vitamin B_3 (niacinamide), folic acid, and magnesium. It is apparent from research that the body does not produce adequate DMG by natural pathways and therefore supplementation of this key metabolite can significantly enhance many cellular processes involving transmethylation. (See chart called DMG Supplementation and Transmethylation on page 34).

The following charts show the transmethylation pathway that involves DMG. The purpose of showing these pathways to you is so

that you can see how interconnected each step is and how important methylation is to other reactions within the body.

DMG SUPPLEMENTATION AND TRANSMETHYLATION

As a methyl donor, DMG impacts cellular reactions that improve the nutritional environment of the cell. DMG provides methyl groups for the synthesis of vitamins, enzymes, hormones, neuro-transmitters, nucleic acids, and antibodies. Methylation is one way the body protects itself from damage on the cellular level. The methyl groups can be used in the production of nucleic acids like RNA and DNA. DNA (Deoxyribonucleic Acid) is found in the cell's nucleus and contains the genetic information of the cell and can be considered the cell's blueprint. Methyl groups coat the DNA to protect it from damage, oxidation, and aging. One way DMG helps to prevent cancer is by providing methyl groups. DNA methylation influences the expression of genes and depends on the availability of methyl groups from SAMe.

DMG helps to replenish the methyl pool that is used by SAMe for transmethylation reactions. So you can see why DMG supple-mentation is so important, since SAMe is required for DNA methy-lation to take place. DMG supplies methyl groups depleted by age, stress, and disease, as well as raising intracellular SAMe and glutathione (GSH) levels.

SAMe

The two methyl groups of DMG can be made available for trans-methylation reactions via SAMe, and through SAMe it can indi-rectly regulate a number of cellular processes. SAMe is formed in the body when methionine (an essential amino acid) combines with ATP (a source of cellular energy). As the body's principle methyl donor, SAMe is involved in over 41 different transmethylation reac-

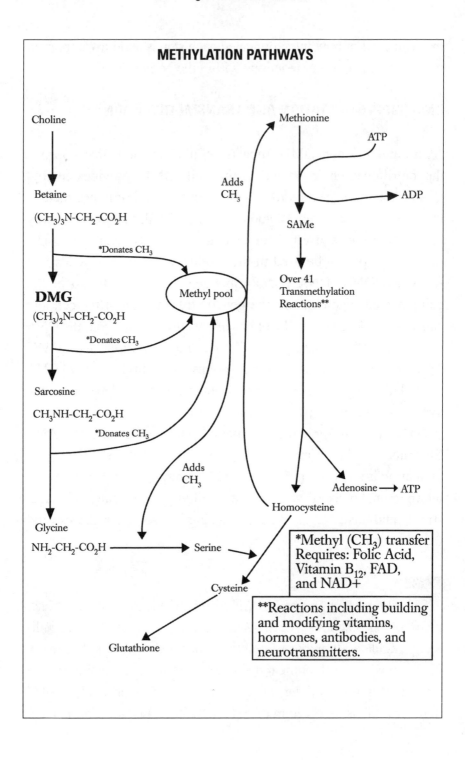

METHYLATION PATHWAYS

Choline

Methionine

ATP

Adds
CH₃

ADP

Betaine

(CH₃)₃N-CH₂-CO₂H

SAMe

*Donates CH₃

Methyl pool

DMG

Over 41
Transmethylation
Reactions**

(CH₃)₂N-CH₂-CO₂H

*Donates CH₃

Sarcosine

CH₃NH-CH₂-CO₂H

*Donates CH₃

Adds
CH₃

Adenosine → ATP

Homocysteine

Glycine

NH₂-CH₂-CO₂H ⟶ Serine

*Methyl (CH₃) transfer
Requires: Folic Acid,
Vitamin B₁₂, FAD,
and NAD+

Cysteine

**Reactions including building
and modifying vitamins,
hormones, antibodies, and
neurotransmitters.

Glutathione

Methylation Pathways: *(see chart, previous page)* On the left hand side of the chart you can see choline at the top. Choline is either taken in from the diet or made from the methylation of serine. Choline can then be oxidized to provide betaine. Betaine can donate a methyl group to become DMG. DMG can donate a methyl group to become sarcosine. Sarcosine can donate a methyl group to become glycine. Glycine can be methylated to provide serine, and serine can be methylated to provide choline starting the cycle again. Each nutrient can be made by this cycle, but each individual nutrient can also be ingested in small amounts in the diet. Vitamin B_{12}, folic acid, FAD, and NAD+ are necessary cofactors in the transfer of methyl groups. On the top right hand side of the chart you can see that methyl groups provided by methyl donors like DMG help to change the potentially harmful amino acid homocysteine into the essential amino acid methionine. Methionine and ATP (cellular energy source) make SAMe. SAMe is used in over 41 transmethylation reactions that include modifying and building vitamins, hormones, antibodies, and neurotransmitters. The use of SAMe after a series of reactions results in the end product homocysteine. Homocysteine in high levels can be harmful. To lower homocysteine it can be methylated back to methionine or it can combine with the amino acid serine in a series of reactions (note how DMG helps provide serine) to form cysteine. Cysteine is a sulfur-containing amino acid that is hard to absorb intact from the diet, and it is the rate-limiting step in the formation of glutathione, the cells' master antioxidant.

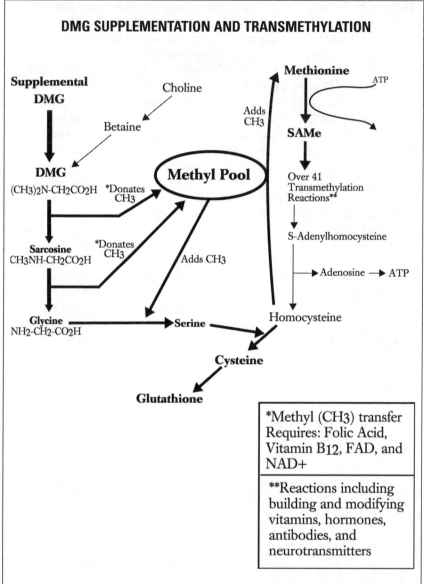

DMG SUPPLEMENTATION AND TRANSMETHYLATION

*Methyl (CH3) transfer Requires: Folic Acid, Vitamin B12, FAD, and NAD+

**Reactions including building and modifying vitamins, hormones, antibodies, and neurotransmitters

This second chart shows which areas in the transmethylation pathway would be enhanced by the addition of DMG to the diet. Adding DMG helps improve methyl donation and increases the end metabolites produced from DMG demethylation. DMG also helps decrease homocysteine levels as well as increasing SAMe and glutathione (GSH) levels.

tions that are critical to health. Donation of methyl groups by SAMe requires the cofactors vitamin B_{12} and folic acid. SAMe has been shown to increase cartilage formation, relieve pain, and decrease inflammation in those with osteoarthritis. SAMe elevates mood by aiding in the production of hormones and neurotransmitters that are essential for proper brain function like epinephrine, norepinephrine, serotonin, melatonin, and dopamine, as well as phospholipids like phosphatidylcholine and phosphatidylserine. Supplementing with SAMe also enhances hormone function by improving the ability of neurotransmitters to bind to their receptor sites, which increases their activity. SAMe supplementation has a positive effect on neuronal membranes; it methylates phospholipids on cell membranes to improve cell communication between neurons, as well as improving cell membrane fluidity in the brain.

With age there is a decreased ability to produce SAMe. The body requires SAMe for normal function and can generally produce enough of it on its own, but the elderly, people with arthritis, depression and other disease conditions (like liver disease) appear to have reduced SAMe levels. SAMe has been used successfully for over 20 years in Europe to treat arthritis and depression without side effects.

When used as a supplement SAMe causes an uplifted mood by acting as an anti-depressent, as well as benefiting joints and connective tissue, enhancing liver function, helping to lower homocysteine levels, and slowing the aging process. SAMe also increases natural levels of glutathione.

Glutathione

Glutathione (GSH) is an antioxidant produced in the liver from the amino acids cysteine, glutamic acid, and glycine. Glutathione functions as an antioxidant, a detoxifier, and an immune enhancer. GSH is one of the most powerful antioxidants in the body, and it improves the effectiveness of other antioxidants like vitamins C and

E. GSH protects the body from cellular damage by inhibiting free radical formation, and neutralizing oxygen molecules before they can become harmful. GSH acts as a detoxifier of heavy metals, drugs, toxins, and carcinogens through a GSH enzyme system, while providing the liver (the main detoxification organ) with antioxidant protection. GSH increases the potency of the immune response, enhances the function of immune cells, and stabilizes free radicals generated by normal immune system function.

As we get older SAMe and GSH levels drop, resulting in less efficient cellular reactions, generation of free radicals, and a decreased ability of the body to deactivate free radicals. When supplemented GSH, like SAMe, has anti-aging effects. DMG can enhance GSH levels through SAMe synthesis as well as by providing glycine.

DMG Provides Glycine

DMG can give up two of its methyl groups to provide the amino acid glycine. Glycine functions as an important inhibitory neurotransmitter of the central nervous system. Glycine is used to produce glutathione, which is the body's primary antioxidant. Glycine can also be remethylated back to DMG, which allows for the donation and acceptance of methyl groups as needed by the body.

BUILDING WITH DMG

Methyl groups are also used to neutralize toxins in your body. DMG donates methyl groups that can be used to detoxify many damaging chemicals. DMG impacts antibody production, activate proteins, methylates amino acids, and many other important physiological events in the body through post-translational covalent modification of proteins.

What is post-translational, covalent modification of proteins you ask? Proteins, like antibodies, go through a modification process after they are

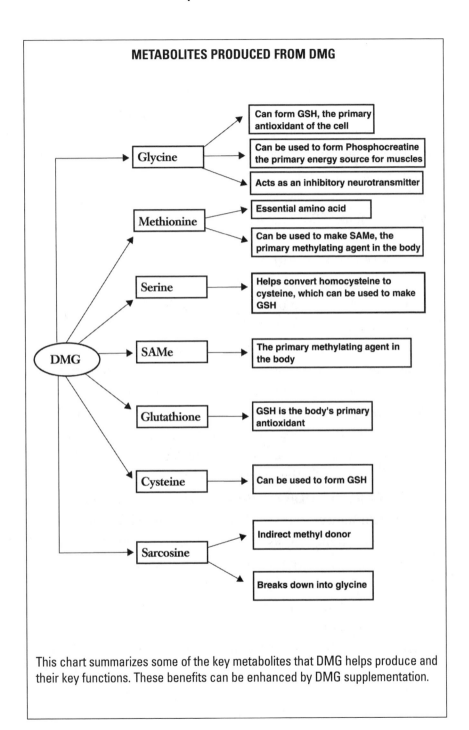

This chart summarizes some of the key metabolites that DMG helps produce and their key functions. These benefits can be enhanced by DMG supplementation.

made in order to activate them. Vitamins, hormones, neurotransmitters, enzymes, nucleic acids, and antibodies all need methyl groups to complete their synthesis and become active in the body. Some amino acids like lysine, arginine, and histidine are usually methylated. Amino acids are the building blocks of proteins and have a wide variety of functions in the body that range from production of enzymes, hormones, immunoglobulins, neurotransmitters, and the structural proteins found in muscles, tendons, hair, and skin. So it is easy to see how a nutrient like DMG can have such a wide range of effects.

DMG FOR WHAT AILS YOU

Below is a list of some of the key areas that DMG affects and a brief explanation of how it works to impact that health area.

- **Alcoholism/Drug Addictions:** DMG benefits those with addictions due to its ability to help eliminate cravings for drugs and alcohol, as well as helping to detoxify the liver.
- **Athletics/Sports Medicine/Performance Enhancement:** DMG benefits athletes or those with performance issues because it can increase oxygen utilization, decrease lactic acid buildup, and make energy production more efficient.
- **Autism/ADD/ADHD/OCD/Behavioral Issues:** DMG benefits those with autism and ADD because of its ability to enhance methyl donation, act as an adaptogen, impact the immune response, and enhance neurotransmitter production.
- **Autoimmune Diseases (like Lupus):** DMG helps those with autoimmune disorders because it has the ability to modulate the immune response.
- **Cancer:** DMG is a useful therapy for those with cancer because of DMG's ability to modulate the immune system, its anti-tumor properties, its ability to act as a methyl donor to protect DNA, and its ability to act directly against cancer cells.

- **Cardiovascular Disease:** DMG benefits those with cardiovascular disease because of its ability to improve circulation, help the body adapt to stress, decrease homocysteine levels, increase glutathione and SAMe levels, and decrease elevated blood pressure, triglyceride, and cholesterol levels.
- **Cataract Prevention:** DMG benefits individuals in any stage of cataract development due to its ability to help increase circulation, rid the area of optical debris, enhance oxygen utilization at a cellular level, and its ability to act as an antioxidant.
- **Chronic Fatigue Syndrome/Fibromyalgia:** DMG benefits those with chronic fatigue syndrome and fibromyalgia due to its ability to enhance oxygen utilization, improve circulation, make energy production more efficient, modulate the immune system, and decrease lactic acid levels.
- **Circulation Dysfunction/Migraines:** DMG is beneficial to those with circulatory dysfunction due to its ability to help increase circulation and improve oxygen utilization.
- **Degenerative Diseases/Arthritis:** DMG is helpful to those with degenerative diseases due to DMG's anti-inflammatory properties and its immune system support.
- **Diabetes Mellitus:** DMG is a useful therapy to those with diabetes due to its ability to improve sugar metabolism, help make hormones like insulin, enhance circulation, prevent cataract formation, and its ability to act as an antioxidant.
- **General Health/Premature Aging:** DMG is important to general health and can help slow the aging process due to its ability to modulate the immune system, increase circulation, improve oxygen utilization, and because it's an adaptogen and provides building blocks needed for synthesis of important body constituents.
- **Immunity:** DMG protects against infection and invasion by pathogens and parasites and is useful as a therapy or preventative for such diseases as AIDS, *Candida albicans*, mononucleosis, and

chronic fatigue syndrome (Epstein-Barr virus) due to its ability to enhance the immune system by activating both arms of the immune response.

- **Liver and Kidney Disorders:** DMG benefits those with liver and kidney disorders due to its antioxidant and lipotropic properties and its ability to be a good methyl donor. DMG also enhances circulation and increases glutathione and SAMe levels.

- **Neurological Disorders/Seizures/Epilepsy:** DMG is beneficial to those with neurological disorders and epilepsy due to its ability to reduce seizures, increase circulation, provide building blocks to important neurotransmitters and hormones, and make energy production more efficient.

- **Respiratory Problems/Asthma/Emphysema/Hypoxia/Allergies:** DMG is beneficial to those with respiratory disorders and allergies due to its ability to increase circulation, enhance oxygen utilization, increase detoxification, decrease lactic acid, and act as an adaptogen.

- **Sexual Performance:** DMG benefits sexual performance in both men and women thorough its ability to enhance circulation, increase oxygen utilization, decrease lactic acid formation, and make energy production more efficient.

- **Stress:** DMG is beneficial to those with high stress or anxiety issues due to its ability to act as an adaptogen and help the body cope with physical, emotional and metabolic responses, to act as an antioxidant, provide building blocks, enhance oxygen utilization, decrease lactic acid formation, and help modulate the immune system.

DMG AND HEALTH

The versatility of DMG to donate methyl groups and generate molecules like glycine, serine, sarcosine, ethanolamines, methionine, and cysteine as well as contributing to the formation of SAMe may explain why DMG has such broad and wide-reaching therapeutic effects on the body. Some of those therapeutic effects include enhancing energy production, increasing circulation, decreasing seizure activity, reducing lactic acid levels, promoting better oxygen utilization, lowering homocysteine, and many other beneficial effects. We have discussed DMG as a methyl donor, adaptogen, and building block, but it also plays an intricate role in oxygen utilization by all the cells in the body, and may be how DMG impacts lactic acid production.

DMG AND THE BALANCE BEAM OF LIFE

Do you have the perfect, stress-free job? Have you been blessed with a saintly family? Do you have amazing good health? If you are never sick and have a perfect stress-free life, then DMG may not be for you! HOWEVER, if you've struggled through rush hour traffic to get to a job that causes you migraines; if after you've picked up the kids from the soccer game, and after you have them and all their gear piled into the house, if you realize that the dog has had an accident on your favorite chair; if you find out it is your night to cook dinner; if you just want to go to bed for the next week, but you already used up all your sick days for the year... If this is your life, then DMG is for you! Why you ask? What can it do for you in your normal everyday stress-filled life? Can DMG really make a difference? Thousands of people over the past 25 years who have used DMG as part of their nutritional program would say YES!

DMG IN THE REAL WORLD

DMG is a major anti-stress nutrient, energy builder, and adaptogen that benefits your metabolism, health, and well-being. The average person has fatigue issues, injuries, gets sick, and has jet lag. People nowadays are stressed! When the body is under conditions of stress, DMG improves oxygen utilization in the body and enhances cellular metabolism. Many studies show that DMG supplementation helps both humans and animals adapt to increased physical activity by reducing blood lactic acid levels, increasing oxygen uptake by tissues, enhancing ATP production, normalizing glucose metabolism, and decreasing fatigue.

So, what you're saying is "I take a little pill and all my problems go away?" Hardly! DMG isn't a cure-all, but it will keep you at your peak performance level longer to allow you to accomplish your daily goals with greater efficiency. Marathon runners benefit from DMG, and now so can you.

MORE ON THE ROLE OF DMG

Aging decreases immunity, but DMG helps enhance immunity to slow the aging process. DMG helps us to age more gracefully. As we get older free radicals and stress damage one's ability to maintain immune function, memory, and physical ability. DMG helps cope with stress, increases tolerance to activity, and helps us fight fatigue as well as improving stamina, sexual function, athletic ability, and mental acuity. And as we get older who wouldn't want those things? It helps protect against degenerative diseases like arthritis, diabetes, cancer, and Alzheimer's. It is very encouraging to realize that one can do something to overcome possible genetic predisposition to certain degenerative conditions. DMG is for active people and for people who want to be more active.

3

DMG and Immunity—
The Natural Disease Defense

Perhaps one of the most significant breakthroughs in the research with DMG came in 1978. At the time I was evaluating the Russian research on calcium pangamate, whose prime active ingredient appeared to be DMG, and comparing it to the work we were doing with DMG. Chuck Graber, Ph.D., Professor of Immunology at the Medical University of South Carolina at Charleston, had reviewed a paper published in the Soviet Union showing that calcium pangamate protected the immune system of guinea pigs that were irradiated with gamma rays. Without the addition of pangamate in their diet, the guinea pigs lost their immune competence or the ability to respond to an immune system challenge. Dr. Graber called me on the phone and asked if I could provide him with any calcium pangamate as he was interested in evaluating the material as an immune system adjuvant. He wanted to know whether it would boost the immune response of healthy rabbits given a vaccine, which would challenge their immune systems. I told him although I did not have

any calcium pangamate, I did have DMG, which I told him was no doubt the active component in the Russian formula anyway. Based on my input he said he would try DMG instead. Not knowing what he would find, I sent him DMG thinking that I probably wouldn't hear from him again. Two months later I got a very excited phone call from him saying that the experiment worked. DMG in a controlled study was clearly found to boost the immune response in rabbits given a vaccine. The DMG triggered a heightened immune response by increasing and more than tripling the antibody production in the rabbits given DMG, which increased their resistance to disease. The next question to be answered was…would it work for humans? The answer is a resounding yes.

DMG BENEFITS TO THE IMMUNE RESPONSE

- DMG has anti-inflammatory, antiviral, antibacterial, and anti-fungal properties.

- DMG improves antibody response.

- DMG enhances B and T cell function and macrophage activity.

- DMG regulates cytokine and interferon production.

- DMG can act directly to modulate the immune response.

DMG AND IMMUNITY

The immune system is the body's defense against foreign invasion. It is our immune system that directs the healing process and protects us from a wide range of potentially toxic and disease-causing agents, such as mold, bacteria, viruses, and even cancer cells. The average American has repeated throat and ear infections, fatigue, chronic infections, colds, flu, and allergies. This may be a sign of a weakened immune system.

Factors that affect the immune response are age, metabolism, genetics, microbial infestation (like yeast issues), infection, stress, nutritional status, drugs, pollution, and degenerative diseases (cardiovascular disease, arthritis, diabetes, and cancer). A strong immune system is necessary for good health and protection from infectious disease. Immune-compromised individuals are at great risk of secondary infection by opportunistic microorganisms. Many people now consume nutritional supplements such as DMG to strengthen their immune systems and to aid their body in over-coming infections. Physicians now recommend DMG to many of their patients because of its immune building properties.

Because DMG is a methyl donor, it enhances the immune response and helps increase general disease resistance. Through methylation, DMG can act as a cell messenger, it can protect cell DNA, and it can enhance antibody production. DMG can also act as a direct cell-to-cell communicator. This is very important to immune system function, which requires intracellular communication. Immune cells transmit critical information to each other in order to launch appropriate attacks against invading pathogens. DMG aids in a more efficient immune response. DMG functions as an adaptogen to reduce stress from physical, emotional or environmental causes as well as improving physical and mental energy levels.

CELLULAR AND HUMORAL IMMUNITY

The immune *system* is composed of immune cells; these are your body's "national guard" and the immune *response* is the body's ability to summon that national guard. The immune system is made up of immune cells (B lymphocytes, T lymphocytes, macrophages, and natural killer cells) and chemical messengers (antibodies, cytokines, lymphokines, interferons, and interleukins) that are responsible for protecting the body from infectious disease.

Together these cells and chemical messengers work together to seek out, identify, and destroy invading microbes that cause disease. An antigen is any substance that can elicit an immune response. The immune response is the action the body takes to defend against antigens. The immune response identifies those things that are foreign to the body or "non-self" and then destroys the elements it considers harmful. It does this through two basic pathways known as cell-mediated and humoral immunity. (See the glossary for a more complete description of any immunological terms).

Cell-mediated immunity involves T lymphocytes that identify and eliminate cancer cells, viruses, and other pathogens. In the thymus, each T lymphocyte is programmed to identify one type of antigen. Once exposed to a new infectious agent, the body produces memory T lymphocytes for each antigen to guard against any future exposure. These lymphocytes can also secrete specialized proteins called cytokines to attack antigens, and stimulate the immune response or the inflammatory response.

Humoral immunity on the other hand involves B lymphocytes that produce antibodies or immunoglobulins (IgA, IgG, IgM, IgD, and IgE) and specialized proteins (interleukins and interferons) that help the immune system communicate and meet specific challenges. Antibodies are specialized molecules that when they encounter their specific antigen either attack it directly or alert nearby T lymphocytes or macrophages to eliminate the invader.

Cytokines are proteins released by immune cells when antigens are present that regulate inflammation and the immune response. Cytokines function as messengers in the immune system, providing a communication network to keep the immune response in balance and functioning properly. Interleukins, lymphokines, interferon, and tumor necrosis factor are all cytokines.

DMG'S EFFECTS ON CELLULAR AND HUMORAL IMMUNITY

DMG can produce multiple positive effects on the immune system. DMG has antiviral, antibacterial, anti-fungal, and anti-tumor properties. Research with animal models and cell cultures show that DMG modulates the immune system by regulating B lymphocytes to produce higher levels of antibodies (humoral branch), potentiating greater activity of T lymphocytes and macrophages (cellular branch), and modifying cytokine levels.

STUDIES ON DMG'S EFFECTS ON IMMUNE RESPONSE

Studies by Dr. Charles Graber at the Medical University of South Carolina showed that DMG used as a dietary supplement increases antibody production, stimulates the activity of macrophages, and improves the production of both T and B lymphocytes to help fight off infection.

Dr. Graber found that in rabbits challenged with a typhoid vaccine, DMG boosted antibody production from B lymphocytes four-fold. After completing the initial experiment in rabbits, Dr. Graber began a series of experiments to see if DMG would work to enhance humoral and cellular immune responses in humans. To that end he completed a double-blinded human study, which was published in the *Journal of Infectious Diseases*. The results showed a 400 percent increase in antibody response, and enhanced lymphocyte production in the people taking DMG in the presence of an immune system challenge. DMG was effective in stimulating humoral (antibody) and cell mediated (T lymphocytes) response in individuals with challenged immune systems. Due to DMG's ability to fight off secondary infections and increase resistance to disease by activating both cell-mediated and humoral immune response, the world's leading producer of DMG, FoodScience

Corporation, of Essex Junction, Vermont, was granted a patent on the role of DMG in potentiating the immune response (U.S. Patent 4,631,198) in 1983.

Dr. Graber also completed an *in vitro* analysis, where blood from 75 individuals was tested and it was found that DMG significantly increased the number of T lymphocytes. A positive response was seen not only in normal individuals, but also in patients with diabetes and sickle cell anemia. Patients with these diseases suffer from more infections than most healthy people due to a weakened immune system.

In 1985, research on DMG and its impact on the immune system was switched to the laboratory of Dr. John Lawson at Clemson University. Further studies done by Dr. Lawson verified that DMG affected both the cellular and humoral immune response. He showed that DMG modulates the production of a number of cytokines produced by T lymphocytes and macrophages. In a study, rabbits given a vaccine or that were immune challenged produced a three- to five-fold increase in antibody levels compared to controls. There was also a ten-fold increase in T lymphocyte production and an increase in interferon levels. Interferon is a cytokine, a product of T lymphocytes which can act as an antiviral and anti-tumor agent.

In other studies using cell culture models, DMG increased production of key cytokines that can regulate inflammation, tumor growth, and the immune response. DMG was found to increase the immune system's production of tumor necrosis factor alpha (TNF-α) and a number of interleukins (including IL-1 and IL-2). The increase of production of these cytokines can greatly enhance immunity to infections as well as increase the killing of cancer cells. This discovery of DMG's ability to increase TNF levels in the rabbit led Dr. Lawson to evaluate a cancer model in mice (see Chapter 5).

An immune study done by the U.S. Army by Bruce Ivins, Ph.D., at the Medical Institute of Infectious Disease, Ft. Detrick, Maryland,

was reported in the *Townsend Letter for Doctors & Patients* in May 2000; it indicates that DMG may also offer protection against anthrax. The study evaluated the effects of DMG on guinea pigs given a human anthrax vaccine. Guinea pigs were given a lethal dose of anthrax and 44 percent of the control animals died, but none of the DMG-supplemented animals died. The DMG-fed animals demonstrated enhanced immunity and cellular response (activation of both T and B lymphocytes).

DMG and the Immune Response Research Summary

- In rabbits vaccinated with typhoid, DMG boosted antibody production four-fold and increased T lymphocyte production ten-fold over controls. DMG was also effective in increasing interferon production in rabbits. Interferon is a cytokine, a product of T lymphocytes, which can act as an antiviral and anti-tumor agent.

- DMG caused a 400 percent increase in antibody response in humans as well as enhanced lymphocyte production in the presence of an immune system challenge.

- DMG was effective in stimulating humoral (antibody) and cell-mediated (T lymphocytes) response in individuals with challenged immune systems. DMG significantly increased T lymphocyte populations in normal individuals as well as in patients with diabetes and sickle cell anemia.

- In cell culture models, DMG increased production of cytokines that can regulate inflammation, tumor growth, and the immune response.

- DMG was found to increase the immune system's production of tumor necrosis factor alpha or TNF-α, and a number of interleukins including IL-1 and IL-2. The increase of production of these cytokines can greatly enhance immunity against infections as well as increase the killing of cancer cells.

- An immune study done by the U.S. Army in May 2000 indicates that DMG may also offer protection against anthrax. The study evaluated the effects of DMG on guinea pigs given a human anthrax vaccine. Guinea pigs were given a lethal dose of anthrax and 44 percent of the control animals died, but none of the DMG-supplemented animals died.

Research shows that DMG may offer protection from upper respiratory problems, and bacterial and viral infections. DMG use offers a safe immune modulating therapy that can offer increased resistance and recovery from degenerative and infectious diseases like cancer, AIDS, influenza, mononucleosis, Epstein-Barr, heart disease, allergies, chronic fatigue syndrome or diabetes. DMG provides an important immune boost for prevention of sickness, immune compromised individuals, or those challenged by a degenerative disease.

DMG has been shown to impact the immune system in the following areas:

- Enhancing cellular-mediated response of:
 T lymphocytes
 B lymphocytes
 Macrophages
- Enhancing antibody production of B lymphocytes
- Modulating production of cytokines:

INF	IL-2
TNF-α	IL-6
IL-1	IL-10

- Enhancing the tumor fighting potential of the immune response

DMG AND MONONUCLEOSIS

About 90 percent of people over 35 have been infected with mononucleosis and have antibodies to it in their blood. Some 85 percent of all cases of mononucleosis are caused by Epstein-Barr virus (EBV), the rest by cytomegalovirus, which are both herpes viruses. Once you have been infected with the EBV your body may periodically shed (release) the virus throughout your life, spreading it to others. Aside from mononucleosis, EBV has been associated with causing chronic fatigue syndrome (CFS), fibromyalgia, and some forms of cancer. DMG supplementation may be useful

because it increases immunity, helps with energy production, enhances endurance, and has antiviral properties.

DMG AND CANDIDIASIS

Candidiasis is caused by *Candida albicans*, a single-celled fungus that is normally present in our digestive and reproductive tracts. Overgrowths of it can cause infections like vaginitis, diaper rash, athlete's foot, jock itch, thrush (infection of the mouth), and others. It most commonly affects the mouth, nose, ears, nails, GI tract, and vagina. Systemic candidiasis is an overgrowth of *Candia albicans* throughout the body, which mainly occurs in those who are immune compromised. DMG has anti-fungal properties, modulates immunity and enhances energy production to help deal with the symptoms of candidiasis as well as helping to regulate the fungal population and control overgrowths.

DMG AND GASTRIC ULCERS

Ulcers are one of the most common diseases affecting Man. Gastric ulcers can have many causes like severe stress, *Helibacter pylori* infection (a bacteria), as well as ingenstion of drugs like alcohol, aspirin, ibuprofen, and non-steroidal anti-inflammatory agents. Studies suggest that free radical damage and lipid peroxidation may be involved in the pathogenesis of gastric ulcers. A recent published study has shown DMG to be as effective as the drug famotidine (brand name Pepcid) in reducing gastric ulcers caused by stress, ibuprofen, and pyloric ligation. DMG did not change acid secretion and may promote the healing of ulcers by acting as an antioxidant, free radical scavenger, anti-stress nutrient, detoxifying agent, and through modulation of the immune system. The study proposed that

DMG would also be useful in controlling ulcers caused by *H. pylori* infection and NSAIDs for the same reason.

DMG AND AGING

As we age we are not able to respond as effectively to immune challenges and are more prone to infectious and degenerative diseases. DMG helps conditions associated with aging. In *Prescription for Nutritional Healing*, DMG has been recommended for weakened immune systems, premature aging, hemorrhoids, hair loss, circulatory problems, infertility, impotence, varicose veins, memory loss, bruising, and senility. DMG benefits geriatric patients by increasing oxygen utilization, promoting healing, strengthening the immune system, increasing energy production, and helping increase circulation.

DMG AND HEADACHES

Approximately 45 million Americans suffer from frequent headaches, while 28 million experience migraine headaches. Headaches can be caused by stress, anxiety, allergies, caffeine, eyestrain, hormonal imbalances, nutritional deficiencies, drugs, fever, environmental irritants, sinus pressure, and many other factors. Most headaches (about 90 percent) are tension headaches that are caused by muscle tension, but some are migraines or vascular headaches caused by inflammation. DMG increases oxygen utilization, helps with detoxification, causes vasodilation of blood vessels, enhances energy production, and modulates the immune system. DMG has been shown to reduce the pain associated with tension headaches. Some people have reported that they can stop a migraine from developing if they take DMG within the first minutes of an oncoming attack.

DMG FOR SKIN CONDITIONS

Early Russian research shows that DMG may be beneficial to those with skin conditions like seborrhea, scleroderma, psoriasis, urticaria, sunburn, eczema, and other dermatitis conditions. DMG may improve these conditions due to its abilities to increase oxygen utilization, improve circulation, act as an antioxidant, decrease inflammation, and modulate the immune system.

DMG FOR HANGOVERS

DMG may be what you grab out of your medicine cabinet after your next late night, because testimonials show DMG may help with hangovers. DMG had been recommended by Dr. Balch for headaches; now, testimonials are flooding in on its ability to conquer hangover symptoms. DMG helps increase oxygen utilization and circulation, cutting down on those headaches, and helps the liver detoxify alcohol to remove it from your system more quickly. So next time you head to a party, bring enough for everyone.

DMG is shown to:

- Strengthen the immune system and allow a more effective immune response by increasing resistance to foreign antigens (bacteria, viruses, and other pathogens) and to speed recovery from infectious disease.
- Have anti-inflammatory, antiviral, antibacterial, and anti-tumor properties.
- Improve immune response by increasing resistance to disease and infection by strengthening both arms of the immune system, including antibody, lymphocyte and cytokine production.
- Balance the immune system by stimulating cytokine production from T lymphocytes and macrophages.
- Reduce physical and environmental stress, which can weaken immunity.
- Offer immune protection from environmental and metabolically induced health problems.
- Act as an indirect methyl donor and provide useful building units for the biosynthesis of antibodies.

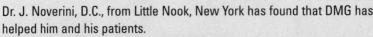

Dr. J. Noverini, D.C., from Little Nook, New York has found that DMG has helped him and his patients.

Several of my patients and myself have been taking DMG. Not only do we feel well overall, but our immune systems and liver and heart functions have impoved as well. I highly recommend DMG!

In the September 1988 issue of *Bestways*, Dr. Frackelton, M.D., a past president of the American College of Advancement in Medicine, reported on DMG and its use on his immune-compromised patients.

I was exposed to dimethylglycine a few years ago as a potential immune system enhancer for my patients. At first I used it for those who had an immune deficiency of some type: frequent infections, pneumonia, or other overall decreases in immunity. I noticed a clear-cut reduction in such infections. My patients experienced a marked improvement in their health histories. Now, for those people who have more serious illnesses, as for instance, cancer, I include DMG as one of the standard nutrient additions to their dietary programs. I don't treat cancer, but I do treat a lot of cancer patients. These people may still have their cancer, but they show symptomatic improvement by taking DMG. It boosts the immune system.

Nutrients that Benefit those who are Immune Compromised

Nutrients	Benefits for those who are immune compromised
DMG	DMG enhances immunity and oxygen utilization as well as the body's ability to detoxify toxins. DMG acts as a metabolic enhancer reducing symptoms associated with physical, emotional, and environmental stressors. DMG benefits geriatric patients by promoting healing, increasing energy production, and helping increase circulation.
Microflora	*Lactobacillus acidophilus* and other microflora can be supplemented to help fight and control the population of pathogens in the gut.
Essential Fatty Acids	Essential fatty acids are important in the healing process, controlling inflammation responses, and in preventing fungus from destroying cells.
Coenzyme Q_{10}	CoQ_{10} increases oxygen utilization and provides antioxidant protection.
Vitamin C	Vitamin C helps increase immunity, and as an antioxidant it helps protect the body from toxins that are released by the pathogens.
Beta-Glucans	Beta-glucans are complex polysaccharides that stimulate the immune system and act as free radical scavengers.
Arabinogalactans	Arabinogalactans from larch tree extract help enhance immunity. They block bacteria and viruses from attaching to cell membranes to prevent invasion.

** Maitake mushroom, olive leaf extract, and garlic all enhance immunity and have anti-fungal and antiviral properties.

4

DMG for
Cardiovascular Disease

DMG BENEFITS TO CARDIOVASCULAR HEALTH

- DMG decreases elevated cholesterol.

- DMG lowers triglyceride levels.

- DMG lowers high blood pressure.

- DMG helps eliminate hypoxia (low oxygen states) by increasing oxygen utilization.

- DMG reduces angina pain.

- DMG enhances circulation.

DMG: MATTERS FOR THE HEART

Dear Dr. Kendall,
My husband and I are retired nurses. Following his fifth hospitalization for cardiac insufficiencies, it became evident that we should have oxygen available at home because of his frequent "blackouts"; however, living in an apart-

ment complex with restrictions in this regard we were prevented from acquiring the necessary oxygen. My husband has been taking sublingual DMG and he has not had any of these attacks since then. Also, the accompanying mental confusion and lack of concentration have been eliminated. He is now able to concentrate and to study an average of five hours daily. We are very grateful for this relief.
—*Thank you from Somerdale, New Jersey*

Dear Dr. Kendall,
I've been taking 3 tablets of DMG a day. It may be a simple coincidence, but the fact is that my chronic anginal pains decreased substantially and have remained much less severe and less frequent for several weeks. I have given prescriptions for it to some of my Canadian patients, and one patient from Germany. My wife will start taking it tonight and I hope that your expectations that it may help relieve her respiratory problems will be realized. I will let you know.
—*Con Sincerita from Miami, Florida*

Dear Dr. Kendall,
This is just a brief note to let you know how DMG has helped me to restore my health. For three years I have been suffering from a low platelet disease in my blood, and as soon as I started taking DMG my platelets increased. I hope this will be of great help to many people.
—*Yours truly in Santa Rosa, Bayamon, Puerto Rico*

Dear Dr. Kendall,
My husband is 81 years old and had three heart attacks and since then, his chest pains were bad. He could not carry a bucket of water to the barn without having to sit down until the pain was better.

He has been taking DMG a month now and can now carry the water without any pain. He also had some numbness in his legs and his hands at times, and would feel as if there was numbness in his head, but now all the symptoms are better.

By the way, I have had a thumping heart for 35 years. I had scarlet fever and my heart was affected, in that when I would be real tired, or excited, or emotional in any form, my heart would just beat so hard, sometimes I couldn't sleep because of it. The older I am, the worse it has been. So I just wanted you to know it's at least 90 percent better and sometimes I barely notice it since the DMG. I'm so grateful to have found out about it.
—*Thanks from Fairdale, Kentucky*

Dear Dr. Kendall,

My father has suffered for over a year now; he is bothered with a heart condition. He has suffered with shortness of breath, angina pectoris, edema, and tachycardia. The cardiologist informed us that my father needed a pacemaker implanted as soon as possible, but my father refused to have the operation.

That is the day I asked you to come and speak to him. He was becoming very depressed which was not like him. Before he was always cheerful and such a hard worker.

You came and spent time with him speaking about DMG. What a blessing! Now he doesn't need the pacemaker and is not bothered at all with the shortness of breath, angina pectoris, edema, or tachycardia. He has gone back to work and there is no way to describe the change in him. Thanks to DMG he is his old self. I should say he is like his young self.

—A grateful daughter in Louisville, Kentucky

Dear Dr. Kendall,

I had a stroke and thank God for my complete recovery. The surgeon removed a clot from my brain. I have been working many months to rebuild my body by taking DMG and feel it has done me a great deal of good.

—M.K. in California

Dear Dr. Kendall,

I'm 68 this month and about eight years ago I had a stroke and had to give up work. Then I found out I also had trouble with my heart and had to take it easy. I suffered a very bad heart attack and was rushed to the hospital; while in intensive care I suffered another heart attack. Then, again, three years later I was back in the hospital with another heart attack. After the first attack the heart specialist told me I only had five years to live and gave me multiple prescriptions that I would stay on for the rest of my life. The medications caused me so much confusion I didn't know night from day half the time so they started me on vitamins too. The vitamins caused my face to break out. My brother heard about DMG and sent me some. The good news is I have been on DMG for over 3 months and I feel great. The numbness I had is gone from my arm, and I walk quite a lot now, and I can drive my car. My face has cleared up. Before DMG I felt tired all the time; now I have more energy. I'm writing because I wanted you to know how wonderful DMG has been for me. I'm now only on DMG and digoxin, and that is 5 drugs I no longer have to take. Thank you for your DMG and for giving me a new outlook on life.

—Respectfully yours in Ashford, Connecticut

DMG'S HEART CONNECTION

I have received these and many other letters over the years that report that DMG supplementation is beneficial for those with circulatory problems, high blood pressure, and cardiovascular disease. It also improves blood circulation and reduces the risk of atherosclerosis by lowering homocysteine levels. As a metabolic enhancer, DMG reduces symptoms associated with physical, emotional, and environmental stressors, which can contribute to heart dysfunction. DMG allows for better oxygen utilization at a cellular level, which helps with circulatory insufficiencies, and angina pain. Clinical evaluations show that DMG is a lipotropic agent (a fat emulsifier) and lowers blood pressure, cholesterol, and triglyceride levels.

HEART STATISTICS

Why should we all care about heart health? Because according to the latest estimates from the federal government's National Center for Health Statistics and the American Heart Association:

- **More than 68 million Americans have one or more forms of cardiovascular disease.**
- **Cardiovascular disease (CVD) is ranked as America's number-one killer, claiming over 40 percent of the nearly 2.4 million Americans who die each year.**
- **Nearly 2,600 Americans die each day of CVD, an average of one death every 33 seconds.**
- **CVD claims more lives each year than the next five leading causes of death combined, which are cancer, lower respiratory diseases, accidents, diabetes mellitus, and influenza and pneumonia.**
- **Almost 150,000 Americans who die from CVD each year are under 65 years old.**

- **One in five people in the United States have some form of CVD.**

CARDIOVASCULAR DISEASE

Cardiovascular disease is a dysfunction of the heart and blood vessels. The major risk factors associated with cardiovascular disease include high blood pressure, increased homocysteine levels, and elevated blood fat (triglyceride levels). Some new studies suggest that it is not just high cholesterol levels but oxidized cholesterol (oxysterols) in the bloodstream that is the primary contributor to heart disease. Arteriosclerosis is any of a group of diseases characterized by thickening and loss of elasticity of the arterial walls (see picture below).

The heart requires energy from fatty acids to keep it beating regularly, and arrhythmias may develop if the transport of fatty acids into the mitochondria of heart cells is disturbed. Arrhythmia is an abnormal heartbeat caused by a disturbance in the heart's electrical

Normal Artery

Blood flows normally

Blocked Artery

Plaque buildup on vessel walls restricts blood flow and affects blood pressure and heart function

impulses and results in an insufficient supply of blood to body tissues. Blood chemistry must be in balance for optimal heart health, which means cholesterol, homocysteine, and clotting factors all need to be at proper levels. These levels can be controlled by proper nutrition, exercise, drugs, and by using nutritional supplements like DMG. Those persons with cardiovascular dysfunction usually suffer from impaired circulation, hypertension, arteriosclerosis, and cardiac abnormalities. DMG can help normalize many cardiovascular problems.

RISK FACTORS ASSOCIATED WITH HEART DYSFUNCTION

High blood pressure—Increased blood pressure can result in heart dysfunction. High blood pressure can be a result of a number of things including a reduction of blood vessel size, defects in electrolyte (mineral) balance, stress, nutritional deficiencies, and enzyme imbalance. Hypertension is abnormally and chronically high blood pressure that can lead to stroke and heart problems.

High homocysteine levels—Increased levels of homocysteine create free radicals that bind with low-density lipoprotein (LDL) to form plaque on artery walls. This can weaken artery walls and cause abnormal thickening of blood thereby reducing blood flow. Doctors have found that those with high homocysteine levels are at a three- to four-fold higher risk for heart attacks than those with low homocysteine levels.

DMG AND HOMOCYSTEINE LEVELS

Homocysteine plays a role in protein synthesis in the body, but a buildup of homocysteine in your blood can do considerable damage to the heart and blood vessels. Homocysteine is an amino acid that can be toxic at high levels and is a risk factor for atherosclerosis.

61

Elevated homocysteine levels may be a major factor responsible for plaque formation leading to cardiovascular disease. Homocysteine is a free radical generator that oxidizes cholesterol and can damage arterial walls. Increased levels of homocysteine create free radicals that bind with LDLs (low-density lipoproteins) and form plaques that lead to the development of atherosclerosis.

Plaque formation on artery walls can lead to blockages, which can lead to heart attacks or strokes. Homocysteine activates clotting factors, increases blood coagulation causing formation of blood clots around plaques, and increases damage to blood vessel walls.

DMG provides methyl groups that can be used to change homocysteine into the essential amino acid, methionine. This transformation also requires vitamin B_{12}, folic acid (THF), riboflavin (FAD), and niacin (NADH).

Folic acid or THF (tetrahydrofolate) is used to transfer methyl groups in the body. DMG gives its methyl group to THF that in turn transfers the methyl group directly to homocysteine to make methionine. This allows DMG to act as a methionine pump, reducing harmful excess of homocysteine, while increasing methionine production. Methionine is unique in that it neutralizes hydroxyl radicals, the most dangerous type of free radical. Methionine can then be used to produce SAMe. Clinical evaluations show that supplementation with DMG can decrease harmful homocysteine levels and thereby decrease the risk of cardiovascular disease or CVD. It also increases SAMe production and helps improve transmethylation reactions throughout the body.

With the right vitamins, minerals and methyl source, such as DMG, homocysteine can be converted into beneficial products. Supplementing with DMG plays an important role in balancing homocysteine levels while making more SAMe available for transmethylation reactions. DMG's ability to support transmethylation is one of the key ways that DMG supports cardiovascular health.

The Clinical Studies of Dr. Mitchell Pries

Cardiologist Mitchell Pries, M.D., Ph.D., conducted clinical trials in over 400 cardiovascular patients with DMG from 1979 to 1984. He found that DMG helped in the treatment of patients with angina pectoris, arrhythmias, primary hypertension (high blood pressure), circulatory insufficiency, hypercholesterolemia, and hyperlipoproteinemia.

Dr. Pries also noted that DMG improved cardiovascular function, increased feelings of well-being, decreased cholesterol and triglyceride levels, reduced angina pain, decreased blood pressure levels, and improved the heart's response to stress tests. These benefits were attributed to DMG's ability to improve oxygen utilization, circulation, and lipid metabolism.

Dr. Pries concluded, "In comparison to the control group, the DMG group made better progress overall and many participants were able to substantially reduce their need for additional drug therapy."

In his clinical studies, Dr. Pries also has found that DMG significantly lowers cholesterol and triglyceride levels. "Patients with high cholesterol and triglyceride levels showed considerable improvement."

Dr. Pries found that taking DMG seems to help control serum lipoproteins by lowering LDL and increasing beneficial high-density lipoprotein (HDL) levels, which is shown in other studies to reduce one's risk of heart attack or stroke.

Dr. Pries also said that after patients were off DMG for three weeks their cholesterol and triglyceride levels began to rise again. When put back on DMG, their blood cholesterol and triglyceride levels began to drop back towards normal again.

Dr. Pries stated that "Most of these 400 patients in my study had blood cholesterol readings in the range of 250 milligrams per deciliter (mg/dl) or higher. After taking 120 mg of DMG daily for 12 weeks, nearly all of them, by the end of the study, had decreased readings and were maintaining their blood cholesterol levels at

around 200 mg/dl. The control group who received a placebo failed to significantly reduce their serum cholesterol levels. Furthermore, the average blood triglyceride levels for patients in the DMG group were lowered to 110 mg/dl from an average of 200 mg/dl. Not so with the control group."

Dr Pries also said that his cardiovascular patients on DMG, "almost universally experienced favorable reactions such as improved well-being, vitality and mobility; overall improvement in circulation as measured by the Doppler method; decreases in elevated serum cholesterol levels; reduction or elimination of pain in those with angina pectoris; fewer recurrences for patients suffering from cardiac arrhythmias; decreases in blood pressure for those with hypertension; and, improvement in cardiac response in patients undergoing exercise stress tests."

Thus, we see that DMG lowers high cholesterol levels, improves

Dr. Pries Cardiovascular Studies
Dr. Pries reported that cardiovascular patients taking DMG had:

- Decreased cholesterol and triglyceride levels.

- Fewer arrhythmias when tested after six months.

- Balanced serum lipoproteins with lowered LDL and increased HDL levels.

- Increased feelings of well-being and optimism.

- Overall improvement in their circulation as measured by the Doppler method.

- Reduced or eliminated pain in those with angina pectoris.

- Decreased blood pressure in those with hypertension.

- Improved cardiac response in those undergoing exercise stress tests.

circulation, reduces high triglyceride counts, and helps individuals maintain a more vigorous, energetic, and optimistic mood.

With aging there is a usual marked increase in damage to the heart and blood vessels causing circulation insufficiencies and difficulties

pumping sufficient blood to the body. Impaired circulation, increased homocysteine levels, nutritional deficiencies, free radical-induced oxidation, and aging are all associated with cardiovascular dysfunction.

Supplementation with DMG can help to maintain optimal heart and cardiovascular function, protect and strengthen the heart and blood vessels, increase energy levels, and maintain proper blood pressure, cholesterol, triglyceride levels and homocysteine levels. DMG decreases hypoxia (low oxygen availability) in the heart tissue, improves oxidative processes, and normalizes lipid and carbohydrate metabolism in the body. DMG decreases total cholesterol and may increase HDL levels. It improves coronary circulation, increases circulation to extremities, improves irregular heartbeats (arrhythmias), and helps individuals during stress tests. Those individuals who supplemented with DMG also had an improved mood and became more vigorous, energetic, and optimistic.

DMG BENEFITS TO THOSE WITH CARDIOVASCULAR DISEASE

- Supports proper heart function.
- Helps maintain healthy homocysteine levels.
- Improves circulatory insufficiency.
- Decreases elevated cholesterol and triglyceride levels.
- Reduces angina pain.
- Increases energy levels.
- Reduces arrhythmias.
- Decreases high blood pressure.
- Improves the heart response to stress tests.
- Improves mood and feelings of well-being.

Nutrients that Benefit those with Cardiovascular Disease

Nutrient	Benefit to cardiovascular dysfunction
DMG	DMG allows for better circulation and oxygen utilization at the cellular level as well as supporting blood pressure, cholesterol, and triglyceride levels within normal ranges. DMG acts as an indirect methyl donor in the biochemical process of transmethylation to lower homocysteine levels by helping to convert homocysteine to methionine.
Carnitine	Carnitine supports heart function by transporting fatty acids from the blood through the mitochondrial membranes and into heart cells so the fatty acids can be converted into ATP (the cell's basic energy molecule.) Carnitine also helps to prevent toxic fatty acid metabolites from damaging heart cell membranes. Changes in cell membranes can impair heart contraction causing irregular heartbeats or even tissue death.
Vitamin B_{12}	Vitamin B_{12} decreases homocysteine levels in the blood by helping to convert homocysteine to methionine. Vitamin B_{12} also helps prevent anemia through its ability to form red blood cells, increases capillary flow, and acts as a natural energy booster.

continued on next page

Nutrient	Benefit to cardiovascular dysfunction
Coenzyme Q_{10}	More CoQ_{10} is found in the heart muscle than in any other muscle in the body. In fact, a deficiency may lead to cardiovascular disease. CoQ_{10} is a naturally occurring cofactor involved in the production of ATP in the mitochondria of the cell. It provides an increase in cellular energy as well as improving cardiovascular functioning. It is a lipid soluble antioxidant that fights against oxysterol formation to help prevent the formation of plaques, and it neutralizes free radicals that can damage cells, vascular membranes, and nucleic acids.
Vitamin B_6	Vitamin B_6 helps to dilate small arteries, acts as a natural diuretic, and protects the heart by decreasing edema (reducing water content in tissues). It is involved in the regulation of electrolyte balance, helps form blood proteins that are used to inhibit platelet aggregation, and is needed for proper metabolism of fat and cholesterol. Vitamin B_6 is involved in the process of converting homocysteine to cysteine, preventing homocysteine buildup in the bloodstream and thereby preventing homocystine from oxidizing cholesterol and damaging the cells lining the arteries, thus helping to reduce the risk of atherosclerosis.
Betaine	Betaine is a methyl donor that helps reduce homocysteine levels in the blood by converting homocysteine to methionine. Betaine can normalize amino acid metabolism, increase muscle mass, break down fat, improve circulation, balance cholesterol levels, and protect the liver from fat deposits.
Magnesium	Deficiencies of magnesium are associated with high blood pressure, irregular heartbeat, poor muscle contraction, and cardiovascular dysfunction. Magnesium increases ATP production within the heart, dilates coronary arteries, inhibits platelet aggregation, prevents arrhythmias, and helps with circulation. It regulates blood pressure, helps maintain integrity of blood vessel walls and normal blood viscosity (thickness), and it strengthens the heartbeat.

continued on next page

Nutrient	Benefit to cardiovascular dysfunction
Folate (Folic Acid)	Folate deficiencies in the heart muscle lead to heart disease. Folate is the limiting factor in the reaction to convert homocysteine to methionine. Folate is also needed for the formation of red blood cells, is shown to prevent the progression of atherosclerosis, and helps increase capillary blood flow.
Potassium	Potassium is a mineral and an electrolyte that has a regulating effect on heart rhythm and blood pressure.

DMG and Cancer

DMG BENEFITS FOR THOSE WITH CANCER

- DMG enhances the immune response.

- DMG prevents metastasis (spread) of tumors.

- DMG improves oxygen utilization.

- DMG has anti-cancer properties.

- DMG enhances circulation.

- DMG reduces lactic acid levels.

- DMG acts as a methyl donor.

- DMG enhances antioxidant protection.

A colon cancer patient recently wrote me to tell me his success in battling cancer, noting that DMG played a key adjunct role. He writes:

About a year ago, in March, I was diagnosed with a mass on the wall of my colon. It was after visiting my doctor and complaining of a sensation of a possible blockage that he sent me to have a colonoscopy. Thankfully, the tumor was benign, but I was encouraged to have surgery to remove the tumor.

After refusing surgery, I decided to look toward an alternative method to reduce the mass. I had been taking DMG, non-religiously, for about two to three years, but I decided on the advice of a friend who had read of DMG's anti-tumor properties, to increase the dose to see what it could do for the mass in my colon.

For the next six months, I took from 4,000 to 6,000 mg of DMG per day. I continued to have monthly biopsies of the mass in my colon, and while they all came back benign, the mass was still there. After three months of a respite from the colonoscopies, I was hospitalized for what was later determined to be bleeding stomach ulcers caused by the daily aspirin I had been taking.

I had another colonoscopy to rule out the mass in my colon as a cause for the bleeding. The technician was extremely surprised when he could not find the mass in my colon. In fact there didn't even appear to be any scar tissue. Even though the technician and my physician could not explain the reason for this discovery, I knew that the disappearance of the mass was due to the DMG. I am now 55 years old and I take about 1,500 to 2,000 mg of DMG each day.
—*Sincerely, W. Skelton, Burlington, Vermont*

WHAT IS CANCER?

Cancer is a disease characterized by excessive growth of abnormal cells. Cancer develops after a cell accumulates mutations in several genes that control cell growth and survival. Only a small percentage of cancer is hereditary (5 to 10 percent); the rest is caused by damage to genes that occur as a person ages. These mutations could be the result of internal or external factors. Some internal factors would be a genetic predisposition, an inherited mutation or immune dysfunction. External factors would be things like radiation, toxic chemicals or infectious pathogens. When a

mutation seems irreparable, the affected cells undergo apoptosis or programmed cell death. If the cell does not die, its offspring may acquire mutations that will enable it to divide uncontrollably. These abnormal cells can then travel throughout the body causing new tumors, and, if not stopped, can result in death. Several viruses are known to cause cancer including the Epstein-Barr virus, the human papilloma virus, hepatitis B and C virus, and HIV. Hormones, sexual lifestyle, occupational exposure, drugs, environmental pollutants, and electric and magnetic fields are all implicated in causing cancer.

Metastasis is the primary cause of death when cancer treatments fail. Metastasis is the active process of cancerous cells separating from a primary tumor, traveling through the body in blood or lymph vessels, invading distant tissues, and causing more tumors to form. Tumors generate their own supply of new blood vessels in a process called angiogenesis. Because the newly formed blood vessels in tumors are leaky, tumor cells can enter them and travel to other parts of the body to infect other organs. After entering the bloodstream the blood is pumped to the lungs for oxygenation and this may explain why the lungs are one of the most common sites of metastasis. Colon cancer often metastasizes to the liver due to the fact that the liver receives blood directly from the intestines for the absorption and metabolism of food. Most circulating tumor cells die either due to the turbulence involved with circulation or by being attacked by the immune system. Not all tumor cells that enter an organ survive, only those tumor cells that begin to proliferate and grow will survive. Stress and depression can promote tumor progression by inhibiting the immune system and allowing more cancer cells to survive and metastasize.

One tool our body uses to prevent cancer formation is apoptosis. Apoptosis is the programmed cell death of unhealthy or abnormal cells controlled by an internally encoded suicide program. Many

chemicals can bind to DNA and then mutate it, leading to cancer. The body is equipped with many factors, such as enzymes and suppressor genes, that prevent chemicals from leading to cancer by activating the apoptosis pathway in damaged cells. Free radicals can also damage DNA in cells causing mutations that could lead to tumors. Researchers have found that antioxidants help neutralize free radicals and prevent abnormal cell formation. Apoptosis regulates tissue growth, maintaining the balance between cell proliferation and cell death. Cells commit suicide when there is a lack of growth factors or physical contact with other cells caused by infection or chemical exposure; this is a built-in defense against metastasis. Activation of apoptosis in tumor cells destroys many metastatic cells before they have a chance to grow.

Who is at risk for developing cancer? Anyone can be, but the risk for developing cancer increases as we age. Most cases are diagnosed in adults who are middle-aged or older. With illness and age there is a marked increase in free radical production that can cause damage to nucleic acids (RNA and DNA) and cause excessive cell replication, increased susceptibility to secondary infection, and decreased ability to maintain health.

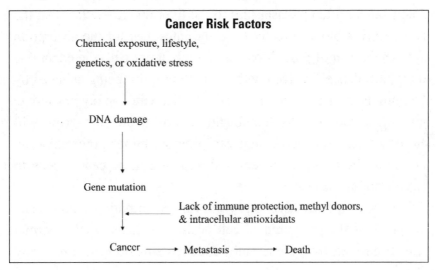

Cancer Risk Factors

Chemical exposure, lifestyle, genetics, or oxidative stress

↓

DNA damage

↓

Gene mutation

Lack of immune protection, methyl donors, & intracellular antioxidants

Cancer ⟶ Metastasis ⟶ Death

Disease, impaired antioxidant levels, nutritional deficiencies, free radical induced oxidation, and aging are all associated with loss of immune function. As we age, normal physiological processes generate free radicals that can damage the DNA within cells; damaged DNA can lead to cancer. At current rates approximately one in two men and one in three women will develop cancer in their lifetimes.

DNA methylation plays a key role in the aging process. DNA expression determines cell function and expression of proteins and other important molecules and building blocks. With age, there is a loss of DNA methylation and a change in genetic expression.

How does DMG lower the risk of cancer? DMG helps provide oxygen at a cellular level, which cancer cells cannot thrive in.

DMG also helps to reduce age-related free radical damage to the cell and its structures like the DNA and cell membrane. DMG's ability to donate methyl groups may also protect against cancer. New studies with animals on diets deficient in methyl donors had increased tumor formation. Supplementing with methyl donors like DMG has been found to prevent this and lower cancer formation.

About 1,344,100 new cancer cases are expected to be diagnosed in 2003. These estimates do not include the one million cases of skin cancer that are expected to occur this year. Cancer is the second leading cause of death, surpassed only by cardiovascular disease. In fact, in the United States, one in every four deaths is caused by cancer. This year (2003) about 556,500 Americans are expected to die from cancer. That is more than 1,500 deaths a day. The American Cancer Society states in the *Cancer Facts and Figures: 2003* that scientific evidence suggests that about one-third of those 556,500 cancer deaths are preventable, because they are caused by factors that can be altered such as diet, physical activity, obesity, and lifestyle choices. This means that a healthy diet in combination with regular exercise and good lifestyle choices can reduce the risk of cancer.

Over the years, we've had the opportunity to work with DMG on many types of patients. I work with a lot of cancer patients on chemotherapy and because this drastically suppresses their immune system, we can keep their immune system functional and they can continue to finish their chemotherapy treatment when they take DMG. I've seen great results in almost every category of patients we've recommended DMG for with several different types of autoimmune disorders.

—*Jim Fox, D.C. & Janine Fox, D.C., Gulfport, Mississippi*

CANCER THERAPIES

Cancer is currently treated with surgery, radiation, chemotherapy, hormone therapy, and immunotherapy (stimulating the immune system). Successful cancer treatment includes treating the primary tumor but also any secondary tumors that may have spread to other parts of the body. Surgery is the oldest form of cancer therapy and consists of removing the tumor before it metastasizes. Chemotherapy is the use of a combination of drugs to stimulate the immune system and/or destroy cancer cells by affecting cell function or DNA synthesis. Radiation therapy preferentially destroys cells that divide rapidly. This usually means it destroys the cancer cells, but can also destroy normal body tissues that divide rapidly like skin, hair, bone marrow, and the lining of the digestive tract. Cells that have an adequate oxygen and blood supply are most susceptible to damaging effects of radiation. Cells closer to the center of a large tumor have a poor blood supply and low oxygen levels. As the tumor shrinks, the blood supply improves, as does its exposure to oxygen, which makes it more vulnerable to the next dose of radiation. Sometimes for advanced tumors a combination of surgery, radiation and chemotherapy is used. Almost everyone who receives chemotherapy or radiation will experience some side effects.

DMG AND CANCER

DMG provides methyl groups and building blocks to repair DNA and regulate gene expression. It also strengthens immunity during cancer therapies, acts directly against tumors, increases anti-tumor cytokines, enhances action of natural killer (NK) cells, decreases lactic acid levels, prevents metastasis, and increases oxygen availability.

Dr. James Frackelton, M.D., of Cleveland, Ohio, notes: I was exposed to dimethylglycine a few years ago as a potential immune system enhancer for my patients. At first I used it for those who had an immune deficiency of some type: frequent infections, pneumonia, or other overall decreases in immunity. I noticed a clear-cut reduction in such infections. My patients experienced a marked improvement in their health histories. Now, for those people who have more serious illnesses, for instance cancer, I include DMG as one of the standard nutrient additions to their dietary programs. I don't treat cancer, but I do treat a lot of cancer patients. These people may still have their cancer, but they show much symptomatic improvement by taking DMG. It boosts their immune system.

In 1986, I contacted Dr. John W. Lawson at Clemson University to see if he would like to do research on DMG and the immune system. Dr. Lawson admits, "Frankly, as soon as I heard 'health food stores,' I wasn't sure about this. But I had a student in my lab who was interested in doing a summer project and they were willing to give her a stipend to support her for the summer."

In the project, rabbits were given either a typhoid or influenza vaccine and some were given oral DMG to improve the immune response. "By the end of the summer when the results came in, I was amazed," reports Dr. Lawson. "In every one of the rabbits given dimethylglycine, a greater immune response was found."

Dr. Lawson's continued research with DMG has focused on cancer research. One of his studies on mice given melanoma injections showed that after eight weeks of observations all the control mice died of cancer with extensive metastasis, and the mice in the DMG group lived. According to Dr. Lawson, "The mice given dimethylglycine lived and it was found that the substance apparently prevented the spread of the tumor."

As a result of this work a U.S. patent was granted to FoodScience Corporation for DMG in treating melanoma. Studies indicate that DMG may give important nutritional support to the immune system against some forms of cancer.
—from "Clemson Professor's Work on Cancer Shows Promise"
Anderson Independent Greenville News, *January 11, 1988, 6A*

DMG AND RADIATION THERAPY

Some Russian studies suggest that DMG might protect the immune system of animals receiving radiation. DMG was given to laboratory animals (rabbits and guinea pigs) receiving radiation. Those animals given DMG maintained their immune system function even after radiation, whereas the controls did not. DMG increased immune system function and restored natural protection that was destroyed due to X-ray damage. DMG appears to act as a protective agent against radiation and potentiate the immune response.

Based on the Russian research, Dr. Lawson investigated the use of DMG on mice exposed to radiation. The mice were challenged with a *Salomonella typhosa* vaccine and those fed DMG did not show any

symptoms of radiation exposure or the vaccine. All of the DMG animals lived while the other groups only had a 50 percent survival rate. DMG also increased interluekin-1 production, which lends radiation protection. These results may be due to DMG's ability to contribute to the transmethylation processes that are necessary for regeneration of damaged cells. DMG also neutralizes free radicals that are the major cause of damage in radiation treatment. DMG's ability to modulate the immune system, donate methyl groups, and act as a free radical scavenger may be useful in restoring the immune system of those who must have radiation or chemotherapy.

METHYLATION AND CANCER

Through methylation DMG also protects the integrity of the cell's DNA and helps to regulate gene expression. DNA methylation, dependent upon methyl groups from SAMe, regulates gene expression. DNA is coated with methyl groups that selectively turn some genes on and others off. Random expression of genes or damage to genetic material can lead to the expression of cancer-causing genes called oncogenes. Optimal methylation of DNA helps prevent cancer by inhibiting oncogenes (cancer-causing genes), so proper levels of methyl donors in the diet or supplementation with DMG is necessary.

METHYL DEFICIENCIES AND THE CANCER CONNECTION

New animal studies show that diets deficient in methyl donors can lead to cancer and that supplementation with methyl donors, like DMG, can help prevent cancer. The mechanism by which supplemental dietary methyl groups protect against the development of cancer is not yet known. It is not known whether increased cancer is related to reduced methylation of DNA and RNA, excessive divi-

sion of the cells, increased oxidative damage or altered carcinogen metabolism. The role of methylation in the regulation of gene expression is another likely explanation for increased cancer formation. Methyl group deficiencies seem to accelerate and magnify the appearance of tumors and limit the body's threshold (i.e., ability to live out one's life span without tumor development) for chemical carcinogenesis. The body is unable to break down these chemicals and tumors develop. A deficiency of methyl groups is a powerful enhancer of chemical carcinogenesis in the liver and can enhance cancer formation throughout the body. Increased cell division increases carcinogenesis by either failing to allow time for DNA to repair itself or by stimulating abnormal cell growth.

Supplementation with methyl donors has prolonged the life of mice with different types of cancer. Studies have demonstrated that supplementation with dietary labile methyl groups and folic acid protect against cancer formation.

Work done by Dr. Lawson strongly suggests that DMG may have anti-tumor properties as a result of DMG's ability to modulate the immune response. DMG was tested on a mouse melanoma model. Mice injected with melanoma cells exhibited massive tumor metastasis and death. Mice were divided into three groups, the first to receive just the melanoma cells, the second to receive DMG and the melanoma cells at the same time, then continue DMG for the duration of the experiment, and the third, which received DMG seven days prior to the melanoma cells and then continued DMG to the end of the experiment. Due to the highly metastatic nature of melanoma, by the time the cancer is detected it has usually spread throughout the body and death usually occurs before the cancer can be stopped. Mice receiving DMG along with the melanoma cells lived longer, had fewer tumors, and demonstrated slower tumor growth. DMG exerted an anti-tumor effect by inhibiting metastasis of the melanoma cells in mice. Histological examination of organ tissue showed that

metastasis to vital organs occurred only in the melanoma group that did not receive DMG. At the end of the study, all of the control mice had died but of those mice receiving DMG, 71 percent were still alive. In the DMG-treated mice, there were more lymphocytes surrounding the primary tumor than in the control group. The tumors were localized by immune cells that were turned on by DMG. This would also account for the fact that the DMG mice lived longer and had fewer tumors than the control mice. The data from this study suggest that DMG may slow down or inhibit metastasis of some cancers. DMG may reduce one's susceptibility to melanomas through its ability to modulate the immune system.

Results of the effect of DMG on mouse melanoma and metastasis		
Treatment	% Primary Tumors	% Metastasis
Water control	0%	0%
DMG control	0%	0%
Melanoma control	70%	50%
DMG post melanoma injection	50%	21%
DMG pre & post melanoma injection	28%	14%

In a follow-up study, mice were divided into five groups. In the control groups, one group of mice received just water, another just DMG, and another was inoculated with melanoma cells. There were two experimental groups, both receiving melanoma and DMG. The first group of mice received melanoma cells, and five days later started DMG. The mice were continued on the DMG for the rest of the study. In the other group DMG was started five days prior to the injection of melanoma cells, and the DMG was continued throughout the study. In this study mice given DMG prior to the melanoma cells would represent those who continuously use DMG as a cancer preventative. The other DMG group that started taking the DMG five

days after the melanoma cell injection would represent those taking DMG therapeutically after they had been diagnosed with cancer. Results confirmed that DMG significantly reduced the formation of tumors and prevented their spread to other sites in the body. This study showed that there may be a great benefit to taking DMG as a cancer preventative (see box on page 79), as well as a cancer therapy.

Further cell culture work done at Clemson University shows that DMG may be active against other cancer types including breast, cervical, and prostate cancer.

DMG also exerted a strong anti-tumor effect against melanoma in a CAM (chorioallantoic membrane chick embryo) assay. DMG reduced tumor growth by 60 percent as compared to controls. This second test method reinforces DMG's potential clinical use against tumors. Melanomas are not readily recognized by the immune system because of the low levels of MHC or major histocompatibility complexes that identify them to immune cells. DMG increases the expression of MHCs on tumor cells to enhance the detection of normally unrecognizable melanoma tumors by the immune system. Future studies will concentrate on determining the most effective daily dosage of DMG required to better control tumor development and prevent metastasis.

DMG and Melanoma

- All the control mice given melanoma cells died, but 71 percent of the DMG mice given melanoma remained alive.
- DMG turned on immune cells that localized tumors and prevented metastasis.
- Mice given DMG and subjected to melanoma lived longer and had fewer tumors and slower tumor growth than those without DMG.
- In chicken embryos DMG reduced tumor growth by 60 percent as compared to controls.
- Mouse studies show that the earlier DMG is given, the greater its anti-cancer benefits.

AN ANIMAL CASE STUDY

There have been several reported examples where DMG may have demon-
strated activity against tumors in dogs or horses as reported by their owners.
One such case was reported on by Hans Kugler, Ph.D., in the *Preventative
Medicine Up-Date* (1990) regarding his 11-year-old Shepherd dog, Foxie. She
was diagnosed with a large abdominal tumor, a possible carcinoma, in late 1987.
James Jensen, D.V.M., made the diagnosis and recommended immediate
surgery. An ultrasound along with blood tests indicated that the tumor was very
large and had probably already spread to the liver and kidneys. Due to these
findings, Dr. Kugler decided against surgery and instead put the dog on a natural
anti-tumor and immune enhancing program including DMG and an extracted
product of spirulina and dunaliella algae called phycotene. He also included a
basic vitamin and mineral supplement along with beef liver concentrate.

Foxie was put on a daily regimen of 250 mg of DMG from FoodScience
Corporation and the equivalent of 100,000 to 150,000 IU of vitamin A from the
phycotene. Starting from a very weakened state, Foxie began to improve after
only one week on the program. Her energy levels and sleep pattern improved
and the tumor mass became noticeably softer upon examination. After six
weeks the tumor had shrunk to nearly half its original size and continued to
decrease in size until the twelfth week when it was then barely palpable. Later
examination by Dr. Jensen revealed that the tumor was completely gone. Foxie
had returned to her own usually active state and no longer had any symptoms
from the disease. Her remarkable recovery was based on the use of a combined
nutritional therapy including DMG. Since other factors had been used, the role
that DMG played in reducing the tumor is not exactly known. Based on the most
recent findings where DMG showed anti-tumor activity in three specific test
protocols, including its ability to increase cellular production of TNF, one can
surmise that DMG probably had a significant role in Foxie's recovery. Only after
the completion of a well-controlled study in animals will a more complete
picture of DMG effectiveness against tumors be known.

DMG'S BENEFITS FOR THOSE WITH CANCER

DMG may act to prevent cancer by detoxifying carcinogens,
enhancing both arms of the immune response, acting as a methyl
donor, reducing lactic acid levels, activating natural killer cells,

increasing oxygen utilization, and providing antioxidant support to protect DNA. Malignant cells thrive in oxygen-free (anaerobic) environments and get their energy from the breakdown of glucose to lactic acid. Because of this, cancer cells die in the presence of oxygen. DMG enhances oxygen uptake by the cells even when available oxygen is low, which effectively reduces lactic acid levels that cancer cells thrive on. Providing a sufficient supply of oxygen also helps keep normal cells from turning into cancer cells. By maintaining a high level of aerobic respiration, increasing oxygen utilization, and decreasing lactic acid levels, DMG makes the environment of the body hostile to tumor cells and more productive for healing and growth of healthy cells.

CANCER AND YOUR IMMUNE SYSTEM

The body's immune system attacks and eliminates not only pathogens, but also cancer cells. A cancer cell is not a foreign invader; it is one of the body's own cells that has been transformed to replicate continually. The body's protection against cancer is regulated by the white blood cells that hunt and destroy cancer cells. Cancer is 100 times more likely to occur in people who are taking drugs that suppress the immune system than in those with a normal immune system. Antigens are found on the surface of all cells, and normally the immune system doesn't mount a defense against them. When a cell becomes cancerous, new antigens that are unfamiliar to the body appear on the cell's surface. The cell is like a ship that has been taken over by pirates; as soon as they hoist a pirate flag, the Navy (white blood cells) knows that the ship no longer belongs to the fleet and starts to mount defenses against it. In the same way, the immune system regards these new identifiers on the cell as foreign and tries to contain or destroy the cancer cells. Even with a fully functioning immune system the body can't

always destroy all the cancer cells. DMG strengthens the immune system to bring about a more effective response against pathogens and cancer cells. DMG can also counter the negative effects of free radicals that are produced in the body through normal cellular processes protecting cells and DNA from free radical damage.

IMMUNE THERAPY

Current research in cancer treatments is geared towards immune intervention by the use of cytokines such as tumor necrosis factor-alpha (TNF-α), interleukin-1 (IL-1), interleukin-2 (IL-2), and interferon-beta (INF-β). DMG increases production of anti-tumor cytokines, especially TNF-α which enhances the ability of the body to fight against cancer. DMG increases cytokine production of immune stimulated lymphocytes. DMG enhances production of TNF-α IL-1, IL-2, and INF-β, which may be one possible explanation for DMG's anti-tumor effects. DMG may act directly on tumor cells to prevent tumor formation. DMG can also act as a chemical messenger and attach to immune cells and modulate them, causing the activation of NK cells, which destroy cancer cells. DMG increases the immune response through methylation and by acting on cells directly as a cell communicator to control any abnormal cell growth. DMG reduces one's susceptibility to cancer by increasing the immune response against aberrant cancer cells. DMG also slows the appearance of tumors and has a direct anti-cancer effect. DMG increases the population of circulating B and T lymphocytes and cytotoxic macrophages, to help the body defend against development of metastasis.

DMG and its Effects on Cancer

- DMG's methyl groups prevent mutation of DNA

- DMG reduces metastasis

- DMG increases immune response

- DMG enhances oxygen utilization and decreases lactic acid levels

Nutrients that Benefit those with Cancer

Nutrient	Benefit to those with cancer
DMG	DMG has anti-tumor properties and is an immune system modulator. It strengthens both arms of the immune system, including antibody and lymphocyte production. DMG increases NK cell activity and increases TNF-α, IL-1, IL-2, and INF-β. It increases oxygen utilization, circulation and decreases lactic acid levels to help fight cancer. DMG boosts the availability of methyl groups, which may be protective against cancer.
Beta-1,6-Glucans	Beta-1,6-glucans from maitake mushroom extract support the immune system and have anti-tumor properties. Beta-1,6-glucans enhance the immune system, and provide cellular protection by stimulating the release of macrophages, NK cells, interleukins and cytokines that activate immune cells. They are adaptogens and can induce apoptosis in abnormal and cancerous cells in the body. (Macrophages are the body's first line of defense, recognizing and destroying the foreign invaders before they cause infection, and NK cells are white blood cells that destroy cancer cells.)

continued on next page

Nutrient	Benefit to those with cancer
Beta-1,3-Glucans	Beta-1,3-glucans extracted from the cell walls of Baker's yeast have immune-stimulating properties and act as a powerful free radical scavenger and antioxidant. They activate macrophages to clear away cellular debris, microorganisms, and cancerous cells. Beta-1,3-glucans increase resistance to foreign invaders by activating natural killer cells as well as B lymphocytes and T-suppressor cells.
Arabinogalactans	Arabinogalactans from larch tree extract are natural phytochemicals that are the active immune stimulating constituents of echinacea. In fact, arabinogalactans are two times more potent than echinacea. They support the immune system by increasing the number of immune cells present in the bloodstream, supporting natural killer cell and macrophage activation, and limiting unhealthy cell replication. Arabinogalactans block bacteria and viruses from attaching to cell membranes to prevent invasion.

6

DMG Provides Clarity

DMG BENEFITS TO THOSE WITH NEUROLOGICAL DISORDERS	
• DMG decreases seizures.	• DMG decreases lactic acid levels raised by stress.
• DMG enhances endurance.	• DMG supports immune function.
• DMG helps cope with stress.	• DMG helps with memory recall.
• DMG boosts cellular energy levels in the brain.	• DMG helps with neurotransmitter metabolism.
• DMG increases oxygen utilization in the brain.	

DMG AND MENTAL ACUITY

DMG is a natural energizer for both the body and the mind. It works better than caffeine because it does not cause your body to crash after you go into a relax mode. Just as athletes can improve their physical endurance and stamina on DMG, the businessman,

truck driver, salesman or student can also optimize their mental focus and brain function with DMG. DMG can give you staying power after working all day when you still have that class or evening meeting to work through. By increasing mental alertness DMG can be a real lifesaver for times when you cannot afford to be less than your best. Its anti-fatigue properties became really apparent to me on an overseas trip when I traveled to Indonesia a few years ago in which I was required to work long hours giving lectures and traveling from city to city over a 10-day period. I found that by taking from 1,200 to 1,500 mg of DMG daily throughout the day that my energy levels remained high and I did not suffer from mental fatigue.

Sonja Baden of Vermont had a similar experience with DMG. She found that DMG helped her with stress management and enhanced mental acuity at a time when it was critical to her success. Sonja tells us:

DMG helped increase my mental alertness and helped with mental fatigue throughout one of the most challenging times in my life. When working full time all day and then going to a three-hour night class, I could not afford to risk being mentally fatigued at a time when my concentration was of most importance. I found that by taking from 1,000 to 1,200 mg of DMG daily throughout the day helped me stay focused and kept my energy level high.

Not only does DMG help me with my academics, but I also found it played an important role in my athletic performance as well. I realized long ago the importance of cardiovascular exercise and strength training to keep my body in shape. With strength training I found DMG allowed me to work out longer and I didn't have as much muscle fatigue. But DMG also allowed me to start running, which I had never done before, as I have asthma and have trouble keeping my breathing normal. While using DMG I was able to start running two to three miles per day and still breath normally.

I attribute my success at getting through one of the most difficult times in my life to DMG's ability to increase my mental alertness, focus, and oxygen utilization.

—S. Baden, Vermont

continued on next page

DMG is also helpful for those going through menopause or who are under stress as Kim Wilson, a single Vermont mother of three will testify:

I am 48 years old and a single mother with three very active children. On many occasions I have experienced the inability to remember the names, phone numbers and/or events that need attending to involving my children. So, with protest, I have been forced to write everything down and keep track daily with the schedules I have planned.

This condition was further escalated by the fact that I have also been experiencing menopause. I often had difficulty focusing on the issues at hand and many times found myself repeating and/or forgetting entirely the task I had set out to do.

In January 2003, I was introduced to DMG. Presently, I find that my memory has improved 100 percent, as well as has my ability to focus. I found myself being able to multi-task and the concentration level is such that I no longer become frustrated because dates, times and events come to mind much quicker and with much more clarity.

I have found that with this formula I am able to conduct my day-to-day activities without the fear of forgetting important events. All is well with DMG.
—K. Wilson, Essex Junction, Vermont

DMG AND NEUROLOGICAL DISORDERS

You're thinking how can DMG possibly help with neurological dysfunction, right? Well, neurological disorders can stem from an imbalance of neurotransmitters, or nerve dysfunction. DMG increases oxygen utilization in the brain and provides building blocks for hormones, neurotransmitters, and key amino acids used by the brain.

Impaired circulation, nutritional deficiencies, free radical induced oxidation, and aging are all associated with loss of brain function. Aging is one of the most significant risk factors for degenerative neurological disorders. With aging there is a marked decrease in brain function including the ability to remember, focus, metabolize neurotransmitters, and properly conduct

neuronal impulses or messages. Normal physiological processes generate free radicals that damage the brain. Supplementation with DMG can help get rid of toxins, strengthen neuron membranes, help in neurotransmitter metabolism, increase ATP production within brain cells, and improve cognitive function.

How DMG Affects Brain Function

- DMG benefits individuals with an inability to focus of those with learning or memory difficulties.

- DMG increases blood circulation, oxygen supply to the brain, cellular energy, and balances amino acid and blood sugar levels.

- DMG is an adaptogen that helps the body cope with stress.

- DMG seems to improve mental alertness and brain function, as well as improving memory and mental clarity.

- DMG acts as an immune modulator keeping the immune system balanced and under control.

- DMG also helps raise the level of SAMe in the body. SAMe helps elevate mood in cases of depression or imbalance, and doesn't have the side effects of antidepressant drugs.

ALZHEIMER'S DISEASE

Alzheimer's disease is a progressive degenerative brain disease and the most common form of dementia in the elderly. According to the Centers for Disease Control and Prevention (CDC) approximately 4 million Americans have Alzheimer's disease. Alzheimer's caused 49,558 deaths in 2000 and was the eighth leading cause of death among Americans. Alzheimer's is a neurodegenerative disease characterized by progressive memory deterioration, loss of comprehension and intellectual function, and changes in behavior and personality.

Alzheimer's is most likely caused by heavy metals or other agents that lead to plaque formation or oxidative stress and free radical damage of brain tissue. The brain is abnormally sensitive to oxidative damage. Oxidative stress or reactive oxygen species may cause damage to the brain. Oxidative damage interferes with cell function, damages lipids, proteins, and DNA. It is also linked with degeneration, dysfunction, toxicity, and inflammation as well.

Therapeutic alternatives should be aimed at limiting free radical production and oxidative stress to help slow the advance of neurodegenerative disease. For this reason detoxification and antioxidant support provided by DMG are important in reducing and delaying the advance of Alzheimer's.

DOWN SYNDROME

Down syndrome is the most frequently identified cause of mental retardation. The degree of mental retardation varies greatly, but IQs are generally between 50 and 60. Down syndrome is one of the most common congenital birth defects; it is generally caused by an extra chromosome 21 in their cells. Down syndrome occurs in approximately 1 out of every 800 to 1,000 live births. Only 3 to 5 percent of Down syndrome is inherited; the rest of the cases arise from a mistake in chromosome arrangement during meiosis (formation of the embryo). Those with Down Syndrome are more likely to have heart defects, increased susceptibility to infections, vision and hearing problems, as well as a multitude of other health concerns. Those with Down syndrome also tend to be prone to bronchitis, pneumonia, colds, ear infections, leukemia, thyroid problems, and later in life Alzheimer's. Testimonials, patient surveys, and clinical studies suggest that DMG may be effective in relieving some complications associated with Down syndrome. One such testimonial is from the mother of Eric Matthes.

Dear Dr. Kendall,
On behalf of my son Eric and my family, I am writing to express our satisfaction with and commitment to nutritional supplementation with DMG.

Our son's general health and development over the years has indeed surpassed our initial expectations. We have concluded from our experience, study and reading that DMG is an important factor in his diet.

Eric was born with Down Syndrome (Trisomy 21—not mosaic). He was smaller than his older brother, yet still a whopping eight pounds! To the eyes of his loving parents, he was a beautiful, long-awaited newborn; but to the attending pediatrician, he exhibited the "classic" hypotonia and other features of Down Syndrome...

My dad, Edward J. Bebko, a doctor of Chiropractic (and "pioneer" in nutritional study and practice), suggested that Eric take "B-15" from DaVinci Laboratories. Eric started on DMG September 1, 1977, when he was three months old. We crushed a tablet and mixed it with a little cereal three times a day.

Thanks to his grandpa, Eric has continued with DMG on a daily basis. However, my dad passed away last October. Because of your ongoing research in the field of nutrition, I thought you might be interested in knowing a little more about Eric and why we think his nutritional supplements have been a very positive influence in his life—and by association—ours!

We certainly do not discount the value of early intervention and sensory stimulation, the home environment, heredity and individuality. But we also observed that Eric has seldom been sick, and, in particular, has not been troubled by chronic respiratory illnesses. He is strong and energetic. He walks long distances and has very good stamina.

It would appear that his neurological development may have been favorably influenced by DMG in that he had minimal behavior challenges in school. With caring teachers, he worked hard to learn and stay on task. He is very focused as a young adult and has good follow-through skills and an enthusiasm for learning new things.

Development of gross motor skills was not particularly delayed. Eric sat up unassisted at 6 months and walked unassisted at 18 months. His comprehension skills surpassed his speech ability in the early years, but today he is very verbal with quite a sophisticated vocabulary. He has great social skills and truly a zest for life!

We realize there are no "magic bullets" in regard to nutrition and that consistency and balance are critical. But we are grateful to my dad for heading us in the right direction when few resources were out there and DMG was but recently discovered! DMG, in conjunction with a nutritionally sound diet, seems to be a key to absorption and healthy metabolic function for Eric.

—*B. Bebko Matthes, Salt Lake City, Utah*

PARKINSON'S DISEASE

Parkinson's disease is a degenerative disease affecting the nervous system. The cause is unknown but the symptoms appear to be caused by a lack of the neurotransmitter dopamine. Parkinson's is one of the most common debilitating diseases in the United States; in fact, approximately 1 in every 200 people over the age of 60 are affected by it. Oxidative stress contributes to the cascade leading to dopamine cell degeneration in Parkinson's disease. DMG helps increase oxygen utilization by tissues, improve neurotransmitter metabolism, and enhances muscle recovery. Although certainly not a cure, DMG can improve the quality of life for a person with Parkinson's disease.

EPILEPSY

Epilepsy is a disorder characterized by reoccurring seizures. It affects more than two million people in the United States. Seizures are a symptom of epilepsy, but not all people who have seizures are epileptic. An epileptic seizure is a temporary malfunction of the brain caused by uncontrolled electrical activity of nerve cells. DMG has anti-seizure properties as a number of research papers demonstrate (see Chapter 7). It is also an antioxidant that increases oxygen utilization and neurotransmitter production.

DMG—FOOD FOR THOUGHT

Aside from helping with brain injuries and neurological disorders like seizures, developmental disabilities, obsessive compulsive disorder, dementia, autism, Down syndrome, attention-deficit/hyperactivity disorder, Alzheimer's, and Parkinson's— DMG also helps enhance normal brain function, and improves

memory retention and mental focus. It is beneficial to the stressed-out student as well as the average aging person. Those facing menopause may also find DMG useful.

For those with neurological disorders, DMG can support physical and mental ability because it helps the body adapt to various forms of stress. It is a precursor to many amino acids and amino alcohols that aid in brain function and also provides precursors to neurotransmitters that help with nerve function. It also improves oxygen uptake for optimal muscle and nervous system functioning. DMG seems to improve mental alertness, mood, and brain function, as well as reduce fatigue.

DMG enhances energy levels in the brain, neuron function, memory recall, neurotransmitter production, amino acid production, blood sugar balance, oxygen utilization by the brain, and immune system function, as well as decreases lactic acid levels raised by stress. It can help battle against fatigue, enhance mental function, and benefit overall mental and physical endurance.

Nutrients that Benefit Neurological Disorders	
Nutrient	*Benefit to those with neurological disorders*
DMG	DMG improves mental alertness and brain function. It's a precursor to many amino acids and amino alcohols that aid in brain function and a building block for many important substances. DMG is involved in neurotransmitter metabolism, increases oxygen utilization in the brain, increases brain circulation, and increases immunity. DMG helps cope with external stressors, and increases SAMe and glutathione levels.

continued on next page

Nutrient	Benefit to those with neurological disorders
Acetyl-L-Carnitine	Acetyl-L-Carnitine is a derivative of the amino acid, carnitine. Acetyl-L-Carnitine helps with neurotransmitter metabolism, and is necessary for normal neuron and brain function. Acetyl-L-Carnitine mimics acetylcholine (responsible for memory and proper brain function), which reduces depressive states and supports proper mental function including: alertness, memory, attention span, and problem solving. Carnitine is involved in long-chain fatty acid metabolism and transport to provide cellular energy. It enhances physical performance, hand-eye coordination, and boosts the body's physical energy for optimal performance.
Phosphatidylserine	Phosphatidylserine is a constituent of cell membranes and, as the major phospholipid in the brain, plays a role in the integrity and fluidity of cell membranes, especially in nerve cells. Phosphatidylserine supplementation improves the release of acetylcholine and dopamine (neurotransmitters) in the brain to improve cognition and memory, and it has a positive impact on behavior. Phosphatidylserine is also needed for proper metabolism of fatty acids and to maintain a healthy immune system.
Choline	Choline has been shown to improve brain function and circulation. Without it, brain function and memory are impaired because it's needed for proper nerve transmission from the brain through the central nervous system. It aids in hormone production. Choline increases noradrenaline and dopamine levels in the central nervous system, which improves learning and memory performance. Choline is essential in manufacturing acetylcholine, a very important neurotransmitter. Acetylcholine is used in many brain processes and benefits memory recall and brain function.

continued on next page

Nutrient	Benefit to those with neurological disorders
Magnesium	Magnesium is needed for normal brain and nerve function, and it increases ATP production to provide energy for the brain and body. It improves cognition and functions as a neurotransmitter to facilitate nerve impulse transmission.
Manganese	Manganese is needed for protein and fat metabolism and the healthy functioning of the nervous system and the immune system. Manganese is also involved in energy metabolism and blood sugar control. Because of its role in glucose utilization in neurons and its ability to help control neurotransmitters it has a significant role in cerebral function.
Glutamine	Glutamine is an amino acid that is considered "brain fuel." It can pass the blood brain barrier and has the ability to provide nutrition to brain cells allowing for improved mental alertness, memory, mood and clarity. Glutamine can cross the blood brain barrier and be converted to glutamic acid, which acts as a neurotransmitter. Glutamine is being recommended for ADD/ADHD, Alzheimer's, and autism.

DMG and Autism

DMG BENEFITS TO THOSE WITH AUTISM

- DMG improves verbal communication.

- DMG improves social interaction.

- DMG enhances energy production.

- DMG improves focus and eye contact.

- DMG reduces seizures.

- DMG helps cope with stress.

- DMG improves sleep patterns.

A parent with an autistic child recently wrote me. I want you to read the letter because it offers real hope to anyone with such a child.

Dear Dr. Kendall,

My daughter is 5 years old and has been diagnosed with autism. She has been on DMG for a year, and the results have been wonderful. When we started her out on the DMG, she was a very frustrated little girl. She would scream and yell at the top of her lungs. She would not let you touch her, she would not look at your face, would not socialize with others, including her sister, uncles,

grandparents and myself. Her sleep patterns were outrageous. She would go to bed at all hours and not sleep through the night. Her attention span was that of three to five minutes at home and at preschool. If something were out of the ordinary, like her schedule being disrupted, she would immediately begin to scream. This was so very hard for her to adjust to. We started her out on two tablets of 125 mg DMG just to see if it made a difference, and the results were amazing. She began to talk, pay attention, respond, play with her sister, and show affection towards others. Her teachers said it was such a difference they thought she might be on Ritalin. I was quick to inform them that it was NOT Ritalin! She is now taking five 125 mg tablets daily and is doing wonderfully. She is potty trained, is pre-reading, spelling words, signing words, and playing with her sister. Her emotional side has also come out. She is concerned when someone is hurt. And she is showing emotion when she misses someone. She is showing compassion for others. Her sleep patterns have become regular. She is in bed at eight p.m. and sleeps till six or seven a.m. When she has been thrown a curve ball in her schedule, she does not act out as she use to. She seems to take it with a grain of salt. This is a totally different child that I've dealt with this last year. The changes have all been for the good. I can't tell you how grateful we are for DMG. I just wish that others might know of this to help their children.
—*Sincerely Appreciative in Idaho*

Hundreds of letters are written every year to both myself and my colleague Dr. Bernard Rimland at the Autism Research Institute (ARI). This is one of the letters he has received on DMG.

Dear Dr. Rimland,
Let me start by telling you that I am skeptical by nature. I am a practicing attorney in Los Angeles. I do not believe in single-solution answers or magic bullets to complex problems. However, I am also the father of a 3 1/2-year-old autistic son. During my son's short life I have never had a single meaningful, one-word conversation with him, other than his definitive "no." I could never understand what, if anything, was going on inside his beautiful head. It has been the most discouraging and frustrating event of my life. My wife and I started Matthew on a regime of DMG a few days ago. As instructed by the literature, we told no one we did this. We sent him off to preschool as always. Yesterday, I received an "urgent" call from Matthew's preschool director. I braced myself for some type of terrible news. *continued on next page*

Instead, I learned that the director had approached Mathew on the play-ground, where he was walking alone. She had asked (knowing full well he would not answer), "Where are you going, Matthew?" I heard her pause for a deep breath; then she told me, "Your son stopped, looked me straight in the eye, and said, 'I'm getting a towel for swimming.'"

Of course, I could think of nothing else the rest of the day. When I got home, I went directly to Matthew, to see if he could answer a simple question. I asked, "Did you eat dinner?" He gave me that blank look I've come to know so well. I asked again, "What did you have to eat?" This time, he looked at me and said, "Chicken." I asked, "Anything else?" He said, "And grapes."

Today, my wife called from her car to say that she and Matthew were on the freeway when they saw my office building. All of a sudden, and out of nowhere, Matthew came to life and started saying "Look, Daddy's office. I want to go see Daddy." My wife said that she was near tears and had to pull onto the shoulder of the highway to regain her control. Again, I'm not a believer in magic bullets; I'm not sure what to make of this sudden change. We are doing nothing differently except adding the daily dose of DMG.
—*Sincerely in Los Angeles*

I have been using DMG for our 16-year-old daughter since she was 5. Prior to that, her language skills were in the classically autistic range—echoalia, virtu-ally no original speech, and little functional communication. After three days on DMG, she started getting the occasional pronouns correct. At ten days, she said "yes" for the first time. For the next three months we saw daily progress in her language skills. By nine months my daughter reversed pronouns only when under stress.

During this time, she was not receiving speech therapy. My daughter also seemed more settled, and her attention span improved. Her tolerance level rose, and tantrums decreased.

When my daughter was seven, my friend noticed that her son calmed down right after being given a dose of DMG. She experimented—carrying it with her and giving it to her son in stressful situations. She found it very helpful. I tried that with my daughter and found that a DMG could get her through situations she previously had not been able to deal with. I could even give her one in the midst of an obsession or tantrum, and have her come out of it in a minute or so.
—*Sincerely, K. Reznek, Berwyn Heights, Maryland*

HOW DMG AFFECTS BEHAVIOR

Neurotransmitters in the central nervous system (CNS) such as norepinephrine and dopamine require a methyl group donated by SAMe to become active. Dopamine is then modified by adding a hydroxyl (OH) group to make norepinephrine. Norepinephrine is then methylated to make epinephrine. Epinephrine (adrenaline) is your fight-or-flight hormone that increases blood flow and oxygen availability, and it is important in the proper functioning of the sympathetic CNS.

Catecholaminergic pathways that control aspects of human behavior depend on methylation for activation. These pathways, known as catecholaminergic (dopamine, epinephrine, norepinephrine) pathways affect the limbic system that controls human behavior, so stimulation of catecholaminergic pathways is associated with altered behavior. Because of the importance of transmethylation and the availability of methyl groups to these pathways, the role of DMG as a methyl donor may be an explanation as to why DMG can modify behavior of those with autism-like disorders. DMG may also affect neurotransmitters in the brain directly. Reports show DMG has anti-seizure activity and benefits those with autism and ADD.

WHAT IS AUTISM?

The federal Centers for Disease Control and Prevention (CDC) in early 2000 reported that there were 67 cases of autism spectrum disorder (ASD) for every 10,000 live births. If only autism was included, the number was still 40 cases of autism for every 10,000 live births. Work continues to clarify the confusion and controversy surrounding the causes, diagnosis, and treatment of autism. The term "autistic spectrum disorder" is frequently employed to

acknowledge the diversity and severity of autism. As different types of autism have been identified through scientific research, the criteria for diagnosing these other types overlap with the definition of autism and tend to make autism more difficult to diagnose. Autism covers a wide variety of children that are as different from one another as they are from "normal" children their own age. Autism is a poorly understood disorder of unknown causes that results in a wide range of puzzling and disturbing social and personal behavior patterns.

Autism is a syndrome, not a disease. Most autistic children are normal in appearance, but have very different behaviors from most "normal" children their age. Autism is a complex behavioral and neurological disorder apparent at infancy or early childhood characterized (usually before 30 months of age) by an unresponsiveness to people or environment. Individuals tend to exhibit severely impaired communication and social interactions, unpredictable and unusual behavior, inability to make eye contact, bursts of hyperactivity, and repetitive mannerisms, along with restricted interests and activities. They may also have an insensitivity to pain or display self-injuring behaviors.

Autism manifests itself in many different forms. Since there are no medical tests at this time to determine whether a person has autism, the diagnosis of autism is given when an individual displays six of twelve characteristic behaviors that match the criteria in the fourth edition of the *Diagnostic and Statistical Manual* (DSM IV), published by the American Psychiatric Association. Those who have autistic behaviors but fail to qualify for six or more of the criteria are diagnosed with pervasive developmental disorder not otherwise specified (PDDNOS).

People with autism are difficult to teach, have problems acquiring and using language, and are rarely able to work productively or be employed. Historically, about 75 percent of people with autism are

classified as mentally retarded. Their most distinctive feature, however, is that they seem isolated from the world around them. They appear detached, aloof, or in a dreamlike world and many individuals often appear only vaguely aware of their environment or other people. Many autistic individuals do not realize that others may have different thoughts, plans, and perspectives from their own.

One would be hard put to find a more zealous champion for the cause of defeating autism than Bernard Rimland, Ph.D. He had previously served as a psychologist in the U.S. Navy and when his son Mark was born and diagnosed with autism, he dedicated his life to finding the causes and solutions to the autism question. He has worked with thousands of parents who have autistic children over the past 30 years giving hope, encouragement, and providing nutritional methods for improving the lives of those with autism around the world. As president and founder of the Autistic Research Institute in San Diego, he has worked tirelessly with clinicians, bionutritionists, and psychologists publishing research and funding public seminars to defeat the rising increase in autism cases sweeping the country.

He conducted his own trial using DMG, but the initial results were mixed. There was evidence that DMG was profoundly effective in some but not all autistic individuals. Dr. Rimland has collected over 5,000 reports from parents who have used DMG for their autistic children and the results have been encouraging. Based on results of several controlled studies with DMG over the years, he has enthusiastically added DMG to the list of those nutrients that individuals with autism should try. (Dr Rimland's studies and information for the parents of autistic children are posted on his website [www.autism.com].) It is Dr. Rimland's dream to see autism overcome and defeated; this will be accomplished in part due to the benefits of DMG.

Remember the 1988 movie *Rain Man*? Dr. Rimland was an advisor for that movie because of his knowledge and research in the

area of autism and autistic savants. It was at his suggestion that Dustin Hoffman play an autistic rather than a retarded savant. MGM credited Dr. Rimland with being the chief technical advisor on autism for the movie *Rain Man*. Dr. Rimland, aside from being a leading authority on autism and the director of the Autism Research Institute (ARI), also has a son Mark, who is an autistic savant. Mark Rimland illustrated a book written by his sister Helen Handalf called *The Secret Night World of Cats* featuring 30 of Mark's cat drawings. About 10 percent of autistic individuals have savant skills. This refers to an ability which is considered remarkable by most standards. These skills are often special talents in music, math or art. Savant mathematical ability allows some autistic individuals to multiply large numbers in their head within a short period of time, or determine the day of the week when given a specific date in history, or memorize large quantities of information like entire phone books. In the 1970s, Dr. Rimland reviewed the literature and evaluated the potential of DMG to help his son. He tested DMG on Mark and found it helped his communication and social interaction. Dr. Rimland then began to recommend DMG to other parents with autistic children.

WHAT CAUSES AUTISM?

There are many possible causes for autism. It may be caused by genetic error in metabolism (like enzymes that function improperly), abnormal immune system response, abnormal brain structure or irregularities of the digestive tract.

There is growing concern that toxins and pollution in the environment can lead to autism. Interestingly, the highest proportion of autism cases have been found in homes that are down-wind from factory smokestacks. The liver in many autistic individuals has very low levels of glutathione and therefore can't detoxify properly, causing high

levels of heavy metals and some chemicals to circulate in the body that may cause some of the symptoms associated with autism.

There is a possibility of a genetic influence in autism. Currently, research is focused on locating the 'autism gene,' but many researchers speculate that three to five genes are likely to be associated with autism. There is also evidence that the genetic link to autism may be a weakened or compromised immune system.

A malfunction of the immune system or the nervous system could contribute to the development of autism. The immune system is dysfunctional in many autistic individuals. A genetic predisposition, viral infection or environmental toxin may be responsible for damaging the immune system. Research on humans and animals has shown that DMG has strong immune modulating properties. The abnormal immune system in most autistic individuals usually consists of decreased macrophage activity, decreased numbers of B and T cells, and decreased NK cell activity. The immune system is abnormal, hypersensitive, its proinflammatory cytokines are turned on, and autoimmune antibodies may be present. DMG modulates the immune system, which reduces these as well as other symptoms associated with autism.

The intestinal tract of autistic children is impaired; in fact, 85 percent of autistic children have a microbial overgrowth of viruses, yeast and pathogens in their gut. With an impaired, digestive tract food intolerance, allergies, and microbial overgrowths result. Left untreated dysfunctional gastrointestinal issues can further complicate neurological problems and worsen physical symptoms associated with autism. Researchers have documented yeast overgrowths (*Candida albicans*) and measles virus in the intestinal tract of autistic children. It is thought that the high levels of *Candida albicans* may be a contributing factor to many of their behavioral problems. Healthy intestinal microbes regulate the yeast present in the intestinal tract, but due to abnormal gut microbes, the yeast present in the

intestinal tract grows rapidly, and releases toxins in the blood. The toxins then influence the functioning of the brain.

There is also evidence that some viruses may cause autism. There is an increased risk in having an autistic child after a mother's exposure during pregnancy to rubella or cytomegalovirus. Additionally, there is also a growing concern that viruses associated with vaccinations, such as the measles component of the MMR vaccine and the pertussis component of the DPT shot, may cause autism in the child vaccinated. Andrew Wakefield, M.D., a pediatric gastrointerologist in London, found live red measles particles in the gastrointestinal tract of 80 percent of the autistic children in his practice. A number of clinical laboratory studies demonstrate that childhood vaccines may cause chronic damage to the gastrointestinal tract, the immune system, the brain, and other organs. Most vaccines also contain toxic levels of the mercury-based preservative Thimerosal to which many children are extremely sensitive.

Could vaccines contribute to autism? Research is still underway, but vaccines are one of the most likely causes. For many years now in the United States and United Kingdom, there has been a debate over whether vaccines cause autism. Thousands of families say they can demonstrate with videotapes and photos that their children were normal prior to being vaccinated, reacted badly to the vaccines, and became autistic shortly thereafter.

The number of vaccines given before age two has risen from 3 in 1940, when autism occurred in perhaps one case per 10,000 births, to 22 different vaccines given before the age of two in the year 2000.

The best current estimates are that autism occurs in 40 to 67 children per 10,000 live births. This means that the prevalence of autism has increased 1,000 percent in the last decade. According to the latest figures just released in January 2003 by the California Department of Developmental Services, California experienced an astounding 31 percent increase in the number of new children

professionally diagnosed from 2001 to 2002 with autism. That means 3,577 new severely autistic children were added in just twelve months (the figures reported did not include any other autism spectrum disorders).

Just for perspective if we go back to 1971 up to 1980, we see that California consistently added 100 to 200 new cases a year; but in the year 2002, California added 3,577 new cases. Since 1980, the documented start of California's autism epidemic, the number of new cases has steadily increased. If we break down those statistics it means that from 1994 to 1995, California only added on average 2 new autistic children a day into its system. In 2001, it was a rate of 8 new autistic children added a day; in 2002, it jumped up to 10 children a day.

Mercury-containing vaccines are still in use today, including the most recently recommended addition to the childhood immunization schedule, 2 shots of flu vaccine for infants, bringing the total number of vaccines up to 41 in California that a child will receive before the age of two. It will take a few years to start seeing the effect of the phasing out of the mercury-containing preservative Thimerosal from childhood vaccines on this autism epidemic.

Many symptoms of autism are similar to those of mercury poisoning. Immune dysfunction, visual disturbances, and motor dysfunction are seen in both. Treating autistic children for removal of mercury and other heavy metals has shown significant improvement in their autistic symptoms. Most autistic individuals have poor liver detoxification, low antioxidant levels, and low levels of glutathione.

Vaccines are effective, but the production and use of vaccines should proceed more cautiously. Currently manufactured vaccines still contain harmful substances like mercury. The link between vaccines and autism is far stronger than the medical community is willing to admit, and more research in this area should be an urgent priority.

One of the causes of autism may be neurological, in that the CNS may have altered sensitivity, and may be unable to process some information, or neurotransmitter levels may be unbalanced. Researchers have located several brain abnormalities in individuals with autism, but the reasons for these abnormalities or how they influence behavior are not known. The two main abnormalities seem to be a dysfunction in the neuronal structure of the brain and abnormal brain biochemistry. It will be important for future researchers to examine the relationship between autism and these two types of abnormalities.

Examination of brain structure of autistic individuals reveals two areas of the autistic brain are underdeveloped: the amygdala and the hippocampus. These two areas are responsible for emotions, aggression, sensory input, and learning. Use of magnetic resonance imaging (MRI) to view the autistic brain also shows two areas in the cerebellum that differ significantly in size. These areas in the cerebellum are responsible for attention span. Defects seem to occur before or shortly after birth due to genetic abnormalities, oxygen deprivation, infection, metabolic disorders, or toxic exposure.

With respect to biochemistry, many autistic individuals have abnormal hormone or neurotransmitter levels. There is also evidence that some autistic individuals have elevated levels of beta-endorphins, an opiate-like substance, which may explain why some autistic individuals seem to have an increased tolerance for pain.

RESEARCH ON DMG AND AUTISM

In 1965, two Russian investigators, Drs. M. Blyumina and T. Belyakova, published a study on mentally handicapped children and calcium pangamate (which contains DMG as its active ingredient). In the study 12 of the 15 children who had previously been unable to speak showed drastic improvement, and, in addition to

increasing vocabulary, the children started speaking in sentences, improved in mental state, and had better concentration and more interest in their environment. In 1975, Dr. Allen Cott published a similar paper after using calcium pangamate that he brought back from Russia on nine children with autism or who suffered from severe disorders of learning, behavior, and communication with similar results. It was Dr. Cott's work that caught Dr. Rimland's attention in the mid-1970s.

In 1990, Dr. Lee Dae Kun of the Pusan (Korea) Research Center on Child Problems administered DMG (125 mg to 375 mg, depending on weight) to 39 autistic children ages three to seven for three months. He reported an 80 percent improvement rate in the areas of speech, eating, excretion (bathroom habits), and coopera-tion/willingness, as well as improved frustration tolerance and sleep quality. He concluded that DMG is very beneficial for chil-dren with autism, even if it is not a cure. Several children had diffi-culty sleeping and were more active for the first few weeks, but this situation improved as the study progressed.

In 1997 in Taiwan, Dr. Shin-siong Jung of the Taipei Springtide Foundation did a double-blind, placebo-controlled study (published in China by Dr. Jung), involving 84 autistic children who were divided into a DMG group (46) and a placebo group (38). The DMG group showed statistically significant improve-ment on five scales used to evaluate effectiveness: irritability, lethargy, stereotypy, hyperactivity and inappropriate speech. The placebo group showed improvement only on the lethargy scale.

Stephen Edelson, Ph.D., from the Center for the Study of Autism in Salem, Oregon, says that DMG is safe, inexpensive, and helps half of all autistic indi-viduals. DMG strengthens the immune system, decreases seizure activity, and helps with mental clarity.

Summary of Research on DMG and Autism

- In 1965, mentally handicapped children in the Soviet Union given calcium pangamate had drastic improvement with speech, increased vocabulary, speaking in sentences, improved mental state, better concentration and more interest in their environment.

- In 1975, autistic children who suffered from severe disorders of learning, behavior, and communication were given calcium pangamate and had drastic improvements in learning, behavior, and communication.

- In 1990, autistic children given DMG had an 80 percent improvement rate in the areas of speech, eating, excretion (bathroom habits), and cooperation/willingness as well as improved frustration tolerance and sleep quality. It was concluded that DMG is very beneficial for children with autism, even if it is not a cure.

- In 1997, autistic children given DMG had statistically significant improvement on five scales used to evaluate effectiveness: irritability, lethargy, stereotypy, hyperactivity and inappropriate speech.

These results confirm the hundreds of communications that the Autism Research Institute, in San Diego, California, under the direction of Dr. Rimland, has received from hopeful parents who have seen remarkable changes in their autistic children after using DMG. Dr. Rimland compiled Treatment Effectiveness Surveys filled out by parents about the effects of different drugs, nutrients, dietary modifications, and therapies on their autistic children. The ratings consist of "made better," "made worse" or "no effect." From the surveys a "better : worse" ratio is established. The results of the survey of 21,500 parents were published in the *Autism Research Review International* newsletter in April 2002. It reviewed the use of key nutrients and found significant results with regard to DMG and behavior modification.

Dr. Rimland has recommended that parents give DMG to their autistic children since 1980. Areas where parents and teachers have noted improvement with DMG and autism include:

- Better verbal communication.
- Better social interaction.

- Better eye contact.
- Improved affection.
- Reduction in seizures.
- Improved quality of sleep.

There are a number of possible explanations as to why the use of DMG has resulted in such remarkable improvement. These may include better oxygen utilization, reduced lactic acid formation, a possible decrease in potential seizure activity, and modulation of the immune response.

A California psychiatrist and mother wrote Dr. Rimland the following letter:

Dear Dr. Rimland,
I am extremely excited by the news about my 23-year-old autistic son, Bruce, since he has been on DMG. Today is his ninth day on DMG, and his third day on 375 mg per day. As you can imagine, we have tried every conceivable remedy and method known to man for the last 23 years. Bruce has stopped yelling and screaming and biting his arm. He is quiet (not listless) and seems happy and contented. He no longer performs his maddening acts of preservation—the ritualistic and compulsive rituals that consumed hours every day and drove us crazy. On Sunday, he sat and watched the Super Bowl on TV. He has never watched TV before in his life. Because of his many compulsive rituals, it used to take him almost two hours to get dressed in the morning. Now he gets dressed in five minutes. His eye contact has improved and he walks around with a happy smile on his face.
—Sincerely in Thousand Oaks, California

And here's another letter...

Dear Dr. Rimland,
In December, my husband and I began giving our son DMG. We had a "nothing left to lose" attitude. Matt was four years and non-verbal for the most part.

Two to three weeks after starting DMG he began to babble, then use jargon. Two months later, he began to make many word attempts. By June he was speaking true words. He puts together about 50 or so two-word phrases. He can write his alphabet, upper and lower case, and his numbers zero to

continued on next page

thirty, and he knows the quantity of numbers one to ten. He can spell his full name and his address, and many other words, and can draw simple pictures, and is toilet trained.

When I tell people about DMG, they ask, "Do you really think DMG did all this?" I reply that I think it really helped. It's cheap, very easy to administer, and it is a nutrient that can't hurt. It may not work with your child but it's worth a try.
—*Sincerely in New York*

This is a letter written to Dr. Rimland from a reverend whose grandson used DMG for autism...

Dear Dr. Rimland,
I will always be especially thankful to you for suggesting several years ago that we try giving DMG to my grandson to help facilitate speech.

I was certain that he possessed receptive language skills and understood spoken language, but that his efforts to respond orally came out "scrambled." At the time, he was learning manual sign language used by deaf and hearing-impaired children.

I remember well the evening of his third day on DMG. He was with me watching television, and had just finished drinking a cup of juice. He had handed me the empty cup and I was trying to decide where to put it, when he pointed to the small table next to him and said, quite clearly, "put it there." I was absolutely stunned—and filled with joy beyond description. I went quickly to the kitchen where I told my wife and our daughter (his mother) what had happened. Needless to say, they were not convinced, and there was no repeat of this miracle in their presence. A few days later, however, in my daughter's home, their doubt, too, was removed. I was not present, but they both tell me how they were seated at the supper table when my grandson got up from his place and went to my wife. "I'll be right back," he said to her, then went to his mother and repeated, "I'll be right back," and then left the room.

Since then, my grandson has received many other therapies. Today, his language skills are very well developed and he is a very bright and pleasant boy. I cannot prove scientifically that the DMG was solely responsible for unlocking his ability to speak. But for those who have not tried DMG, I can only repeat what you have told me: "It can do no harm, and may prove helpful."
—*Sincerely in Bethesda, Maryland*

SEIZURES

Seizures are considered a symptom of autism; it is estimated that one third of those with an autism spectrum disorder will exhibit seizures by adulthood; twenty percent of persons with autism experience seizures during puberty. On top of that Canadian researchers are now suggesting that the self-injurious behavior associated with autism may not be a "behavior" but a symptom of a temporal lobe seizure.

There is considerable evidence that DMG can function as a safe and effective anti-seizure agent due to its balancing and regulatory effects on the brain and neurons of the CNS. Veterinarians have also reported good success in preventing seizures in dogs and cats using DMG.

In a letter to the Autism Research Institute (published in the Autism Research Review International [volume 6(1)]), a woman reported that DMG had a profound effect on reducing her brother's seizures and improving his verbal communication.

My brother has fragile X syndrome, mental retardation, and autism. He has been plagued with seizures for many years, often having several minor motor seizures a day. After leaving the hospital recently, he continued to have seizures. He was still getting phenobarbital, mysoline, and dilantin. I called the Autism Research Institute (ARI) and found out about DMG. I immediately bought some and sent it to his facility. They gave it to him. He has not had a single seizure since. It has been over three weeks. Ever since my brother started taking the DMG (125 mg two times a day), he has been talking a blue streak. He is talking about a variety of subjects and is using more phrases and sentences. He even told a nurse, "I told you no. N-O!" He has never spelled anything before. He is also counting. He is happy as a lark. He is better able to control himself if something upsets him.
—*Sincerely in Menlo Park, California*

Drs. E. Roach and L. Carlin of the Bowman Gray School of Medicine, as reported in the *New England Journal of Medicine*,

found DMG to be effective in controlling epileptic seizures of a 22-year-old mentally retarded man who had 16 to 18 grand mal seizures a week. He was on standard anticonvulsants (therapeutic levels of phenobarbital and carbamazepine) with no effect. When put on 90 mg of DMG twice a day, within a week he was having only 3 seizures per week. Two attempts to eliminate DMG supplementation resulted in a major increase in seizure frequency.

Dr. William Freed confirmed DMG's ability to prevent or reduce epileptic seizures in mice. Dr. Freed speculated that DMG's anticonvulsant property may be linked to a yet unrecognized disorder of sulfur-amino acid metabolism.

Thomas Ward, M.D., found that DMG significantly reduced mortality associated with induced seizures in rats. Dr. Ward linked DMG's anti-seizure abilities to a possibility that DMG increases glycine levels or acts directly on receptor sites in the central nervous system (CNS).

There are several other reports of DMG aiding neurological and seizure patients. DMG may not work equally as well for all epileptic or seizure patients, but it does seem to help prevent seizures or at least the rate of seizures in some individuals, as this letter I received testifies....

Dear Dr. Kendall,
Our daughter has been a grand mal epileptic three years now and has been on phenobarb since second grade. She has continuous seizures that we have to rush her into the hospital to stop with medical treatment. She also has a heart valve problem, which complicates this. Our lives have not been normal or even close since this started. Since Risa started taking DMG she has been having no headaches, no blackouts, NO seizures, no problems with sleep and no leg problems. It was almost like getting a new kid.

I also use it for myself to help with vascular migraines and it has helped control them to where I don't have them at all—and mine were crippling—when they would start I couldn't see, speak or move. Thank you, THANK YOU and THANK YOU AGAIN!
—Sincerely in Tukwila, Washington

DMG IN TREATMENT OF AUTISM

There is a growing body of evidence that DMG is beneficial for individuals with autism. Autism is linked to abnormal metabolism, neurological dysfunction, and an irregular immune system, and studies show DMG benefits autistic individuals in these areas. DMG seems to enhance verbal skills, improve social interactions, and may reduce lethargy. DMG can improve the behavior patterns, social communication, and attention span of some autistic individuals. DMG can help balance behavior. It has been studied extensively and may improve eye contact, repetitive mannerisms, and help individuals to cope with changes in daily routines. Testimonials show that DMG may benefit obsessive compulsive disorder by correcting behaviors like hand washing, asking the same question repeatedly, and squeezing things.

Recent publications have shown that individuals with autism tend to have abnormal immune systems, and DMG acts as an immune modulator keeping the immune system balanced and under control, which may reduce symptoms associated with autism. Further studies in this area are needed to clarify the specific role DMG may play in helping to reverse symptoms of autism. Individuals who are prone to panic attacks and increased anxiety tend to have increased lactic acid levels that can affect brain chemistry. By preventing the buildup of lactic acid levels in the blood, DMG may be effective in reducing panic attacks and normalizing the stress response in these individuals. A decrease in lactic acid buildup implies a shift toward better oxygen utilization during times of stress and improved aerobic performance. DMG's ability to improve performance, energy production, and oxygen utilization may directly improve brain function in autistic individuals by providing increased oxygen for optimal brain and nervous system functioning.

DMG helps reduce overactive neuron function in the brain, which

may be one of the ways DMG helps reduce some symptoms of autism, like seizures, lack of communication, and poor eye contact. DMG acts as a building block for many important substances that support brain activity. It can make hormone and neurotransmitter metabolism more efficient. DMG is a precursor to many amino acids and amino alcohols that aid in brain function and can provide precursors to neurotransmitters that help with brain and nerve function. DMG provides glycine, which functions as a neurotransmitter in the central nervous system. Glycine is also used to produce phosphocreatine, an energy source for the CNS and muscles. DMG can cross the blood brain barrier more efficiently than glycine. In the brain it may mimic glycine or supply glycine to the brain or it could modify excitatory or inhibitory amino acids in the brain and central nervous system. Further research in this area is under way. DMG is an anticonvulsant and has been shown to reduce the frequency (number) and intensity (severity) of seizures.

Another letter from the files of Dr. Rimland tells us that DMG provides true hope to autism patients.

Dear Dr. Rimland,
In April we started our son Zach on ¹/₂ of a DMG pill. He came home from school that day and said, "Hey you." His dad and I were shocked. He had never put two words together before. A few days later Zach said his first sentence "I want pop, please." We almost cried. I told no one at the school for speech what I was doing. On his second day of DMG, his speech teacher and her boss ran him through some tests. They were amazed at how well Zach behaved, listened, and did. At school the same thing happened, as one teacher notes, "Zach's been trying to talk all day, just babbling." Another told us, "Zach's really doing good now, he's playing so much better with the children."

Each day we saw improvement in Zach. He has a friend now at school plus all the children were excited. One little child came up to me and said "Zachy can talk now."

continued on next page

At the end of the month I told everyone what I had done. They were amazed. I have increased him to one pill in the morning and one in the afternoon. He is a little hyper sometimes, but it's nothing we can't handle. We visited the doctor at Easter Seals yesterday, and she could not believe that this was the same child she saw six months ago.
—*Sincerely in McKinney, Texas*

The following letter is from the staff at the school attended by the above child.

Dear Dr. Rimland,
I am writing to you concerning Zachary and the remarkable progress that we have seen him make over the past several months.

I am the Associate Director of the Child Development Center where Zachary attends school on a full time basis. My staff and I have worked with Zachary for a little over a year now and have seen more progress occur during the past several months that in the time previous.

We (my staff and myself) were unaware that Zachary began taking an all natural medication, which has been known to help children with autism and PDD. During this time, Zachary almost instantly became potty trained. He began to use more language, sounds and gestures. His verbalization also became more clear when naming teachers, children and communicating. He also began imitating sounds and actions of other children. We have also noticed that Zachary has begun to use more pretend play than before. He will on more occasions play in the dramatic play center with the other children. He used to play more independently and now shows more of an interest in parallel play and group play.
—*Sincerely, Collin County Community College*
Child Development Center, McKinney, Texas

Given the range of people affected by autism and the diversity of symptoms, careful individualized assessment is needed to focus on therapies that correct each symptom. Each individual can benefit from a holistic therapy that is designed based on their unique needs using the various supplements, treatments and therapies available.

Autism spectrum disorder or ASD is a myriad of behavioral, neurological, metabolic, and biochemical abnormalities. ASD is controlled by dietary restrictions, heavy metal detoxification,

supplementation (DMG, folic acid, vitamin B_6, vitamin B_3, magnesium, zinc, calcium, omega-3 fatty acids, and digestive enzymes), and behavior modification therapies.

Chelation therapy or detoxification of heavy metals can cause drastic behavior changes in some autistic individuals. DMG, magnesium, glycine, and SAMe are used to help detoxify heavy metals.

Behavior modification involves a variety of strategies, like positive reinforcement and time-outs to increase appropriate behaviors, communication and social behavior, and to decrease inappropriate behaviors. DMG benefits about half of the autistic individuals, modifying and improving behavior, mental alertness, and brain function, as well as reducing lethargy and seizures.

SUPPLEMENTATION

Work at the Autism Research Institute in San Diego by Dr. Rimland has shown that hundreds of autistic children have been helped by DMG. Dr Rimland in *Autism Research Review International* writes, "A number of parents have reported that within a few days of giving their children one 125 mg tablet of DMG per day, the child's behavior improved noticeably, better eye contact was seen, the child's speech improved, or more interest and ability in speaking was observed."

Now the recommended dosage for an autistic child is one to four 125 mg tablets and two to eight 125 mg tablets for an adult. Initially give one 125 mg tablet and then increase the amount by one tablet every two to three days.

If agitation or hyperactivity is seen, it is recommended that folic acid should be given in the amount of two 800 microgram tablets for each 125 mg of DMG taken. Some professionals suggest that DMG should always be supplemented with folic acid since it cannot cause any harm, prevents vitamin B complex deficiencies, reduces the

possibility of agitation/hyperactivity, helps correct some autistic behaviors, and could possibly allow DMG to be more effective than when given alone.

Nutrients that Benefit those with Autism

Nutrient	Benefit to those with autism
DMG	DMG improves mental alertness and brain function. It's a precursor to many amino acids and amino alcohols that aid in brain function, and it's a building block for many important substances. It is involved in neurotransmitter metabolism, increases oxygen utilization in the brain, increases brain circulation, increases immunity, helps cope with external stressors, and increases SAMe and glutathione levels.

Dr. Bernard Rimland is the foremost authority on autism in the U.S. He's been recommending DMG for many years and reports positive results occur in 50 to 75 percent of all autistics. Results are improved verbal skills, behavior, eye contact, social interaction, and mental state as well as better concentration and longer attention spans. |
| Magnesium | Magnesium is an essential mineral that is needed for normal brain and nerve function, and it increases ATP production to provide energy for the brain and body. It improves cognition and it also functions as a neurotransmitter to facilitate nerve impulse transmission. |
| Betaine | Betaine improves behavior and increases social interaction. Betaine helps to improve circulation, normalize amino acid metabolism, and protect the liver from fat deposits. While parents of autistic children have also reported positive results with betaine or tri-methyl-glycine (TMG), there are no reports published on its efficacy for autistic individuals. TMG breaks down into DMG and helps SAMe production in the body. SAMe is a nutritional supplement and is sometimes used to treat mood disorders such as depression. |

continued on next page

Nutrient	Benefit to those with autism
Vitamin B_6	Vitamin B_6 is necessary for proper brain and nervous system function. It improves behavior and results in better eye contact, less involuntary physical action, and more interest in participation. It is a cofactor and enzyme for amino acid metabolism, hormone formation, hemoglobin formation for red blood cells (to supply the brain with more oxygen), and break-down of glycogen to glucose (to provide glucose for the brain).
Zinc	Zinc maintains proper vitamin E levels. In a study done by the Autistic Research Institution 43 percent of autistic children showed behavior improvement when on zinc alone. Zinc deficiencies are common in autistic individuals.
Vitamin E	Vitamin E is a fat-soluble antioxidant that prevents cellular damage by inhibiting fat oxidation. Since vitamin E is important in preventing fatty acid oxidation and peroxidation, more may be needed if a child is receiving an essential fatty acid supplement.
Folic Acid	Folic acid improves symptoms associated with attention deficit, and helps in the metabolism of the amino acids used by the brain.
Vitamin B_{12}	Vitamin B_{12} acts as an energy booster, enhances sleep patterns, and improves production of the neurotransmitter acetylcholine, which assists in memory and learning.
Vitamin A	Vitamin A may help reverse autistic symptoms in areas of language, cognition, social interaction, expression, and motor skills

8

DMG and Sports—
Nature's Edge

DMG BENEFITS TO ATHLETIC PREFORMANCE

- DMG enhances endurance and stamina.

- DMG helps cope with stress.

- DMG boosts cellular energy levels.

- DMG improves oxygen utilization.

- DMG decreases lactic acid levels.

- DMG increases muscle strength.

- DMG provides faster muscle recovery.

DMG WILL PERFORM FOR THE ATHLETE

In 1985 after reviewing the research that dealt with DMG's ability to reduce lactic acid after strenuous exercise, I got the idea that I would do a personal test to see if DMG was effective in dealing with muscle cramps and fatigue. The studies done by Meduski and Myer indicated that DMG has the ability to reduce lactic acid levels

and works rather quickly. I decided to go out running and purposefully run myself to exhaustion. After I had muscle spasms and severe cramping, I took five of the 125 mg sublingual DMG tablets. Within five minutes the pain and cramping in my calves and thigh muscles were gone! I continued to run two more miles without discomfort. I was convinced at that point that DMG does provide a quick response, it does improve endurance, and it can reverse the effects of lactic acid. I was living proof! Full of enthusiasm I delved even further into DMG research to figure out what this thing called DMG was and how it worked.

But, first, let me share with you this heartening letter about a very good athlete, Ashley Wilson, and how DMG helped her to reach peak performance.

Dear Dr. Kendall,

My daughter, Ashley Wilson, was diagnosed with a ventricular valve defect (VSD) at birth. Throughout her young life she developed into a superior athlete. With the approval from Dr. Scott Yeager, her cardiologist, she was able to participate in many sports: track, basketball and soccer at the varsity level.

But as time went on throughout her high school athletic career, she had complained about being tired, cramping in her legs and at one point, experiencing pain in her chest. Of course, she was immediately seen by her physician and, after the appropriate tests, was placed on a monitor for a month. After evaluating her complaints with the test results, it was determined that she was overexerting herself and with the added stress and growth, that the pains were normal.

I was first introduced to DMG in June 2001. I immediately started Ashley on the chewable 250 mg tablet, twice daily. She was playing basketball twice a week, with practices on the off days. After about a month, I increased the dosing to 250 mg three times daily, 500 mg being taken prior to game/practice time and the additional 250 mg after game/practice. We saw excellent results in the areas of stamina during game/practice time and unbelievable recovery time after.

Ashley has been able to play full games back to back during basketball season. With her speed and stamina during

continued on next page

track season Ashley was declared the undisputed fastest Division I Champion for the last three years. On many occasions, prior to the DMG introduction into her body, she had complained that she was unable to catch her breath, and had muscle cramps in her shoulders and legs. DMG has been a product that she herself has carried with her to college. Ashley received a full athletic track scholarship to Northeastern University in Boston, Massachusetts, and continues to reap and promote the benefits of DMG to her fellow teammates.

Being a former athlete myself, I wish that I had had knowledge of this product because I would have certainly benefited from its use. But rest assured, I will continue to promote the extraordinary benefits of DMG and continue to take it myself.
—Sincerely, K. Wilson in Vermont

DMG, THE STAMINA NUTRIENT

DMG has been used for many years by professional athletes and weekend sports enthusiasts to improve performance and counter the effects of muscle fatigue. It doesn't matter whether you are a professional athlete or just a recreational jogger, muscle stamina, physical endurance, and staying power are key to athletic success.

Runners, weight lifters, and endurance athletes know all too well the frustration and pain of cramping leg muscles. Muscle fatigue for an athlete is like a car that runs out of gas. Why is that? It has to do with two principle reasons: a lack of oxygen and a buildup of lactic acid.

Our muscles need both fuel and oxygen to produce the energy to move the body. Unfortunately as more stress is placed on a muscle, it demands more and more oxygen from the lungs and circulatory system in order to function at maximum performance. When the muscles can't get the oxygen that is needed they go into "oxygen debt." The lack of sufficient oxygen causes the body to start converting pyruvate, a breakdown product of glucose, into lactic acid. Lactic acid buildup stops the muscles from working properly,

causing muscles to go on stand-by until the oxygen debt can be repaid. Lactic acid buildup first generates fatigue and then burning sensations, spasms, and finally muscle cramps that force the muscle to stop working and rest allowing available oxygen to carry away the lactic acid before activity can continue.

DMG is shown to lower lactic acid buildup and enhance stamina, as well as improve overall performance, oxygen utilization, and recovery time of muscles after strenuous exercise. DMG has long been used by athletes to improve overall ability, speed, and recovery from stress. DMG can be the competitive edge that can make the difference between winning or losing.

Gary Null, Ph.D., well-known nutritionist and health researcher, reported in 1983 how DMG improved his performance in a marathon:

In an effort to test the effects of DMG on running ability, I conducted an experiment on myself. During last year's New York City Marathon, I consumed two 125 mg tablets of DMG for every two miles. The result was that when I reached the twenty-fourth mile I felt as if I had just begun a four-mile run. There was no fatigue and the excruciating pain associated with running this distance was absent. I had no cramps or lactic acid buildup. I can only attribute this to the DMG.

In 1984, Dr. Null conducted a marathon study with the Natural Living and Running Walking Club in New York. Marathoners compared their results in two successive marathons. No DMG was taken for the first race, but on the day of the second marathon, the athlete was to take 3 tablets under the tongue one-half hour before the race, and then 2 tablets starting at the eight-mile mark and every two miles after that. A total of 21 tablets (2,625 mg DMG) were to be taken during the marathon.

Dr. Null reported that the response of the runners was very positive. They found DMG greatly reduced leg fatigue, muscle cramping and

stiffness, and resulted in faster post-race recovery. The times for the second marathon on average were substantially improved over the times of the first by several minutes. Several runners also reported an "easier race" even if their second marathon time was close to that of their first. The overall conclusion based upon the compiled statistics and reports of the marathoners was that DMG supplementation improved racing times and reduced fatigue from the eighteenth to the twenty-sixth mile mark of the marathon. These results show that all endurance athletes, whether professional or amateur, can benefit from using DMG as part of their training program.

DMG is especially effective in older athletes who might be beyond their prime. One masters athlete, Don Davidson, wrote of his experience with DMG saying it gave him more staying power.

Dear Dr. Kendall,
I am sixty years of age and have used Aangamik DMG, two 125 mg tablets daily, for several years. I run at least three miles most days of the week and use my performance in that activity to evaluate various supplements that I try. None has made such an obvious difference as your DMG. Without it my pace is slowed drastically, my heart beats too rapidly, and I am breathing too hard when I finish the three miles. When I have used DMG regularly for a few days my speed increases just as dramatically, my heart never beats over 140 to 160 and I can carry on an easy conversation while running, which is usually faster than the majority of those 25 to 30 years my junior who run at the same track. I have also had the same experience on the treadmill during my annual stress test (for curiosity reasons). When I have been using DMG before going in they have a hard time getting my heart rate up to the point where they can test it. Another benefit I have noticed is that when I don't use DMG my legs feel stiff and weighted when I run. With DMG they feel light and loose and move freely like when I was young. It makes running a great joy. Also, my resting pulse is between 54 and 60 when I am using DMG. I don't think that there is any question, at least in my case, that DMG dramatically improves cellular respiration.
—Sincerely, Don Davidson

DMG improves the function of several metabolic pathways. It helps maximize the amount of energy produced for each molecule of oxygen consumed, resulting in improved physical endurance. DMG helps maintain homeostasis during extreme physical stress and is a versatile normalizer of physiological function. It also protects the athlete from stress-induced infections (colds, flu) by promoting a healthy immune system.

DMG TO THE RESCUE

You don't have to be an athlete to suffer from fatigue. Many of us have suffered from fatigue at some point in our work or in our daily activities. The fatigue we feel could be caused by oxygen starvation and poor energy conversion. To fight fatigue and improve stamina, many athletes have incorporated DMG into their training programs. Research studies show that DMG significantly improves perform-ance of track athletes, increases Vo_2 max, and improves endurance. DMG's apparent ergogenic effects could be attributed to its ability to make oxygen utilization and cellular respiration more efficient; its ability to reduce lactic acid buildup; and, its ability to enhance lipid and carbohydrate metabolism.

DMG has positive effects on the biological processes that occur during muscle activity. DMG helps maintain a high level of aerobic oxidation and increases the body's resistance to hypoxia. This helps the body to a speedy recovery after heavy exercise. DMG not only enhances oxygen utilization but also seems to provide an energy boost by increasing production of ATP (the body's main energy source). In fact, the 1970s super-energy diet from the late Robert Atkins, M.D., called DMG a "health-enhancing, energy-providing, life-prolonging, disease-preventing agent." DMG helps the body recover from oxygen debt, because it improves oxygen utilization, reduces lactic acid formation, reduces muscle cramping, and increases ATP levels.

When lactic acid levels are lowered, muscle cramping during physical stress and recovery time are decreased. In stressful situations lactic acid levels increase in the blood. So anything that impairs the supply or utilization of oxygen increases production of lactic acid. DMG supplementation helps increase oxygen utilization and decrease lactic acid levels in the blood.

During muscle contraction, ATP is consumed as the primary source of energy. When ATP concentrations fall, phosphocreatine is used as the "backup" reservoir of high-energy phosphate bonds. When the phosphate group on phosphocreatine is transferred to ADP to make ATP, creatinine is released. The creatinine made from the use of phosphocreatine is excreted in the urine as a metabolic end product and causes a continual and irreversible loss of methyl groups. DMG provides the body with a constant supply of methyl groups to keep these reactions going, and to keep ATP levels high.

In 1978, Dr. Jerzy Meduski, M.D., Ph.D., began to investigate DMG's ability to improve oxygen utilization and reduce lactic acid buildup. In a series of experiments, he proved that DMG could act as a metabolic enhancer and adaptogen by helping animals function better and recover faster when put under conditions of physical stress. Under hypoxic conditions, New Zealand white rabbits were exposed to severe surgical stress, a condition known to increase blood lactic acid levels in animals. The rabbits on DMG showed decreased levels of lactic acid in their blood as compared to control. Rabbits not on DMG had lactic acid levels about ten times greater than normal. Dr. Meduski linked DMG's ability to reduce lactic acid buildup due to its ability to use the available oxygen more effectively.

In a follow-up study, Dr. Meduski put rats in an enclosed, air-tight container and oxygen consumption was measured under controlled conditions. The control rats received no DMG whereas the test rats received DMG in their drinking water. Rats fed high doses of DMG adapted better to hypoxic (low oxygen) situations than control rats.

The DMG-fed rats were able to take in more than 20 percent more oxygen as compared to the controls. Such an increase in oxygen intake may explain the reduced lactic acid levels seen in animals given DMG as part of their diet.

DMG significantly improved performance in a group of track and field athletes. Exercise physiologist Thomas V. Pipes, Ph.D., at the Institute of Human Fitness in Escondido, California, tested the effects of DMG in a controlled, double-blind study using twelve male college track athletes. He ran them to exhaustion on a treadmill using either DMG or a placebo. Dr. Pipes found that DMG produced an increase in the runner's Vo_2 max by 27.5 percent. He also found that the runners taking DMG had a 23.6 percent increase in their maximum exercise time before exhaustion forced them to stop. He also noticed the athletes on DMG recovered faster from muscle fatigue. This may be why the Russians and East German athletes taking a DMG formula at the 1968 Olympics had such good results.

Dr. Daniel Hamner, M.D., in his book *Peak Energy*, calls DMG a pro-oxygenator, a supplement that can boost your energy and endurance by enhancing the way your body uses oxygen. He should know because as a middle-aged runner he was beginning to slow down on the track. His best marathon performances were behind him. When he added DMG to his training program he found that it increased his endurance, boosted his running times, and his muscles recovered more quickly. Better recovery allowed him to increase his workout periods and improve his speed at the same time. As an added side benefit he found that DMG boosted his mood and mental alertness. According to Dr. Hamner, DMG helps the body stay at its peak longer by overcoming the stress of hypoxia, reducing the buildup of lactic acid, and improving oxygen availability to the cells.

Dr. Hamner felt DMG's oxygen enhancing power had far-reaching health benefits for many of his patients whose low

oxygen usage was actually life threatening. He found that his heart patients, who had angina due to low oxygen availability, as well as diabetics who have poor circulation to their extremities, improved greatly on DMG.

Phil McGaw, president of the North Medford Club in Milton, Massachusetts, which is one of the oldest race-walking clubs in New England, discovered the value of DMG to his overall performance in a national championship two-hour race walk competition. He wrote:

I felt DMG was useful and helped me to perform to my potential with greater ease than would have been expected. I really felt great out there. There was definitely more stamina for me.

Since then, I have been using it daily—with extra doses for a specific race. I feel that it has helped me achieve performances that otherwise would have been unrealistic with the amount of training that I have been doing. On November 12, I competed in the New England 10K Championship. I posted my personal best time while holding off and out-sprinting my teammate who is 17 years younger than I am. I finished in 49:58 on a very hilly course. I would have realistically expected to do no better than 51 minutes. To be able to finish 60 seconds faster than expected is very significant.

I take three tablets per day now, between meals. I take more just before a race. I took six tablets (750 mg) before the 10K. I found that I was able to go full out the entire race, not needing to coast to recover over hills, as is my usual course of action. I had a strong kick at the finish and could have withstood a stronger finish if called for. I can safely say that if I had not incorporated DMG into my training schedule, I would not be the defending New England Champion at 10 kilometers.

Many athletes like Phil McGaw are increasing their competitive edge by adding DMG to their training and race program.

DMG AT THE TRACKS

For over 30 years DMG has been used to improve the stamina in racehorses. This was one of the first areas in the United States

where DMG's benefits were explored and evaluated in optimizing performance and improving recovery times after heavy exercise. In 1968, Dom Orlandi, founder of U.S. Animal Nutritionals® of Vermont, first discovered DMG's remarkable effects on horses when he tried feeding DMG to several thoroughbred trotters and pacers which have the tendency to fade in the stretch. When the horses were on DMG, their elapsed times improved by nearly three seconds in a mile and a sixteenth. These horses made their greatest time improvement in the last quarter of the race showing that DMG was able to help the horses hold their fastest pace longer without fading. To prove that it was the DMG that made the difference, he took them off the supplement and the pacers all returned to their original racing times after three days. Orlandi also noted that the horses on DMG were overall less stressed, had quicker recovery times from fatigue, and were ready to race sooner.

Several published studies by veterinarians showed that DMG was effective in reducing lactic acid buildup in racing standardbreeds after heavy training. They also reported that DMG prevented muscle fatigue and loss of endurance in these horses. Other veterinarians reported that the respiration and heartbeat of horses on DMG would return to normal much faster than those not taking DMG.

Animal studies in DMG research are very important—as our four-footed athletes can't lie to us because there is no placebo effect in animals. A 1982 study by Drs. Myre and Grey in the *Equine Practice Journal* showed DMG's rapid ability to reduce a horse's lactic acid level when compared to animals not on DMG. There was a five-fold decrease in lactic acid levels for the DMG animals when compared to controls. Research by G. Potter and his associates at Texas A & M confirmed these results. They found in horses supplemented with DMG (1.6 mg per kg), there was a significant reduction in blood lactic acid concentration after strenuous exercise on a treadmill. Results also show that

when DMG is part of a horse's diet they exhibited greater speed and stamina.

In 1982, Dr. James Grannon, D.V.M., and I published a report in *Canine Practice Journal* showing that performance of racing greyhounds taking DMG improved. One of the most interesting discoveries was that the increase in time came near the end of the race, when the dogs usually slowed their pace due to exhaustion. There was consistent improvement in the ability of the greyhounds to maintain their maximum speeds for longer periods.

DMG, SUPREME ATHLETIC SUPPORTER

The animal studies, laboratory research, and field evaluations, all show that DMG is beneficial to the endurance of athletes (runners, team sports) as well as short-timed events (weight lifters, sprinters).

Although the mechanism of how DMG improves oxygen utilization and reduces lactic acid accumulation are not totally understood, many reports of DMG's positive results do show that it is effective in improving athletic performance. DMG can also improve the mental and physical performance of business people, students, and active seniors. DMG is the nutrient of choice for athletes and people who want to be more active and have a revitalized stamina to meet their daily challenges.

DMG Studies on Human and Animal Athletes

- Dr. Null reported marathon runners found DMG reduced leg fatigue, muscle cramping, and stiffness, and resulted in faster post-race-recovery.

- Dr. Pipes found DMG improved performance in track and field athletes by increasing the oxygen they could utilize and their time until exhaustion.

- Dr. Meduski reported rabbits under hypoxic conditions showed decreased levels of lactic acid in their blood as compared to the control. (Rabbits not on DMG had lactic acid levels ten times greater than normal.)

- Dr. Meduski also found that rats fed DMG adapted better to low oxygen situations than control rats, because DMG rats took in 20 percent more oxygen than control rats.

- Drs. Grannon and Kendall found that DMG increased the performance of racing greyhounds. DMG allowed greyhounds to maintain their maximum speed for longer periods of time.

- Drs. Myre and Grey reported that DMG had the ability to cause a five-fold reduction in lactic acid levels for horses on DMG as compared to the control horses.

- Dr. Potter's group found horses supplemented with DMG had reduced blood lactic acid levels after strenuous exercise on a treadmill.

- Dr. Cator found horses also exhibited greater speed and stamina.

Nutrients that Benefit Athletic Performance

Nutrient	Benefits to athletes
DMG	DMG helps the body stay at its peak longer by helping the body to cope with stress, reducing lactic acid levels, improving circulation, improving oxygen utilization, and helping the body recover from cramps and fatigue.
	DMG's apparent energy enhancing effects could be attributed to its ability to make oxygen utilization and cellular respiration more efficient, its ability to reduce lactic acid buildup, and its ability to enhance lipid and carbohydrate metabolism.
Branched-Chain Amino Acids	Branched-chain amino acids (Valine, Leucine, and Isoleucine) can be used by the muscles as an energy source.
Coenzyme Q_{10}	CoQ_{10} increases tissue oxygenation, helps with circulation, enhances immune support, provides cardiovascular support, and helps improve energy production.
L-Carnitine	L-Carnitine helps transport long-chain fatty acids into the mitochondria of cells to be burned for energy. The fatty acids L-Carnitine transports are a major source of energy for muscles, especially the heart.
Octacosanol	Octacosanol is clinically proven to increase oxygen utilization during exercise and improve glycogen stores in muscle tissue.
Arginine	Arginine is important for muscle metabolism. It aids in the building of muscle mass and the reduction in body fat.
Ginseng	Ginseng helps combat fatigue and gives the body an energy boost. It spares glycogen stores in liver and muscle cells and increases the use of fatty acids as a source of energy.

DMG CAN PUT ZIP BACK IN YOUR LOVE LIFE

By the way, as a postscript to this chapter on athletic performance, we might as well tell you about our findings with DMG and sexual performance. Obviously, the propsect of better sex gets our attention, and now DMG is getting its fair share of attention from experts who say it can help with erectile function and overall sexual performance. Testimonials report increased endurance and stamina, spectacular climaxes, more frequent orgasms, and increased desire. DMG has been credited with increasing the quality of sexual experiences across America. Men are able to perform longer. Women are finding DMG makes it easier to achieve sexual excitation, with more intense pleasure, and a more fulfilling performance allowing them to reach orgasm sooner and have it last longer.

Impotence or chronic erectile dysfunction affects more than 30 million American men. In the past impotence was considered a psychological condition, but now experts believe that the majority of impotence cases are due to a physical cause like nerve or blood vessel disease or a hormone abnormality. Robert Krane, M.D., states that erections result from a combination of brain stimulus, blood vessel and nerve function, and hormone action.

DMG not only helps those with erectile dysfunction, by helping with circulation, oxygen utilization, hormone production, and mental concentration, but it also helps with energy production, endurance, and stamina. DMG is also beneficial for penis expansion according to Dr. Morton Walker who reports that DMG can make the penis thicker, longer, and stronger.

DMG is also credited with stimulating the sexual libido of women. Orgasms are reported to be prolonged and deeper due to DMG's ability to keep blood vessels dilated during orgasm.

According to Howard Lutz, M.D., of the Academy of Orthomolecular Psychiatry and medical director of the Institute of

Preventative Medicine, men have found that DMG allowed them to engage in frequent sessions of sexual intercourse without loss of performance. Dr. Lutz recommends DMG as a sexual enhancer. It is especially important for those with a loss of sexual urges or desire, erectile dysfunction, orgasmic dysfunction, and lack of ejaculation.

Brenda Forman, in her book on DMG, reported that when users were interviewed for using DMG for other purposes, 60 percent of them credit DMG with a measurable improvement in the quality of their sexual experience. They found that sexual excitation was easier to achieve, pleasure was more intense, men were able to perform longer, and women were able to reach orgasm sooner or experienced more than one orgasm during intercourse.

For most men just the work of getting an erection exhausts the oxygen in the blood supply to the penis. Exhausted erectile tissue and over-sensitizing of the penis's nerves causes rapid ejaculation. Under conditions of excitation, the average man or woman has blood that engorges the sexual organs that is subnormally oxygenated. In other words, the average person has blood that may be just sufficiently oxygenated to enable basic engorgement, copulation, and ejaculatory completion to take place, but when taking DMG male and female organs receive blood that contains more available oxygen than they are used to, causing greater and sustained erections in men and more orgasm-sensitive reactions in the vagina and clitoris in women.

Nutrients that Benefit Sexual Performance

Nutrient	Benefits to performance
DMG	DMG helps the body stay at its peak longer by helping the body to cope with stress, reducing lactic acid levels, improving circulation, improving oxygen utilization, and helping the body recover from cramps and fatigue.
	DMG's apparent energy enhancing effects could be attributed to its ability to make oxygen utilization and cellular respiration more efficient, its ability to reduce lactic acid buildup, and its ability to enhance lipid and carbohydrate metabolism.
Vitamin E	In *Nutridisiacs: Nutrients That Have You Feeling Sexual,* Dr. Morton Walker states that vitamin E prevents the loss of penile or clitoral erection prior to climax and can be used for chronic impotence. Vitamin E helps promote oxygen utilization by the body, and acts as an antioxidant.
Vitamin B Complex	In *Nutridisiacs: Nutrients That Have You Feeling Sexual,* Dr. Morton Walker states that vitamin B complex increases the length of time that a man's penis remains erect. Vitamin B_6 or pyridoxine is found in muscle cells and is important for maintaining muscle tone and contractibility and allows the penis to stay rigid.
L-Arginine	L-Arginine is a conditionally essential amino acid that has been found to be effective in raising growth hormone and male sexual performance. A recent study published in the *European Journal of Urology* demonstrated that when combined with yohimbine, arginine was effective in treating erectile dysfunction in 40 percent of patients receiving the combination. The amino acid appears to increase the production of nitric oxide which allows for penile erections.

9

DMG and Diabetes–
A Spoonful of Sugar

DMG BENEFITS THOSE WITH DIABETES

- DMG increases oxygen utilization.

- DMG enhances circulation.

- DMG improves detoxification.

- DMG can help maintain blood glucose levels within normal ranges.

I have received many testimonials about DMG's benefits with diabetes. Here are a few examples, several from doctors who are extremely pleased that their diabetic patients' health improved so dramatically.

Dear Dr. Kendall,
One of my patients has recently improved dramatically on dimethylglycine. This patient had a severe diabetic infection of the foot, which cleared up after taking DMG. This really was a dramatic improvement and I am interested in further research.
—Sincerely, Dr. E. Jennings, Georgia

Dear Dr. Kendall,
As a diabetic I started taking DMG two months ago; at that time my sugar count was 278 mg/dl. I recently visited my doctor for my monthly check up and my sugar count was normal at 120 mg/dl. According to my doctor my urine and blood pressure were also normal. My skin tone is better and I walk with greater ease. This is the best my health has been in ten years. I attribute my better feeling and health to DMG.
—Sincerely, RT in Michigan

Dear Dr. Kendall,
I would like to take a few moments to express my initial excitement about DMG. We have been doing research at the Bluefield Clinic and in a small group of patients we have seen significant findings in a rather short period of time. These patients are diabetic, overweight, and have circulatory problems. The most dramatic results to date were on a diabetic amputee, who was having circulatory problems in the remaining leg. Her cholesterol was above 300 mg/dl; her triglycerides were off the chart at over 500 mg/dl. Phos (liver fraction) was also elevated. After 20 days, her cholesterol was within normal limits. Both pre- and post-DMG laboratory work was done in a hospital and is on record. I am going to continue with this clinical research and am very excited about what I am seeing with DMG.
—Sincerely, Dr. C. Bartholomew, West Virginia

DMG IN THE TREATMENT OF DIABETES

Treatment of diabetes primarily focuses on reducing elevated blood glucose levels towards more normal ranges. Diabetes can be controlled with insulin, diet, exercise, weight loss, and nutritional supplementation. Supplementation with DMG can help maintain blood glucose levels within normal ranges. DMG stimulates glucose oxidation, helps to regulate blood glucose levels, and enhances oxygen utilization. It also improves circulation, which enhances the healing of gangrene, wounds, and ulcers. For diabetics, excess sugar becomes a toxin in the system clogging up the respiration of cells and preventing the kidney from doing its job. DMG increases blood and cell oxygenation to improve respiration and detoxification.

DIABETES MELLITUS

Diabetes mellitus is a group of diseases characterized by hyper-glycemia (high levels of glucose in the blood) resulting from defects in insulin production and/or insulin action. Diabetes is associated with many serious complications, but by controlling blood glucose levels, diabetics can lower their risk of complications. If not properly controlled, diabetes can lead to circulatory dysfunction, eye disease, heart disease, nephropathy (kidney disease), edema, neuropathy (nerve damage), infections, and skin issues.

According to the Centers for Disease Control and Prevention (CDC), 17 million people or 6.2 percent of the U.S. population has diabetes, and 5.9 million of those people are undiagnosed. According to the American Diabetics Association (ADA), diabetes is the sixth leading cause of death in the United States and is the primary cause of blindness for people ages twenty to seventy. Having diabetes raises the risk of blindness, stroke, high blood pressure, amputations, dental disease, and pregnancy complications.

There are two types of diabetes mellitus. In insulin-dependent diabetes mellitus, or type 1 diabetes, the pancreas does not produce enough insulin to actively transport glucose into the cells causing a buildup of glucose in the bloodstream. Risk factors for type 1 diabetes include genetics, compromised immunity, and environmental factors. A genetic predisposition can increase your risk of developing type 1 diabetes. Type 1 diabetes may be an autoimmune disorder, caused by the body destroying its own beta cells (that make insulin), or by producing antibodies against insulin. This type of diabetes can be treated with insulin injections to help promote glucose metabolism and uptake of glucose by cells. Some medical professionals consider type 1 diabetes to be an autoimmune disease. Environmental factors can range from intake of a poor diet to toxins in the air, food, and water.

Dear Dr. Kendall,
Being an insulin-dependent diabetic, I have had difficulty with circulation in my toes and feet for some time. In July of 1997, I started taking six of the 125 mg sublingual DMG tablets a day. Within two-weeks time my toes went from a light purple to a pale pink color. As of today, I only take three or four tablets per day and have full circulation in my toes and feet.
—*Sincerely, J. Brunelle in Vermont*

In type 2 diabetes the beta cells in the pancreas produce enough insulin, but the body is resistant to it, so glucose cannot be absorbed or metabolized properly causing both high levels of insulin and glucose in the blood. Over 90 percent of diabetics are type 2 or non-insulin-dependent diabetics (also called adult-onset diabetes). Major risk factors for developing type 2 diabetes are age, poor diet, obesity, a family history of diabetes, impaired glucose tolerance, and lack of exercise. Research studies in the United States have found that lifestyle changes (like diet and exercise) can prevent or delay the onset of type 2 diabetes in high-risk individuals.

Increased blood glucose occurs after a meal and stimulates the release of the hormone insulin. Insulin attaches to a receptor on the cell surface and sends a signal into the cell that causes glucose to be brought into that cell. Muscle and liver cells store glucose as glycogen, and when blood glucose levels drop, glycogen can be converted back to glucose to maintain blood glucose homeostasis.

DMG enhances carbohydrate metabolism by reducing elevated blood sugar levels in diabetic patients. Supplementation seems to reduce diabetic complications like: abnormal blood sugar levels, problems resulting from impaired circulation, and gangrene, wounds, and ulcers. DMG also improves oxygen utilization, promotes cellular respiration, and reduces lactic acid levels under conditions of physical and emotional stress, which is also beneficial to diabetic patients.

STUDIES ON DMG'S BENEFITS FOR DIABETES MELLITUS

Soviet literature reported that calcium pangamate (a source of DMG) helped patients with sugar metabolism. Russian scientist Dr. Shpirt also reported at a symposium in Moscow that calcium pangamate lowered blood sugar to normal levels in mild forms of diabetes, and testing showed that there was no glucose in their urine. This seems to support DMG's ability to stimulate glucose oxidation.

To evaluate DMG's possible metabolic effect on diabetes mellitus, an animal study was conducted by Dr. M. Autori on a diabetic strain of mice at the University of Bridgeport. Mice exhibiting characteristics similar to diabetes in man—including hyperglycemia (high blood sugar); obesity; glycosiuria (sugar in the urine); and morphological changes in the pancreas—were used for this study. The experimental group of mice were given a solution of DMG, whereas the control group received just water. Diet and other environmental factors were kept the same for both groups. After statistical analysis, results showed that the diabetic mice fed DMG had significantly lower blood glucose concentrations (15 to 20 percent) and lower weight gains (25 percent) as compared to the control group. These animal studies confirm DMG's role in improving glucose metabolism.

Studies on DMG and Diabetes

- DMG has been shown to lower blood sugar to normal levels in mild cases of diabetes and tests showed that patients did not have glucose spilling over into their urine. Effects were speculated to be due to DMG's ability to stimulate glucose oxidation.

- Diabetic mice given DMG had 15 to 20 percent lower blood glucose concentrations and 25 percent lower weight gains than diabetic mice not fed DMG. These animal studies confirm DMG's role in improving glucose metabolism.

- Diabetic rats fed DMG developed cataracts much slower than those not given DMG.

High insulin levels lead to faulty fat metabolism, and glucose will be stored as fat instead of being used for energy. When glucose metabolism is faulty, lactic acid levels also increase as the body tries to make energy without being able to properly utilize glucose. There are many side effects associated with increased lactic acid levels including circulation problems and eye disorders.

PREVENTION OF CATARACTS, ULCERS, AND GANGRENE

Diabetics are at high risk for forming cataracts. Cataract formation is a leading cause of blindness. DMG may slow cataract development because of its ability to increase oxygen uptake by hypoxic tissues. DMG increases oxygen uptake into the lens of the eye, promotes circulation, improves healing time, and enhances the eye's ability to clear away debris. Consider the following letter I received:

Dear Dr. Kendall,
I am an 87-year-old woman who on your recommendation tried the DMG drops for a detached retina. I was going to have a retina transplant in my right eye and a cataract operation in my left eye. After using the DMG drops in both eyes for two months I can now see outlines and shapes from my right eye and I don't need the cataract operation. My doctor has been very impressed.
—Sincerely, EE in Ohio

The risk of developing gangrene and ulcers is higher than normal for people with diabetes because of poor circulation. Ulcers are patches of skin that, due to poor circulation, deteriorate leaving open sores. Gangrene is when body tissues decay and die as a result of inadequate oxygen supply. DMG is effective in helping to prevent ulcers and gangrene in those with poor circulation, because it increases oxygen utilization to hypoxic tissues, helps increase circulation, enhances immunity, and provides antioxidant protection. DMG also has antiviral and antibacterial properties to help protect against viruses and bacteria that may cause ulcers.

HYPOGLYCEMIA

Dr. Carlos Mason in his book called *The Methyl Approach to Hypoglycemia* states that hypoglycemia is one of the most common diseases in America, affecting 25 to 50 million people. More and more Americans are becoming hypoglycemic. Contributing factors include a poor diet consisting of a high intake of carbohydrates, sugars, alcohol, caffeine, and soft drinks.

Hypoglycemia or low blood sugar is usually the result of over secretion of insulin by the beta cells in the pancreas. It occurs commonly in those with diabetes mellitus due to insulin overdose or insufficient carbohydrate intake. Hypoglycemia can be inherited, but it is primarily caused by diabetes, inadequate diet, liver failure, candidiasis, and severe stress.

Hypoglycemia or decreased blood sugar occurs when insulin removes too much glucose from the blood. When this occurs there isn't enough glucose to supply the energy needed to make the body function properly. Glucose is the body's fuel and a surplus of insulin causes glucose to be wasted resulting in fatigue. If you take simple sugars when you have low blood sugar, the body will release more insulin, causing a buildup of lactic acid. Lactic acid causes most of the symptoms associated with low blood sugar.

Drs. Stanley and Schlenk have reported that a shortage of methyl groups can also lead to impaired glucose metabolism. Lactic acid levels are also known to be higher in hypoglycemic patients due to poor cellular respiration and improper glucose metabolism. Stress and lactic acid negatively impact hypoglycemia, but supplemental methyl groups (CH_3) can help to support liver, adrenal, and pancreas functions.

DMG is beneficial for hypoglycemics because it reduces elevated lactic acid levels; enhances oxygen utilization; helps stimulate cellular respiration; and supplies a rich source of methyl groups for transmethylation reactions in the body.

SYNDROME X

More than 60 million Americans have syndrome X. Health care professionals recognize this epidemic and call it by several names: insulin resistance, metabolic syndrome, glucose intolerance, pre-diabetes, or syndrome X. Syndrome X refers to a group of health problems that include insulin resistance (an inability to metabolize dietary carbohydrates and sugars), high levels of blood fats (cholesterol and triglyceride levels), high blood pressure, and obesity. This cluster of conditions may indicate a predisposition to diabetes, hypertension, and heart disease. The primary problem of those with syndrome X is insulin resistance. Experts estimate that 10 to 25 percent of the population may have some degree of insulin resistance. Insulin resistance is the chief characteristic of adult-onset diabetes.

Syndrome X is primarily caused by diets high in refined carbohydrates. Normally after a meal your body breaks down carbohydrates into glucose. Then glucose causes the release of insulin, which helps transport glucose from the blood and into the cells where it can be burned for energy or stored as glycogen. When a person eats lots of refined carbohydrates over a long period of time insulin levels remain chronically high and cells become less responsive and then resistant to it. Consequently, relatively little glucose gets burned and levels remain high and then high glucose levels and insulin resistance evolves into diabetes. Many researchers have implicated glucose as a major source of dangerous free radicals. Supplementing with DMG can help lower glucose levels, make insulin more efficient, decrease lactic acid levels, help prevent diabetic complications, and act as an antioxidant to protect the body. People with syndrome X may be able to prevent the many complications associated with this condition through dietary modification, exercise, and supplements like DMG.

Nutrients that Benefit Diabetics

Nutrient	Benefit to those with diabetes
DMG	DMG is an anti-stress nutrient that enhances oxygen utilization, improves glucose metabolism and has been shown to reduce cataract formation.
Vanadyl Sulfate	Vanadyl sulfate has been shown to have significant insulin-like effects on glucose transport and metabolism. In non-insulin dependent diabetics, vanadyl sulfate inhibits insulin secretion, stimulates glycogen synthesis, and reduces gluconeogenesis.
Gymnema Sylvestre Extract	Gymnema has regulating effects on blood glucose levels. Studies in humans with both type 1 and type 2 diabetes showed it to normalize blood glucose levels and increase the normal production of insulin. In studies using 400 mg/day, patients with type 2 diabetes had improved blood glucose control and were able to reduce their oral medication. Type 1 diabetics showed improved fasting blood glucose levels and a reduction in the amount of insulin required. The herb was also found to reduce high cholesterol and triglyceride levels in diabetics.
Quercetin	In diabetic patients quercetin can significantly reduce sorbitol accumulation in the lens, which prevents cataracts and serious eye problems. It inhibits aldose reductase, the enzyme that converts glucose to sorbitol. Once sorbitol is formed, it can accumulate in various parts of the body and cause damage (like in the lens of the eye, kidneys, and peripheral nerves). Studies have confirmed that aldose reductase inhibitors are essential in the treatment of sorbitol-induced neuropathies, kidney disorders, and eye disorders.

continued on next page

Nutrient	Benefit to those with diabetes
Alpha-Lipoic Acid	Alpha-lipoic acid is a potent antioxidant that protects the body from free radical damage, and protects against the serious side effects of diabetes such as nerve damage, blindness, heart disease, and accelerated aging. It's important in controlling blood sugar levels. Alpha-lipoic acid reduces glycation by promoting glucose transport into the cells when insulin activity is low. Alpha-lipoic acid extends the life of vitamins C and E and glutathione, which studies have shown can protect against cataracts in diabetic patients.
Chromium	Chromium is important for proper glucose control because it increases insulin sensitivity, which reduces the amount of insulin needed. Chromium has been shown to help restore normal insulin function in type 2 diabetics.
Bilberry Extract	Bilberry protects the retina from oxidative damage caused by diabetic complications. It contains anthocyanoside flavanoids, which protect ocular tissue from free radical damage and excess glucose. The flavanoids in bilberry strengthen capillary basement membranes and help to stabilize collagen.
Bitter Melon	Bitter melon supports glucose metabolism. The active ingredient charantin acts like insulin in both structure and function. It enhances glucose transport and utilization by the cells, as well as suppressing glucose release by the liver.
Lagestroemia Speciosa L. Extract	Lagestroemia contains corosolic acid, which has a strong insulin-like effect. Oral doses in rabbits lowered blood sugar, and showed effects similar to insulin injections. Many animal studies support its ability to enhance glucose transport to the cells.

DMG for Respiratory Disorders

DMG BENEFITS TO THOSE WITH RESPIRATORY DISORDERS

- DMG increases oxygen utilization.

- DMG enhances circulation.

- DMG modulates the immune system.

- DMG improves detoxification.

- DMG helps the body cope with external stressors.

- DMG helps promote SAMe and glutathione levels.

- DMG has antiviral and antibacterial properties and has been found effective in preventing respiratory infections.

About 10 percent of our lungs are solid tissue while the rest is filled with air and blood. They are an interface of two systems, respiratory and circulatory, that work together to exchange carbon dioxide for oxygen. The lungs are highly unique organs that bring oxygen into our bloodstream so that it can be delivered to cells throughout our body. We breathe about 25,000 times a day, which means we inhale more than 10,000 liters of air. We inhale mainly oxygen and

nitrogen, but the air also contains other gases, bacteria, and viruses, as well as toxins like smoke, car exhaust, and other atmospheric pollutants, which can lead to serious respiratory problems.

Respiratory problems can be caused by inhaling toxins in the workplace or at home, from exposure to chemicals or because of harmful lifestyle choices like smoking. Infections, genetics, stress, and weakened immunity can directly or indirectly contribute to respiratory problems.

Lung diseases can be classified either as individual and specific diseases or as a group of diseases that share common features. Some examples are diseases of the airways, of pulmonary circulation, or gas exchange. Many of these diseases occur together, particularly if they are caused by infection, inflammation or cancer. Asthma, chronic bronchitis, emphysema, and cystic fibrosis are common airway diseases. Chronic bronchitis and emphysema when grouped together are called chronic obstructive pulmonary disease (COPD).

CHRONIC OBSTRUCTIVE PULMONARY DISEASE

Chronic obstructive pulmonary disease or COPD is a term used to encompass a group of slowly progressive diseases characterized by gradual loss of lung function that includes chronic bronchitis, emphysema, and asthmatic bronchitis. The two most common conditions that cause permanent airflow problems are chronic bronchitis and emphysema. Although a person may have either chronic bronchitis or emphysema, most people have a combination of both conditions. COPD, if left unchecked, can worsen and may lead to severe difficulty breathing, heart problems, and eventual death. In 2000, COPD was the fourth leading cause of death in the United States with 122,009 deaths. It is also one of the most rapidly increasing causes of death. Ninety percent of COPD is the result of smoking. DMG may help those trying to quit smoking by helping

curb addiction, detoxifying toxic substances, and by acting as an antioxidant to help repair damage to lung tissue. DMG helps those with COPD and other respiratory dysfunctions by allowing the body to put more oxygen into the bloodstream.

According to the CDC's National Center for Health Statistics, COPD affects more than 30 million people, but only 16 million have been diagnosed. Of those 16 million, roughly 14 million have chronic bronchitis and approximately 2 million have emphysema.

EMPHYSEMA

Emphysema is estimated to affect approximately 2 to 3 million Americans. In the year 2000 over 16,700 deaths were due to emphysema alone. Emphysema is a degenerative lung disease that develops after years of exposure to toxins that pollute the air. The disease stems from damage to the lungs, which causes a constant state of breathlessness, chronic cough, and discharge, and leaves the individual susceptible to lung infections. In emphysema the elastin in the lungs is destroyed, collapsing the airways and leading to an inability to exhale causing stale air to stay in the lungs. DMG benefits those with emphysema because it increases endurance, oxygen utilization, and immunity. It helps the body cope with the stress of hypoxia, and enhances detoxification.

CHRONIC BRONCHITIS

Chronic bronchitis is less well known than emphysema, but it is ranked as the seventh leading chronic condition in the United States. The primary cause for both chronic bronchitis and emphysema is smoking cigarettes, which causes more than 82 percent of COPD-related deaths. A smoker is ten times more likely than a non-smoker to die of COPD—although other indoor and outdoor air

pollutants may damage the lungs (especially those of smokers) and contribute to COPD. Genetic factors may also play a role in susceptibility to chronic bronchitis.

Chronic bronchitis symptoms include chronic and excessive secretion of mucus in the airways, inflammation, airway spasms, and infection. Chronic bronchitis is an inflammation of the airways in the lungs. When the airways are irritated and inflamed, thick mucus is formed, which makes it more difficult to get air into the lungs. Chronic bronchitis can be caused by and aggravated by prolonged stress, bacteria or virus exposure, antibiotics, weakened immune system, and exposure to toxins. Other common causes for chronic bronchitis are smoking, air-born toxins, lack of exercise and poor circulation. DMG benefits individuals with chronic bronchitis in the same way it benefits those with emphysema.

ASTHMA

Asthma is a chronic lung condition that causes the lungs to become inflamed making it difficult to breathe. Asthma is one of the most common chronic conditions in the United States, especially in children. According to the National Health Interview survey in 2001, 31.3 million people had been diagnosed with asthma at some point in their life. An inherited predisposition to asthma can make one more sensitive to allergens or irritants in the environment. Airways are overly sensitive to a wide variety of environmental triggers causing the inflammation that makes it so hard to breathe. Asthma symptoms include inflammation, contraction of airways, and increased mucus secretion.

Asthma is a pulmonary (lung) disease caused by obstruction of airways. More than 5,000 Americans die from asthma a year; approximately 11 million Americans have an asthma attack each year. An asthma attack occurs when the muscles surrounding the

airways in the lungs constrict, blocking airflow. A chronic inflammation and hypersensitivity of the airways to stimuli is what causes this disorder. Any allergen can provoke asthma attacks—allergens like pet dander, feathers, foods, fumes, mold, and smoke. Non-allergenic causes of asthma attacks include anxiety, stress, temperature changes, exercise, humidity, fear, laughing, blood sugar, and infection.

The incidence of asthma has increased more than 75 percent since 1950, and 160 percent in children. This may be due to genetics, pollution, global warming, food additives, toxins, and allergens.

These are letters I have received on DMG's benefits to allergies and asthma.

Dear Dr. Kendall,
I have found that DMG is effective in regards to allergies, increasing aerobic capacity for exercise, recovery from physical and strenuous activity and overall general endurance. It also strengthens the immune system and I just think it's a great product. For patients with allergies, and asthma, it is very beneficial to them too. I think it is a product everyone should know about.
—*B. Lahey, N.D., in New York*

Dear Dr. Kendall,
My son Greg has been plagued with all types of allergies since birth. His eczema has been so severe that he has been hospitalized several times. Since the age of 18 months he has been plagued with asthma. Some attacks required hospitalization as he found breathing difficult. Medication prescribed by doctors did not help. For the last four years his asthma has been of the coughing type. During the day he would have three attacks and during the night at least two. He would go into spasms of coughing where he would be gasping for breath. Then, he would end up wheezing for a periods of a half hour. This would drain him of energy. During the latter part of August I obtained some DMG. For two weeks he took three a day, then he took a maintenance dose. In November, it suddenly dawned on us that Greg was free of asthma. We were all sure it was the DMG! In December our *continued on next page*

family went on a hayride. Shortly after we got going we realized that Greg's body was reacting to the hay. His eyes began to get bloodshot and his face began to swell. Then, the coughing spasms started and he had severe wheezing that continued through the night. This seemed to aggravate his breathing passage as he began to cough daily again but without the harsh spasms, and only two a day and no coughing at night. He continued on the maintenance dose of DMG. I think these pills have helped his eczema also.
—*BR in California*

Dear Dr. Kendall,
I was diagnosed with mercury toxicity. My dental fillings were poisoning my body and causing me to have multiple allergies. I would never know when something I was eating or exposed to was going to bring on an allergic reaction. Some of the allergic reactions were so bad I would go into anaphylactic shock. I discovered that if I placed three tablets of DMG under my tongue the allergic reaction would stop within 5 to 10 minutes and sometimes sooner. I always carry DMG in my purse with me when I travel.
—*VB in Indiana*

ALLERGIES

Allergies affect more than 50 million Americans a year. Allergies are the sixth leading cause of chronic disease in the United States according to the American Academy of Allergy, Asthma, and Immunology in 2001. Allergies are considered an autoimmune disease because they are caused by an inappropriate response by one's immune system to a non-harmful substance. The immune system mistakenly identifies a nontoxic substance as harmful and initiates an immune response that causes damage to the body. Molds, foods, pet dander, dust, immune dysfunction, and emotional stresses all aggravate allergies.

COLD AND INFLUENZA

A cold is a viral infection of the upper respiratory tract. There are over 200 viruses that can cause the common cold. Influenza or the flu is also a viral infection, but it is caused by different types of viruses and it can become life threatening to those who are immune compromised. It is estimated that even a healthy adult has an average of two colds a year. DMG has antiviral properties and is especially effective against respiratory viruses; it modulates the immune response, helps the body cope with stress, and improves oxygen utilization in the body.

PNEUMONIA

In the United States approximately 5 million cases of pneumonia are reported every year and about 63,548 people will die from it. Pneumonia is a lung infection that has more than 30 different known causes, including viruses, bacteria, fungi, protozoa, and mycoplasms, as well as allergic reactions and environmental toxins. Air sacs within the lungs become infected, inflamed, and filled with pus and mucus, which keeps oxygen from entering the bloodstream. Pneumonia usually starts as either an upper respiratory infection, cold, influenza, or a measles outbreak. It is more common in those who are immune compromised. No matter which of the organisms cause the pneumonia, it is a serious condition resulting in weakness that usually extends at least four to eight weeks after the infection has resolved.

DMG is helpful in modulating the immune response and allowing those who are immune compromised to have a better chance of preventing infection by viruses, bacteria, and other pathogens that could cause pneumonia. In fact, a double-blind study by Dr. Graber at the University of South Carolina showed that those individuals

receiving DMG along with a pneumonia vaccine had a greater protective immunity versus the control group who did not receive DMG. This means DMG supplementation would be both protective and therapeutic in regards to pneumonia. It can also help detoxify toxins that might cause pneumonia or other respiratory disorders.

DMG IN THE TREATMENT OF RESPIRATORY DISORDERS

In oxygen deficient states like respiratory disorders, emphysema, and asthma DMG helps the body adapt to the stress of hypoxic states, helps promote SAMe levels, protects the body against secondary infections by boosting the immune system, and has anti-inflammatory properties. DMG can benefit those with respiratory problems due to its ability to increase the capacity of the lungs to exchange carbon dioxide for oxygen, and by increasing oxygen utilization.

Nutrients that Benefit those with Respiratory Disorders

Nutrient	Benefit to respiratory disorders
DMG	DMG increases oxygen utilization, increases circulation, increases immunity, helps cope with external stressors, and helps promote SAMe and glutathione levels. It has antiviral properties and has been found effective in preventing respiratory infections.
Coenzyme Q_{10}	CoQ_{10} is an antioxidant that enhances oxygen utilization and improves detoxification.
Proanthocyanidins	Proanthocyanidins extracted from pine bark or grape seed are potent antioxidants with antihistamine effects that help with breathing and healing.
Essential Fatty Acids	Supplementation with essential fatty acids helps in production of anti-inflammatory cytokines and aids in healing.

continued on next page

Nutrient	Benefit to respiratory disorders
Zinc	Zinc is an antioxidant that protects the lungs and helps maintain proper vitamin E levels.
Vitamin E	Vitamin E is a fat-soluble antioxidant that prevents cellular damage by inhibiting fat oxidation. It also helps with healing and boosting immunity.
Vitamin C	Vitamin C is an antioxidant and free radical scavenger, enhances the immune system, and increases energy. It helps reduce inflammation, promotes healing, and fights off cold viruses.
Vitamin A	Vitamin A is an antioxidant that helps with healing and immunity, and fights inflammation in mucus membranes.

** Maitake mushroom, olive leaf extract, and garlic have antiviral properties and help enhance immunity.

DMG for a New Life– Chronic Fatigue and Fibromyalgia Syndromes

DMG BENEFITS TO THOSE WITH CHRONIC FATIGUE SYNDROME

- DMG modulates the immune response.

- DMG enhances energy production.

- DMG improves metal alertness.

- DMG improves mood.

- DMG decreases muscle aches and pains.

- DMG improves oxygen utilization.

- DMG enhances circulation.

- DMG reduces lactic acid levels.

- DMG enhances antioxidant protection.

- DMG enhances physical and mental ability.

- DMG reduces the effects of fatigue.

- DMG enhances liver function.

- DMG improves glucose and lipid metabolism.

CHRONIC FATIGUE SYNDROME

Dear Dr. Kendall,
I have been taking DMG for about four weeks now, and it seems to help. I was starting to fear the symptoms of fatigue, anxiety and restlessness because of the circumstances of my life, which have been becoming a little hard to deal with, and the fear of deployment during our crisis of possible war. Also being a student full time along with other factors made me try this product, and lately I've been sleeping better and been able to cope and carry on with normal everyday routines. It has helped my well-being, thank you.
—Sincerely, CD in Nevada

Some medical professionals believe that chronic fatigue syndrome (CFS) is one of our most profound and under-recognized conditions, a hidden epidemic affecting more than 4 million people in the United States alone. Most experts believe that CFS is an autoimmune disorder in which the body is so geared up to defend against invaders that it begins to attack its own tissues. The cause for CFS is unknown, but possibilities may include viruses, anemia, arthritis, sleep problems, improper blood pressure regulation, fibromyalgia, chronic mercury poisoning from dental fillings, hypoglycemia, hypothyroidism, *Candida albicans*, low-grade infection, glucose intolerance, and poor liver function.

Chronic fatigue syndrome includes a complex array of symptoms like achy muscles and joint pain, anxiety, depression, poor memory, fever, headache, low blood pressure, poor energy levels, allergies, intestinal problems, pain, irritability, environmental sensitivities, jaundice, loss of appetite, mood swings, upper respiratory tract infections, candidiasis, sensitivity to light, sleep disorders, sore throat, swollen glands, immune abnormalities, and extreme fatigue. It is generally hard to diagnosis because the symptoms are diverse and can be mistaken for other disorders. Many people with CFS may also have fibromyalgia, a muscle disorder that causes pain, weakness, and fatigue. Indeed, the symptoms of CFS closely mirror those of

fibromyalgia; in fact, 70 percent of those diagnosed with fibromyalgia have symptoms that match a diagnosis for CFS. The main difference is that in fibromyalgia there is a requirement for muscle pain while for CFS the main criteria is debilitating fatigue lasting at least six months.

While chronic fatigue syndrome is not life threatening it can cause damage to the immune system. The use of DMG can offer several direct benefits for those with CFS. Those with CFS generally have a compromised immune system and DMG increases resistance to and recovery from infectious diseases caused by viruses and bacteria. DMG can also produce greater mental alertness, improved physical energy, and reduction in joint and muscle pain, which are common symptoms for those suffering from CFS.

FIBROMYALGIA

DMG BENEFITS TO THOSE WITH FIBROMYALGIA

- DMG enhances energy production within muscle cells.

- DMG reduces the effects of fatigue.

- DMG helps to maintain optimum muscle function.

- DMG helps detoxify.

- DMG enhances oxygen utilization by muscles.

- DMG acts as an antioxidant to destroy free radicals that damage muscle cells.

- DMG decreases muscle pain by reducing lactic acid levels.

- DMG improves mood, enhances mental function, and helps the body cope with stress.

- DMG balances immune system function when compromised in cases of fibromyalgia.

Dear Dr. Kendall,
I am a 74 year old who lives in Toms River, New Jersey. I recently came down with fibromyalgia, a very painful and complicated muscle illness... After suffering with it about four months, my son found DMG. After taking it three times a day for a month, I found my muscles were so much better and I could do things like gardening and housework that I couldn't do before.
—Sincerely, HM in New Jersey

Dear Dr. Kendall,
I started taking DMG and, within three to four days, I was sleeping much better. Upon waking, I began noticing increased mobility, reduced muscle fatigue, and a sense of better well-being.
—Sincerely, JL in Vermont

Fibromyalgia is considered by some health experts to be a form of nonarticular rheumatism that is characterized by chronic, achy muscular pain, stiffness, sleeping and digestive problems, and fatigue. The cause is not known, but some evidence points to problems with the immune system or digestive tract.

Normal physiological processes generate free radicals that damage muscles, and in fibromyalgia syndrome, the muscles can't break down the levels of lactic acid, and, meanwhile, a self-augmenting, stress-generating process raises lactic acid levels that cause muscle pains.

DMG has been shown to have balancing and regulatory effects on the brain and neurons in the central nervous system. It is also a precursor to many amino acids and neurotransmitters that help with nerve function. DMG acts as a building block for many important substances like phosphocreatine. Phosphocreatine is a high-energy phosphate in muscles that maintains ATP levels needed for muscle contraction. DMG improves energy production to combat fatigue, helps reduce muscle pain caused by lactic acid, and helps with neurotransmitters for nerve impulses; it also helps improve mindset,

and helps those with fibromyalgia to better deal with stress and depression. DMG's ability to enhance and modulate immunity may have a key role in helping individuals with fibromyalgia.

Nutrients that Benefit those with Chronic Fatigue and Fibromyalgia Syndromes

Nutrient	Benefit for chronic fatigue and fibromyalgia syndromes
DMG	DMG helps to maintain optimum muscle function, increase energy in muscles, detoxify toxic substances, increase neurotransmitter production, battle against fatigue, and enhance mental function. DMG enhances oxygen utilization by muscles, destroys free radicals that damage muscle cells, and decreases muscle pain by reducing lactic acid levels that are increased by stress. DMG supports and enhances mood, helps the body cope with stress, and balances immune system function. DMG acts as a building block for many important substances.
Malic Acid	Malic acid seems to help pain and mindset. Malic acid is involved in energy production in muscle cells, increasing ATP production because it's involved in the Krebs cycle. It is also needed for glucose metabolism, which is important for nourishing muscles and nerves.
Gamma-Aminobutyric Acid (GABA)	GABA is needed for proper brain function. GABA is the brain's natural relaxant; it quiets nerves, and supports proper sleep patterns. It reduces muscle tension, depression, and anxiety. It is an amino acid that acts as an inhibitory neurotransmitter keeping nerve cells from becoming overactive.
Magnesium	Magnesium is a mineral that is essential for proper muscle, brain, and nervous system functions. It helps to relieve muscle spasms and aches, and helps utilize malic acid. A deficiency of magnesium can result in neuromuscular irritability as well as low and agitated moods.

continued on next page

Nutrient	Benefit for chronic fatigue and fibromyalgia syndromes
Nicotinamide Adenine Dinucleotide (NADH)	NADH is an antioxidant that helps reduce levels of toxic substances that damage sensitive parts of the brain. NADH increases L-Dopa synthesis and improves mental function. NADH is an integral part of the body's main energy-generating pathway, the Krebs Cycle.
Coenzyme Q_{10}	CoQ_{10} increases immunity, protects the heart, and helps remove toxins from the body.

12

DMG for Arthritis, Lupus, and Other Autoimmune Conditions

DMG BENEFITS TO THOSE WITH ARTHRITIS

- DMG enhances circulation.
- DMG is an arthritis preventative.
- DMG helps reduce pain and joint tenderness.

- DMG does not give an elevated response of self-antigens.
- DMG has anti-inflammatory properties.

DMG AND AUTOIMMUNE DISEASES

Research studies and clinical practice have found DMG to be an immune system modulator. DMG allows the body to enhance the immune response in those who are immune compromised, but down regulates the immune response towards self-antigens in those with an autoimmune disease. Current research has been focused on the use of DMG in autoimmune diseases like rheumatoid arthritis and lupus.

As an immune modulator, DMG balances the activity of the immune system, instead of just switching it into high gear. DMG does not give an elevated response of self-antigens; it seems to respond to foreign antigens by increasing the level of antibodies in the body. So in both autoimmune and allergy situations, DMG actually acts as an immune circuit breaker, keeping the immune system from going overboard.

When all of the components of the immune system function properly and remain in balance, it works effectively to fight off infection and other immune challenges. An autoimmune disease can cause either a weakened or overactive immune system, which leaves the body compromised and open to further infection.

Many different disorders including asthma, allergies, lupus, rheumatoid arthritis, diabetes, and pernicious anemia are caused by an inappropriate immune response, which involves immune cells attacking the body's own tissues. Recent research with DMG on autoimmune diseases shows promise. Individuals with lupus and asthma have responded well with DMG therapy. In a lupus mouse model, DMG was shown to reduce antibodies being produced against their own DNA. Evidence also seems to indicate that DMG does NOT cause proliferation of autoimmune antibodies. This is especially important for people who may have autoimmune conditions like rheumatoid arthritis.

ARTHRITIS

Arthritis is an inflammation of the joints. Arthritis can be caused by viral, bacterial, or fungal infection of a joint. It is characterized by pain, stiffness, swelling, inflammation, and diminished range of motion. More than 55 million Americans suffer from osteoarthritis, rheumatoid arthritis or related inflammation conditions, including fibromyalgia, gout, lupus, Lyme disease, bursitis, and many others.

Arthritis and other musculoskeletal diseases are the primary source of disability in the United States.

Osetoarthritis is a degenerative joint disease that is caused by the deterioration of the cartilage protecting the ends of the bones due to "wear and tear." Osteoarthritis makes bones brittle and prone to fractures. Injury, diet, nutrition, exercise, inherited defects, and aging are all risk factors for osteoarthritis. Osteoarthritis affects individual joints where as rheumatoid arthritis affects multiple joints in the body. DMG acts as an antioxidant to protect the joints, it helps with circulation to bring blood supply to brittle bones, and helps control inflammation of affected joints.

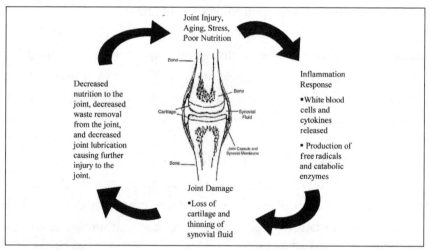

Rheumatoid arthritis is an inflammatory autoimmune disease. The body identifies the synovial membrane that encases the body's joints as foreign, stimulates an immune response, and mounts an attack against it. This immune response results in inflammation and an increase in production of protolytic enzymes, which cause destruction of the cartilage and bone surfaces, thereby breaking down the joint and causing severe pain. Approximately 2.1 million Americans have rheumatoid arthritis and 75 percent are women.

In a rheumatoid arthritis rat model, DMG was shown to have anti-

inflammatory effect properties and actually prevent development of rheumatoid arthritis in rats. The study done by Dr. John Lawson at Clemson University found that DMG prevented and reduced an inflammatory response in a rheumatoid arthritis rat model. DMG was 70 percent effective in preventing arthritis, and DMG slowed the onset of arthritis in those rats that did develop arthritis. Perhaps through immune system modulation, DMG can help in the treatment of degenerative joint disease and rheumatoid arthritis by reducing one of its most debilitating symptoms: inflammation. DMG animals actually had a higher titer of immunoglobulins (specifically, IgM and IgG), which indicates that DMG is an arthritis preventative, and could be used as a possible treatment of arthritis. DMG has been used successfully to aid in the reduction of pain, inflammation and joint tenderness in individuals with rheumatoid arthritis. DMG and *Perna canaliculus* work synergistically to reduce inflammation in those with arthritis. A recommended program for both rheumatoid and osteoarthritis would be 3,000 mg of *Perna canaliculus* and from 750 to 1,000 mg of DMG daily, taken in divided doses.

DMG supplementation can help relieve pain and inflammation, stop further deterioration of the joints, and help healing.

Research on DMG and Rheumatoid Arthritis

- DMG was 70 percent effective in preventing arthritis in experimental studies and effective at slowing onset. Results indicate that DMG is an arthritis preventative, and could be used as a possible treatment of arthritis.

- DMG was shown to have anti-inflammatory properties including reduction of pain, inflammation and joint tenderness in rats with rheumatoid arthritis. It may work to control inflammation through immune system modulation.

- DMG and *Perna canaliculus* (also known as green-lipped mussel) are shown to work synergistically to reduce inflammation in those with arthritis or SLE (lupus).

Nutrients that Benefit those with Arthritis

Nutrient	Benefit to those with arthritis
DMG	DMG increases circulation and modulates the immune response. DMG has anti-inflammatory properties, can help reduce pain and joint tenderness, increases oxygen utilization, and improves healing. Research has shown DMG can help prevent arthritis. DMG and Perna is a powerful therapeutic combination that is now under study for lupus and rheumatoid arthritis.
Perna Canaliculus	Perna is very beneficial for helping to restore joint function without the side effects of other treatments. Perna is a whole food and provides proteins, amino acids, chondrotin sulfates, glycosaminogylcans, and glucosamine as well as naturally chelated vitamins and minerals in an easily absorbable form.
Glucosamines	Glucosamines can help provide nutrients to the bones and cartilage making regeneration and healing more efficient. Glucosamines help build glycosaminoglycans and glycoproteins in cartilage. Glycosaminoglycans are needed to produce proteoglycans that stimulate the repair of cartilage damaged by arthritis and encourage other anabolic processes (rebuilding of the joint). Glucosamine helps thicken the synovial fluid and is needed for joint, bone, and cartilage formation and repair.
Essential Fatty Acids	Essential fatty acid supplementation is helpful for production of anti-inflammatory prostaglandins to control inflammation reactions. Omega-3 fatty acids help reduce interleukin-1 production in synovial fluid and decrease the activity of catabolic enzymes that breakdown the joint.

continued on next page

Nutrient	Benefit to those with arthritis
Chondrotin Sulfates	Chondrotin sulfates act as a cellular and metabolic regulator that prevent most of the symptoms associated with arthritis. Chondrotin sulfates help strengthen joints, ligaments, and tendons. Chondrotins have anti-inflammatory properties, enhance the synthesis of hyaluronic acid and cartilage proteoglycans for healing, inhibit proteolytic enzymes that tear down the joint structures, and decrease the level of damaging oxygen free radicals.
MSM	MSM is a source of organic sulfur that is needed by the body. Studies show that MSM improves joint elasticity of connective tissue, reduces stiffness and swelling, improves circulation, reduces pain and inflammation, and is used in joint and tissue repair.
Proanthocyanidins	Proanthocyanidins extracted from grape seed or pine bark improve joint flexibility and connective tissue repair by decreasing inflammatory prostaglandins, inhibiting histamine release, and decreasing possible tissue damage.
Manganese	Manganese is essential in the synthesis of glycosaminoglycans.
Vitamin E	Vitamin E helps modulate inflammation in those with arthritis, improves circulation, and acts as an antioxidant.

DMG AND SYSTEMIC LUPUS ERYTHEMATOSUS (SLE)

DMG BENEFITS FOR LUPUS

- DMG is effective in the prevention and treatment of SLE.
- DMG does not give an elevated response of self-antigens.
- DMG has anti-inflammatory properties.
- DMG enhances circulation.
- DMG helps reduce pain and tenderness.
- DMG protects the kidneys.
- DMG reduces anti-nuclear antibodies to DNA.

Anne MacKenzie of Covington, Louisiana, was diagnosed in early 1999 by her rheumatologist as having lupus. She suffered from extreme fatigue, high levels of antinuclear antibodies, and extreme joint pain in her legs. The doctor prescribed prednisone, 20 mg daily, and rest.

Beginning in June, she began to take DMG (750 mg) and Perna canaliculus (4,000 mg) daily in divided dosages. After several weeks on the new program, she began to experience some relief from the severe pain in her legs and greater exercise tolerance. After three months, Anne's doctor reduced her cortisone levels and her lab results improved significantly. The high antibody titers to antinuclear antibodies had returned to normal. After six months, she had more energy, less joint pain, and her prednisone dosage has been reduced to only 5 mg daily. Anne and her doctor were delighted with her progress and attribute her improved condition to the DMG and Perna canaliculus program she took faithfully during that six-month period.

SYSTEMIC LUPUS ERYTHEMATOSUS

Systemic lupus erythematosus (SLE or lupus) is an autoimmune disease in which the body's own immune system begins to attack itself. It may involve genetic and environmental factors. SLE patients have high levels of autoantibodies to their own DNA. This means that their immune system seeks out and destroys its own DNA. DNA is found in the nucleus of cells and contains instruc-

tions for every function inside the cell as well as the recipe for all of the enzymes, proteins, building blocks, and structures used in the cell. The DNA is also a blueprint of the cell containing all the genetic information the cell needs in order to replicate itself. So when the body recognizes its own DNA as an antigen the body starts fighting against itself.

Systemic lupus erythematosus is a chronic inflammatory disease that affects multiple systems within the body. One of the initial manifestations of lupus is often arthritis. Some other typical symptoms include fatigue, fever, anemia, photosensitivity, skin rash, severe inflammation, joint pain, and progressive kidney failure. Treatment focuses primarily on dealing with the symptoms; there are no effective treatments for lupus.

DMG allows the body to enhance the immune response in those who are immune compromised, but down regulates the immune response towards self-antigens in those with an autoimmune disease. Research shows that DMG is effective in the prevention and treatment of SLE. DMG reduces autoantibodies and inflammation, and regulates the immune system of those with SLE.

RESEARCH ON DMG AND LUPUS

New studies show that DMG is effective in the prevention and treatment of lupus. A study using the combination of DMG and *Perna canaliculus* was done in a lupus mouse model. For twelve weeks, the progression of lupus in the mice was documented and basic tests were done.

Perna used alone showed no significant differences in lupus progression when compared to the control group. Amazing synergistic results were found when DMG and Perna were used together. The study showed that the SLE animals had an unbalanced immune system in comparison with normal mice. Results showed that both

the DMG alone and Perna-DMG combination treatment groups modulated the immune system and restored immune cell ratios.

Inflammatory cytokines are involved in the lupus syndrome. The use of the Perna-DMG combination significantly decreased levels of the inflammatory cytokine, interleukin-6. Studies have suggested that interleukin-10 (IL-10) also might play a role in inducing autoantiobides to be expressed in human lupus. The Perna-DMG combination lowered IL-10 levels, suggesting that DMG and Perna work together to produce a regulatory and anti-inflammatory effect.

Analysis of nuclear (DNA) autoantibodies showed that the group taking the combination Perna-DMG had DNA antibody levels that initially rose (along with the controls). However, by the ninth week they were significantly lower than those of the untreated controls. This low level of expressed autoantibodies continued and became even more pronounced up until the end of the study. The decrease in nuclear autoantibodies could well be associated with the lower levels of expressed IL-10 in lupus patients taking the Perna-DMG combination. At the end of the study, the Perna-DMG group had a reduction in autoantibodies and inflammation, and better immune system regulation.

This synergistic combination of Perna and DMG may be a possible treatment for lupus. Further studies are now underway to see if this combination will be as effective in treating human lupus patients. So far, the results have been very promising. In fact, I have received both a U.S. and a European patent based upon this remarkable discovery.

A Study on How DMG and Perna Benefit Lupus

- In an SLE mouse model, mice treated with the combination of DMG and Perna canaliculus (green-lipped mussel), showed improvement in SLE symptoms over controls. Results indicate that symptoms may have been alleviated by restoration of the immune system.

- Studies suggest that inflammatory cytokines are involved in the SLE syndrome and that the use of the Perna-DMG combination significantly decreased inflammatory cytokines.

- Studies have suggested that interleukin-10 (IL-10) may play a role in inducing autoantiobides to be expressed in human SLE cases. The Perna-DMG combination lowered IL-10 levels. Analysis of nuclear (DNA) autoantibodies showed that the group taking the combination of DMG and Perna had a lower level of expressed autoantibodies.

- When Perna and DMG are used together there is a reduction in autoantibodies and inflammation, and better immune system regulation. Also there was less damage done to the kidneys in the group using the Perna and DMG combination.

DMG aids the body in healing and restoration, enhances the immune response, and improves detoxification. DMG can be safely combined with any nutritional or therapeutic product without negative side effects. DMG combined with other beneficial, nutritional, and therapeutic food factors, like Perna, can have significant synergistic effects.

Nutrients that Benefit those with Systemic Lupus Erythematosus

Nutrient	Benefit for those with SLE
DMG	DMG increases circulation and modulates the immune response. DMG has anti-inflammatory properties, can help reduce pain and tenderness, increases oxygen utilization, and improves healing. Research has shown DMG can help control some symptoms associated with SLE, and help modulate the immune system to prevent the body from mounting an immune response against its own DNA.
Perna canaliculus	Perna canaliculus is very beneficial for helping to restore joint function without the side effects of other treatments. It is a whole food and provides proteins, amino acids, chondrotin sulfates, glycosaminogylcans, and glucosamine sulfate, as well as naturally chelated vitamins and minerals in an easily absorbable form. DMG and Perna canaliculus are a powerful therapeutic combination that is now under review for lupus and rheumatoid arthritis.

DMG and Detoxification— How DMG Helps with Liver Clearance and Cellular Detoxification

DMG BENEFITS TO THOSE WITH LIVER DYSFUNCTION AND FOR DETOXIFICATION

- DMG helps reduce toxins (drugs and alcohol) in the body.

- DMG helps chelate heavy metals.

- DMG promotes glutathione and SAMe production.

- DMG has antioxidant properties.

- DMG enhances circulation.

- DMG modulates the immune system.

- DMG is a lipotropic agent.

- DMG has anti-inflammatory properties.

DMG AND DETOXIFICATION

DMG is a detoxifying agent that protects the body from unwanted chemical reactions that cause free radicals. DMG is recommended for use during chelation therapy and for those with liver dysfunction. The body also detoxifies potentially damaging

chemicals through DMG's ability to give up its methyl groups to produce SAMe, a highly effective detoxification compound. DMG regulates a number of cellular processes indirectly through SAMe. As the body's major methyl donor, SAMe is involved in over 41 methyl transfer reactions that are critical to health such as maintenance of cartilage, liver detoxification, and the production and regulation of neurotransmitters such as serotonin, melatonin, and dopamine.

HEPATITIS AND LIVER DYSFUNCTION

Liver dysfunction can be caused by malnutrition or chronic inflammation. Hepatitis is chronic inflammation of the liver. Hepatitis and liver disease affects 1 in every 10 Americans or approximately 25 million people. Hepatitis can be caused by viruses, toxic substances or immune abnormalities. In hepatitis, the liver is so inflamed that it can no longer perform its vital functions such as filtering, detoxifying, and regulating constituents in the blood, and helping with digestion and absorption. There can be many causes for hepatitis but the most common types are toxic and infectious hepatitis (caused by a hepatitis virus). Toxic hepatitis is caused by exposure to chemicals that damage the liver. Most cases are caused by alcohol abuse. This form of hepatitis is called alcoholic hepatitis and is caused by chronic alcohol ingestion. As alcohol can act as a poison to the body, the effects of chronic alcohol consumption include damage to the brain, liver, pancreas, duodenum, and central nervous system. Alcohol decreases oxygen to the brain, harming brain cells, depressing the immune system, and causing metabolic changes within every cell in the body. The liver processes 95 percent of the ingested alcohol and repeated ingestion causes damage that impairs enzyme production, and absorption and storage of nutrients, as well as causing fats to build up in the liver, causing

fatty liver, hepatitis or cirrhosis. Alcoholism is a chronic disease that can lead to cirrhosis of the liver.

Cirrhosis is a degenerative inflammatory disease that results in hardening and scarring of the liver. Scarred liver cells prevent blood from passing through the liver, thereby inhibiting normal function. Cirrhosis can be caused by alcoholism, viral hepatitis, autoimmune disease, and other unknown causes. Chronic liver disease and cirrhosis caused 26,552 deaths in the year 2000 and was the twelfth leading cause of death according to the Centers for Disease Control and Prevention.

DMG supports liver metabolism and function, detoxifies dangerous chemicals, and can reduce the incidence of liver tumors. DMG has been shown to inhibit fatty degeneration of the liver, due to its lipotropic properties. By improving oxygen utilization, DMG can help eliminate hypoxia to the tissues and help promote healing. DMG provides antioxidant protection and aids in the elimination of toxins from the bloodstream. It increases transmethylation pathways and makes more methyl groups available for detoxification of toxic amines. Individuals undergoing either chemical or drug detoxification can benefit from DMG supplementation for improved cellular metabolism, higher energy levels, and improved detoxification.

DMG AND ADDICTIONS

Dear Dr. Kendall,
I am a 41-year-old male and a recovering chronic alcoholic salesman. I went into a treatment center in September in Tacoma, Washington for six weeks. A start, but not sufficient. I began drinking soon after my release. I entered still another center in Montana in February for 28 days along with strong AA support. After this center I remained sober, but apparently was lacking in real determination, ambition and/or drive; my general state of well-being was in a continuous up and down cycle. Today? Well, thank God I'm still alive. I've taken my last drink. I won't give DMG all the credit, however. The gal beside me also shares the spotlight. Thanks.
—Sincerely, RJ and JB in Washington

Dear Dr. Kendall,
Our doctor supplied us with several bottles of DMG in an effort to assist my husband in controlling his alcoholism. He has been taking the DMG since the end of April, and it is the beginning of June and he has already been able to cut his consumption by fifty percent. Thank you.
—*Sincerely, LT in Maryland*

Research shows that DMG is effective in reducing addictive cravings and helping the detoxification of toxic substances. Research has shown that after large doses of DMG, subjects lost their desire for liquor and even refused to drink it. Thus, some health experts say DMG might also help prevent cirrhosis of the liver.

Studies and testimonials show DMG to be effective in helping those addicted to alcohol, smoking, and drugs. DMG seems to help with behavior re-patterning, neurotransmitter metabolism, and detoxification (breakdown and removal of addictive substances), and provides an increased sense of well-being.

CHELATION THERAPY

Chelation therapy is the use of molecules to bind and remove toxic substances and heavy metals in the body. DMG is a useful addition to chelation therapy. Many physicians who utilize chelation therapy with their patients recognize the value of DMG for improving oxygen uptake and circulation to the extremities of the body. During the chelation process, DMG supplementation can enhance efficiency of cellular metabolism, stimulate liver detoxification, and improve fat and carbohydrate metabolism. Individuals undergoing chelation for atherosclerosis, alcoholism, diabetes or sexual dysfunction would benefit from supplementation of 750 to 1,000 mg of DMG daily.

Nutrients that Benefit those with Liver Dysfunction

Nutrient	Benefits for those with liver dysfunction
DMG	DMG supports liver metabolism and function, detoxifies dangerous chemicals, and reduces the probability of liver tumors. DMG has been shown to inhibit fatty degeneration of the liver, due to its lipotropic properties. DMG provides antioxidant protection and by improving oxygen utilization it helps promote healing. It increases transmethylation pathways and makes more methyl groups available for detoxification. Patients undergoing either chemical or drug detoxification benefit from 750 to 1,500 mg of DMG a day to improve cellular metabolism, increase circulation, enhance immunity, increase energy levels, and improve detoxification.
Essential Fatty Acids	Essential fatty acids are helpful in enhancing liver function, boosting antioxidant protection, and improving detoxification. Cirrhosis patients usually have imbalanced fatty acid levels, so supplementing with essential fatty acids can help correct imbalances.
Garlic	Garlic helps detoxify the liver and enhances immunity.
Amino Acids	Supplementing with the amino acids L-arginine, L-cysteine, L-methionine, L-glutathione, and L-carnitine can help eliminate toxins and protect the liver.
Coenzyme Q_{10}	CoQ_{10} provides antioxidant protection, enhances energy production and helps detoxification within the body.
Proanthocyanidins	Proanthocyanidins extracted from grape seed or pine bark are powerful antioxidants that help protect the liver.

DMG and Veterinary Medicine— DMG Use in Companion Animals

DMG BENEFITS TO ANIMALS

- DMG has antiviral, antibacterial, and anti-fungal properties.

- DMG has anti-inflammatory and antioxidant properties.

- DMG improves performance of animal athletes.

- DMG has anti-seizure activity.

- DMG enhances healing and metabolism of carbohydrates and lipids that is important to geriatric and diabetic animals.

- DMG can act directly to modulate the immune response for immune-compromised animals.

- DMG improves cardiovascular health.

When people learn that a particular nutritional supplement works effectively for them, they sometimes look at their suffering animal companion and wonder whether if it has helped them it will help their pet, too. This was true for Kathy Tobey of Vermont whose dog, Austin, was experiencing severe seizures.

Dear Dr. Kendall,
Austin, one of my male cocker spaniels, started suffering from seizures when he was two years old. They started off as mild teeth-chattering episodes and blank stares into space. Over time, the seizures increased in severity and frequency. The vet I worked for suggested starting low doses of phenobarbital to get the seizures under control. I decided to try the DMG tablets first, and, within days, his seizures started to decrease. When I would take him off DMG, his seizure activity would increase. I now have him on 250 mg of DMG per day, which has totally eliminated this problem. It has now been seven years and he has done fantastic!! No more seizures!! He is a wonderful dog leading a wonderful life—thanks to DMG!
—*Sincerely, Kathy Tobey in Vermont*

DMG AND ANIMAL APPLICATIONS

Dietary components play a significant role in the health of companion animals, especially those exposed to stress, toxins, and free radicals. Nutritional supplementation can be effective in treating animals suffering from oxidative stress and toxicity. DMG helps maintain natural antioxidant levels and protect against degenerative diseases associated with free radical damage and toxin exposure. Supplementation with DMG can positively influence the health and life span of those animals whose immune systems and detoxification systems have been compromised.

Veterinarians and trainers were the first to use DMG in horses and dogs in the United States. The use of DMG in animals is noteworthy because animals do not experience placebo effects like humans. This makes them ideal models to help review the effectiveness of DMG. The important role that DMG can play in the health and

performance of our companion animals completely parallels what researchers have found in humans. DMG has been used successfully in the animal field for over twenty years. There are studies, veterinary case studies, and testimonials that reveal that DMG does in fact work and can have dramatic results in a variety of problem areas.

In the *Natural Health Bible for Dogs and Cats*, Shawn Messonnier, D.V.M., recommends DMG for horses, dogs, and cats for performance and enhanced recovery from illness. DMG is suggested for therapeutic uses in the areas of osteoarthritis, stress, seizures, allergies, heart disease, cancer, feline immunodeficiency virus (FIV), feline infectious peritonitis (FIP), and diabetes.

DMG's metabolic role is to provide methyl groups, increase SAMe, enhance oxygen utilization, prevent lactic acid accumulation, improve muscle metabolism, improve cardiovascular function, decrease recovery time after vigorous physical activity, enhance immunity, and act as an anti-stress nutrient.

DMG improves immunity in animals, has anti-arthritic properties, decreases seizure activity, and benefits respiratory issues by decreasing allergic reactions, improving oxygen utilization, and turning down the inflammation response.

Arthritis

As mentioned in Chapter 12, DMG can be beneficial for helping the body overcome both rheumatoid and osteoarthritis. A recent publication has shown DMG to have both anti-inflammatory and antioxidant activity in a cell culture model using canine chondrocytes. The work was done at the Washington State University on the Vetri-Science Laboratories product Glyco-Flex III. The ongoing research project involved both a forced-plate evaluation on a stable stifle osteoarthritis model in dogs as well as the *in vitro* cell culture work. The Glyco-Flex III contains DMG as one of its key constituents.

In the cell culture work, using canine chondroctyes, DMG exhibited anti-inflammatory activity against cytokine-induced (using IL-1 beta) proliferation of inflammatory markers including nitric oxide (NO), prostaglandin E2 (PGE2), interleukin-6 (IL-6) tumor necrosis factor alpha and matrix metalloproteinase-3 (MMP-3). In a separate experiment, DMG showed a dose-depen-dant response in an antioxidant Trolox model demonstrating its ability to destroy harmful free radicals.

These results support the use of DMG as part of canine anti-arthritic formulations or as a stand-alone product.

Cancer

Cancer in animals can be caused by viruses, genetics, aging, toxins, and free radical damage. Research shows that DMG enhances immunity to fight off cancer-causing viruses, neutralizes toxins, acts as a free radical scavenger, and provides methyl groups to protect nucleic acids from mutation. Researchers from the Kazan Veterinary Institute in the former Soviet Union report that DMG is effective in restoring the immune system of X-irradiated (immune system destroyed by X-ray) guinea pigs and rabbits. This means that DMG could be useful in restoring the immune system of those animals that receive radiation or chemotherapy.

Cardiovascular Disease

DMG helps cardiovascular disease in animals by improving oxygen and energy utilization by the heart, improving circulation, reducing cholesterol and triglyceride levels within the blood, and helps with strengthening the heart muscle (see Chapter 4 for more information). DMG also enhances immunity to help fight off infec-tions and serious conditions like heartworm.

There have been reports by owners and veterinarians that DMG has demonstrated anti-tumor activity in their dogs, cats, and even horses. In fact, Hans Kugler, Ph.D., (in the Preventative Medicine Up-Date, *1990) reported that DMG helped his eleven-year-old Shepherd dog, Foxie, who had been diagnosed with a large abdominal tumor.*

James Jensen, D.V.M., Foxie's veterinarian, made the diagnosis and recommended immediate surgery, but ultrasound along with blood tests indicated that the tumor was very large and had already spread to the liver and kidneys. Due to these findings, Dr. Kugler decided against surgery and instead put the dog on a natural anti-tumor and immune enhancing program including DMG, phycotene, freeze dried liver concentrate, and a basic vitamin and mineral supplement. Foxie was put on a daily regimen of 250 mg of DMG from FoodScience Corporation and the equivalent of 100,000 to 150,000 IU of vitamin A from the phycotene.

Starting from a very weakened state, Foxie began to improve after only one week on the program. Her energy levels and sleep pattern improved. After six weeks the tumor had shrunk to nearly half its original size and continued to decrease in size until the twelfth week when it was then barely palpable. Later ultrasound examination by a different doctor revealed that the tumor was completely gone. Foxie had returned to her own usually active state and no longer had any symptoms. Her remarkable recovery was based on a combination of nutritional and immune stimulation therapies including DMG (see Chapter 5 for more information).

Cognitive Disorders

DMG has healing effects on the nervous system; it increases oxygen utilization by the brain; helps make phosphocreatine, a source of energy for muscles and nerves; and helps detoxify chemical and molecular toxins in the brain to help prevent cognitive disorders in dogs, cats, and horses (see Chapter 6 for more information).

Dental Disease

DMG helps fight off infections, increases circulation, and helps keep gum tissues healthy. Almost 80 percent of dogs and cats between the ages of one and three have some form of periodontal

disease that requires treatment. DMG can be used as a therapy or preventative for these animals and has even greater synergistic effects when taken with Coenzyme Q_{10} (CoQ_{10}).

Diabetes

In animals with diabetes, DMG can help maintain proper glucose metabolism, improve circulation, enhance energy levels, and prevent cataracts. Between 50 and 70 percent of all diabetic animals have type 1 diabetes, or the inability to produce adequate insulin (see Chapter 9 for more information).

Immune Compromised

DMG helps modulate the immune system and has antiviral properties that is especially important in diseases caused by viruses including kennel cough, parvovirus, feline leukemia virus infection, feline immunodeficiency virus infection, feline infectious peritonitis, and cancer (see Chapter 3 for more information).

A veterinarian, Ellen Prieto, D.V.M., in Pennsylvania told me the following after she had success in treating two young kittens that tested positive for feline leukemia (FeLV).

Dear Dr. Kendall,
Feline leukemia represents a particularly difficult clinical problem to treat. Knowing of DMG's ability to potentiate and enhance immune response in immune-compromised animals I decided to use DMG on two kittens, which had tested positive to FeLV. The two stray kittens were about five to eight weeks old. They both tested positive for feline leukemia on two different tests I used. I used 200 mg of liquid DMG daily on these kittens for six weeks and retested the animals. Both tests came back negative and the kitten's overall health improved. I don't know if the FeLV hadn't gotten into the bone marrow yet, but I've never seen a FeLV kitten that tested positive become negative, much less two!! Normally their immune system is just too weak. I was very impressed with the results I got with DMG and will continue to use it on all of my distressed cats and especially on those challenged by feline leukemia or other disorders of the immune response.

Injury

DMG boosts the body's ability to heal itself. DMG increases oxygen utilization and circulation, and enhances immunity to fight off secondary infections.

Inflammatory Bowel Disease

DMG helps with inflammation, circulation, healing, and detoxification, aiding animals with inflammatory bowel disease.

Liver Dysfunction

DMG detoxifies hazardous substances in the body; it has antioxidant properties, and is a lipotropic agent that helps prevent fatty liver. DMG also helps chelate heavy metals and promotes glutathione and SAMe production (see Chapter 13 for more information).

Performance

Researchers have found that DMG increases performance and decreases lactic acid buildup in equine and canine athletes. Track studies show it enhances stamina and endurance of racing greyhounds and standardbred horses (see Chapter 8 for more information).

Seizures

DMG has been found to be useful in treating seizures in dogs and cats. Studies, testimonials, and case studies confirm that DMG does have powerful anti-seizure activity.

Recommended Daily Dosage of DMG for Dogs and/or Cats

Cardiovascular Disorders

DMG 50-250 mg
Also helpful: CoQ_{10} 20-100 mg
L-Carnitine 500-1,000 mg

Geriatric Animals

DMG 25-100 mg
Also helpful: Vitamins B_1,B_2, B_6 5-30 mg
Vitamin B_{12}, folic acid 10-100 µg
CQ_{10} 20-100 mg

Allergies

DMG 50-250 mg
Also helpful: Proanthocyanidins 10-200mg

Seizures

DMG 50-500 mg
Also helpful: Betaine 100-300 mg
Proanthocyanidins 10-200 mg

Colitis or
Irritable Bowel Disease

DMG 50-250 mg
Also helpful: N-Acetyl Glucosamine 250-1,500 mg
Proanthocyanidins 10-200 mg

Demodicosis

DMG 50-250 mg
Also helpful: Proanthocyanadins 10-200 mg

Feline Leukemia

DMG 50-250 mg
Also helpful: CoQ_{10} 20-100 mg

Feline Immunodeficiency
Virus

DMG 50-200 mg
Also helpful: CoQ_{10} 20-100 mg

Neoplasias—
Tumor or Melanoma

DMG 50-500 mg
Also helpful: Proanthocyanadins 10-200 mg
CoQ_{10} 20-100 mg

Cataracts

DMG 100-400 mg
Also helpful: CoQ_{10} 20-100 mg
Proanthocyanidins 20-200 mg

Arthritis

DMG 50-500 mg
Also helpful: Perna canaliculus 600-1,200 mg

Immune Disorders
(cancer, feline
immunodeficiency virus,
diabetes, vaccinosis)

DMG 30 mg per pound
of body weight of the
animal daily

DMG USE IN BIRDS

DMG has also been used on all species of birds as an anti-stress nutrient. Positive benefits have been seen on birds with chronic feather picking habits, immune-related infections, and liver toxicities. It has also been effective in reducing the negative effects of captive stress in wild birds.

The following are two excerpts from the book Super-Nutrition for Animals! Birds Too!! *from pages 129-130, about the use of DMG in birds.*

One of the negative aberrations of wildlife rehabilitation, and in particular with certain species of birds, is their low tolerance to captive stress. As a rehabilitator of raptors and songbirds, I am always look for ways to decrease the stress of handling these birds. I discovered the benefits of a natural anti-stress nutrient known as N,N-Dimethylglycine, or DMG. In helps to oxygenate the birds' cells, acts as a detoxifier, and stimulates their immune systems. I have observed birds, who, under certain conditions, would have typically shown symptoms associated with captive stress (rapid breathing, increased loss of muscle mass from around the breast bone, lethargy, lack of self-feeding, death, etc.) recover better than expected. Some birds' survival rates increased, and some were released back into the wild sooner.
—*Jean Semprebon, Certified Wildlife Rehabilitator, Vermont*

For roughly a month, following a bout of liver problems, an African Grey Parrot, who had an extended vocabulary, showed a tendency towards one phrase over and over again. This raised concern by the owners (and a slight annoyance). The bird was treated with a daily dose of naturally-occurring immune stimulant, liquid DMG. The veterinarian explained that his experience in treating birds with stress-related behavioral disorders or immune-related diseases had been very positive. After several weeks, the bird's vocabulary returned to normal.
—*David Hertha, D.V.M. in Huntsville, Alabama*

DMG USE IN HORSES

DMG Benefits to Working and Performance Horses

- DMG enhances the recovery time from heavy training, reduces shipping stress, improves muscle metabolism, and increases resistance to infectious diseases.

- DMG is effective in improving endurance because it reduces lactic acid buildup during exercise.

- DMG is valuable in overcoming fatigue, improving respiration efficiency, and strengthening both the cardiovascular and the immune systems.

- DMG doesn't build up in the horse's system because it is converted in the liver to other useful metabolites.

- DMG does not alter the normal blood chemistry.

The use of DMG in horses goes back to the 1970s when it was shown to improve equine performance as well as speed recovery from illness. One of DMG's most exciting characteristics is its ability to potentiate and improve the immune system. This is critical to a horse's performance when it has been exposed to various viral and bacterial agents. Supplementing with DMG lowers the horse's risk of infection.

David Hayes, D.V.M., reports in the August 1987 issue of *Horse Times* the value of DMG to a horse's performance and overall health:

Many veterinarians and trainers feel that the addition of DMG to the daily diet can help horses with upper respiratory disease, and ease breathing in the horse with heaves. DMG also has been successfully used for horses who habitually or occasionally tie-up after heavy exercise, because of its ability to increase oxygen supply to the muscle mass, and decrease lactic acid buildup. DMG is a sensible prophylactic dietary addition for hard working athletes.

Although scientists cannot describe the exact mechanisms of DMG, the clinical effectiveness of improving the performance of

equine athletes has been well recognized and its use should be considered if your horses are not working to their full potential.

Equine research and field experience continues to demonstrate that DMG is effective for dealing with injuries, infectious disease, lactic acid, muscle fatigue, and slow recovery from heavy training. DMG helps everything work better in a horse, from the immune system to its healing and regenerative capabilities to its energy production and stamina.

DMG Research on Animal Performance

- Research by S. Levine, et al. showed that DMG lowers blood lactate levels following training. Horses were found to be stronger, have better appetites and attitudes, and recover faster from racing and training than control groups.

- J. Grannon and R. Kendall reported that animals on DMG covered set distances faster and had better recovery times. DMG also reduced the incidence and severity of muscle cramps in the greyhounds, showing that DMG is effective in improving strength, endurance, and performance.

- J. Meduski found that DMG decreases lactic acid production under hypoxic conditions as well as improving oxygen utilization.

- R. Cator found that thoroughbred horses fed DMG had increased velocities at 210 heartbeats per minute as well as reduced blood lactate levels compared to the controls. This means that DMG allows horses to maintain full velocity for greater time periods, increasing stamina.

According to Marge Moehlman of Greenville, Texas, an avid horsewoman, DMG is a lifesaver. She has used DMG for over sixteen years and has seen tremendous regeneration of horses that have suffered from a number of stress conditions like infertility in mares, active infections, acute muscle lacerations and even melanoma. Using a combination of diet, exercise, and DMG, she has been able to restore many mares and stallions that she did not think would recover back to health.

As an immune potentiating nutrient, DMG can help maintain the horse's health, and optimize physical fitness. DMG can give a horse the competitive edge that can make the difference between winning or losing.

Recommended Daily Dosage of DMG for Horses

Geriatric	DMG 750-3,000 mg
Allergy, Hoof, Skin, Hair, or Coat	DMG 750-3,000 mg
Azoturia or Other Muscle Diseases	DMG 1,000-3,000 mg
Respiratory Distress (pluritis, exercise asthma, pulmonary disease, rhinopneumonitis, influenza)	DMG 1,500-3,000 mg
Poor Performance— Athletic or Breeding	DMG 1,000-3,000 mg
Melanoma	DMG 3,000-6,000 mg

15

What Kind of DMG
User Can I Be?

DMG SUPPLEMENTATION BENEFITS

Nearly half of all Americans use some type of dietary supplement. Nutritional supplementation allows the body to fill in nutritional holes and prevent deficiencies that over time could contribute to metabolic disorders and degenerative disease. Supplementation allows the body to function at optimal efficiency. To achieve optimum health you must provide all the nutrients in a given meta-bolic pathway in adequate levels. If a particular nutrient is lacking, the metabolic pathway in which it operates will be inefficient, turned off or will be rerouted.

DMG is not an essential nutrient like vitamin C, which the body cannot make. However, although the body makes DMG, it is not in sufficient levels to counter the many stress factors that assault the body. DMG is an anti-stress nutrient and metabolic enhancer that provides a wide spectrum of benefits to health, vitality, and well-

ness. It also has many healing and therapeutic benefits. The specific benefits that a person will receive from taking DMG are very unique to that person's overall health, lifestyle, age, and stress level. Based upon my years of research and experience with DMG, I am convinced that all people can derive meaningful short and long term benefits from using DMG on a daily basis. If you decide that DMG supplementation may be right for you, the questions that remain are how do I use DMG effectively, how much should I take and is it completely safe? Let's look at those questions more closely to see if DMG is right for you.

DMG for What Ails You

Condition	Area of Application or Benefit	Metabolic Response or Physiological Effect
Cardiovascular Disease	Arteriosclerosis Angina pectoris Heart attack Hypertension High cholesterol	Improves oxygen uptake by the heart muscle Improves cardiovascular function Adaptogen Methyl donor Promotes glutathione production Promotes SAMe production Decreases cholesterol and triglyceride levels Decreases blood pressure Decreases homocysteine levels Increases circulation
Diabetes	Glaucoma Cataract Poor wound healing Poor circulation Improper sugar metabolism Increased susceptibility to infection Kidney failure Gangrene	Improves glucose utilization (metabolism and storage) Increases oxygen utilization Increases circulation Promotes healing Enhances immune system Building blocks for hormones like insulin Cataract prevention Antioxidant Methyl donor

continued on next page

Condition	Area of Application or Benefit	Metabolic Response or Physiological Effect
Skin Issues	Seborrhea	Acts as an antioxidant
	Scleroderma	Increases oxygenation of tissues
	Psoriasis	Modulates the immune system
	Urticaria	Helps remove toxins from the body
	Sunburn	Increases circulation
	Eczema	
	Dermatitis	
Immune	AIDS	Immune modulation
Compromised	Mononucleosis	Anti-inflammatory
	Cancer	Helps alleviate symptoms
	Chronic fatigue	(headache, fatigue...)
	(Epstein-Barr virus)	Destroys free radicals
	Meningitis	Enhances oxygen utilization
	Herpes virus	Detoxifies
	Fibromyalgia	Decreases lactic acid levels
	Gangrene	Anti-cancer properties
	Autoimmune diseases	Antiviral properties
	Allergies	Makes energy production
	Arthritis	more efficient
	Infection	Cell communicator
	Candidia albicans	Methylation
	Parasites	Enhances macrophage activity
	Spider bites	Enhances T and B lymphocyte activity
		Modulates cytokines
		Increases antibody production
		Increases interferon
		Promotes glutathione production
Respiratory	Emphysema	Enhances oxygen transport
	Bronchitis	Increases oxygen in cells
	Asthma	Improves endurance
	Allergies	Increases circulation
	Hypoxic conditions	Decreases lactic acid levels
	Breathing difficulties	Adaptogen

continued on next page

Condition	Area of Application or Benefit	Metabolic Response or Physiological Effect
Cancer	Prostate cancer Skin cancer Breast cancer Melanomas Neoplasia Radiation therapy Chemotherapy	Increases cellular and tissue oxidation Increases immunity (fights off secondary infection) Detoxifies Increases methylation of DNA Anti-tumor properties Prevents metastasis Promotes SAMe production Methylation
Circulatory Problems	Bruising Raynaud's disease Headache Migraine Ulcer Varicose veins Impotency Gangrene Heart disease	Increases oxygenation Increases circulation Promotes healing
Liver Problems	Cirrhosis of the liver Hepatitis Fatty infiltration of the liver	Increases oxygen levels within cells Increases circulation Detoxifies Lipotropic agent Enhances liver function Methylation Chelating agent Mineral transporter
Behavioral & Neurological Disorders	ADHD Autism Addictions—alcohol, drugs and smoking Schizophrenia Senility Down syndrome Epilepsy Parkinson's disease Alzheimer's disease Vertigo	Provides building blocks for neurotransmitters and hormones Modulates the immune system Detoxifies Destroys free radicals Promotes SAMe production Promotes glutathione production Fights cravings to addictions Improves memory Decreases seizures Improves communication and social interaction Increases oxygen to brain Enhances energy production Improves circulation

continued on next page

191

Condition	Area of Application or Benefit	Metabolic Response or Physiological Effect
Athletics	Muscle cramps Muscle injury Endurance Stamina Performance	Improves oxygen utilization Decreases lactic acid levels Enhances energy Improves muscle recovery time, endurance, and performance Improves lipid and carbohydrate metabolism Adaptogen
Aging	Impotence Infertility Memory Compromised immune system Decreased immunity Senility Alzheimer's Hemorrhoids Hair loss Arthritis Varicose veins	Increases oxygenation of cells and tissues Enhances energy production Increases immunity Enhances memory Enhances glucose metabolism Increases circulation Anti-inflammatory properties Increases mental acuity Promotes healing Provides building blocks for healing Adaptogen
Stress	Mental stress Emotional stress Physical stress Metabolic stress	Adaptogen Detoxifies Anti-inflammatory properties Provides building blocks for hormones Modulates the immune system Increases oxygenation of cells and tissues Decreases lactic acid levels Enhances energy production Decreases free radicals Cell communicator

HOW TO USE DMG

DMG is best taken between meals to avoid competitive uptake from other amino acids although it can be taken with food as well.

Individuals with heavy work schedules (stress), athletes or people dealing with a major health problem including active infections or compromised immune systems can benefit from higher intakes of DMG. Depending on the specific area of use, the recommended dosage of DMG can range anywhere from 125 mg to over 2,000 mg a day. An additional one to two 125 mg tablets can be taken for every two to four hours of exercise or heavy stress. Due to biochemical individuality results can show up anywhere from within a few days to a few weeks. Consult a health care professional to see what levels of DMG would be right for you.

DMG is quickly broken down and used in the body, so smaller doses multiple times a day is better than taking it all at once, in order to maintain consistent availability to the body.

Recommended Ranges for Use of DMG- taken daily in divided doses

General Use & Anti-Aging	125-500 mg
Sports Practice & Fitness	375-1,000 mg
Endurance Sports	1,000-2,500 mg
Immune Response (Prevention)	375-750 mg
Compromised Immune Response	750-1,200 mg
Cardiovascular & Circulatory Problems	375-1,000 mg
Diabetics & Hypoglycemics	375-1,000 mg
Autism, ADD & Seizures	375-1,000 mg
Cancer	1,500-2,500 mg
Autoimmune Diseases (Lupus)	750-1,000 mg
Chronic Fatigue/ Fibromyalgia	1,000-1,500 mg
Liver Detoxification	750-1,000 mg
Respiratory (Asthma/Allergies)	750-1,000 mg
Stress	250-750 mg

HOW LONG HAS DMG BEEN AROUND AND IN USE?

DMG has been used as a supplement in the United States since 1965. DMG has been recommended by thousands of physicians, veterinarians, and health care professionals for over three decades without adverse or negative side effects.

DMG QUALITY

A patented DMG product may help you find a better quality supplement, because the company has researched and patented a particular health application. Funding nutritional research can be expensive but is a necessary part of demonstrating the specific benefit and therapeutic mode of action of the nutrient. Be sure to buy your DMG from a reputable company who makes a quality product and employs good manufacturing practices.

CAN YOU TAKE TOO MUCH?

DMG is a water-soluble nutrient that is either used by the body or excreted. You can take too much of any nutrient, but the upper limit on DMG is extremely high. Some people have taken up to 5,000 to 6,000 mg daily without complications.

ABSORPTION

DMG is very effectively absorbed from the digestive tract and mouth.

Ingested DMG is absorbed in the small intestine and goes directly to the liver where it is either transported to the cells of the body or is rapidly metabolized. Sublingual ingestion of DMG provides effective and rapid absorption. If taken sublingually, this prolongs its beneficial effects, since initially it will bypass the liver.

DMG SAFTEY

DMG is an intricate part of human metabolism. DMG is hypoaller-genic and is an extremely safe food substance that can enhance normal metabolic pathways in the body. It is safe for use in children of all ages. Dr. Rimland has been recommending DMG for autistic children since 1980.

Dr. Meduski's extensive animal studies on the safety of DMG showed that DMG is actually as safe as vitamin C. DMG actually has protective abilities against mutagens and carcinogens that may be in our food and the air we breathe.

Paul Buck, Ph.D., nutritional biochemist at a Food and Drug Administration-approved laboratory in Waverly, New York, is quoted to have said (page 23 of *B-15, The 'Miracle Vitamin'* by Brenda Forman) that "the average person would have to ingest twenty-one pounds or more of DMG in a short amount of time for it to be toxic, and at that point it would be a problem more with the volume than with the actual toxicity of the DMG."

Gary Todd, M.D., describes DMG safety in his book entitled *Nutrition, Health and Disease* on page 206. Dr. Todd summarizes the extreme safety of DMG with this illustration: "the average DMG tablet is 125 mg, so you would have to take 4,144 tablets in a single dose to achieve the LD_{50} for the average 70 kg male, which would cost you $1,167.23. The intake of this much DMG would take an impossibly long time to swallow all the tablets, so a toxic dose would be impossible in humans, considering it would take almost 50 liters of H_2O to swallow the pills, which in itself is a lethal dose."

DMG AND THE BOTTOM LINE

Where do we go from here? Now that you have read this book and know how DMG works and what it can do for your health and well-

being, what are you going to do with this knowledge? I am certain you have found areas in your own health and performance that could benefit from DMG supplementation. I believe that DMG can significantly improve how you deal with stress, fatigue, and immune challenges. Good health is not a matter of pure chance but of making good choices and practicing healthy habits.

Science is learning a great deal about how a person can achieve better health. Good health, long life, vitality, and an absence of disease is not the result of any magic bullet, but results from application of common sense and sound knowledge.

One of the easiest things you can do for yourself is to supplement your diet with key nutrients. With over 25 years of research experience with DMG and seeing the thousands of people that DMG has helped, I know that DMG should be on everyone's supplement list for better health. DMG is a scientifically proven health enhancer. It helps maintain good health, promotes optimal mental and physical performance, boosts your immune defenses, and fights degenerative and infectious disease. DMG is a healing nutrient that does the body good. It can be used in combination with any nutritional or therapeutic program. DMG is not a magic bullet, but it is high caliber ammunition with a proven track record. The many published research papers, clinical experiences, and countless testimonials prove its benefits in multiple areas. Its presence enhances most major pathways of the body and provides benefits whether you are an athlete, senior citizen or coping with a serious health challenge.

THE FOCUS OF FUTURE DMG RESEARCH

DMG research is important because the studies that are being published in the scientific and medical journals provide information on how it works and reveals the ever increasing ways it can be used in the treatment of disease. DMG is a safe, effective, and natural way

to build wellness and optimal health. Using DMG is a practical way to prevent diseases, cope with stress, slow the aging process, and allow us to stay healthier by fortifying our body against diseases.

The DMG journey is not over. There is much still to be learned about this marvelous nutrient. Past research has focused on how DMG works. Current research confirms DMG's many health benefits and use in a wide variety of areas. Future discoveries will focus on new possible nutritional therapies and approaches for the reversal of many degenerative conditions.

WHAT IS THE 'TAKE HOME' MESSAGE?

DMG can help you live a longer, better, and healthier life. DMG can add years to your life and life to your years. Continued research with this nutrient will reveal even more about how DMG can be used effectively to combat the stresses and health problems that affect so many as we advance into the new millennium. DMG can help you build wellness, so share this book with friends and family who could truly benefit from its contents. Take the DMG challenge and learn what DMG can do for you.

The History Behind DMG

In the early 1950s the discovery of pangamic acid and vitamin B_{15} occurred simultaneously half way around the world from each other. Japanese researchers isolated an active factor from the liver and called it vitamin B_{15}, and the Krebs in the U.S. reported finding pangamic acid in certain seeds. After both published their findings, the two events were later connected. Russian scientists picked up the work on pangamic acid. The Russians used calcium pangamate (the salt of pangamic acid) in their research.

Between 1955 and 1960, calcium pangamate appeared on the European market and was widely distributed as a B_{15} product for a wide range of benefits.

In 1964, Russian scientists published claims for the therapeutic and nutritional properties of calcium pangamate, reporting that it could improve oxygen use by tissues, enhance detoxification, and improve lipid metabolism. Looking over the translated Russian literature, the principle areas of research were in the areas of cardiovas-

cular disorders and sports medicine. It was used to enhance muscle activity, increase endurance, and improve recovery rates in athletes.

In 1968, the use of calcium pangamate at the 1968 Summer Olympics by Russian and East German athletes generated intense interest in its ability to boost stamina and performance, provide greater energy, and reduce fatigue among athletes.

In 1970, Dom and Guido Orlandi formed a nutritional company, FoodScience Corporation, to distribute a "B_{15}" product to doctors and health food stores in the U. S. Dom Orlandi knew of Krebs and their earlier research on B_{15}, and found that the Krebs had insufficient scientific studies to support their product, so the Orlandis sponsored their own translation of the Russian research so they could review all the substances that were associated with calcium pangamate and "B_{15}" including dimethylglycine (DMG).

As the Orlandis looked over the Russian studies, it was very clear the Russians considered DMG a part of the active ingredient of calcium pangamate, but not the active ingredient. The Orlandis found that the mixture of dimethylglycine and calcium gluconate gave the "B_{15}" effect. In 1971, they launched their product, which was a mixture of DMG and calcium gluconate. They called their product Aangamik-15®, which is a trade name that is a Russianized version of Pangamic/B_{15}. FoodScience launched one of the most successful nutritional products of the seventies.

In 1978, I joined the research and development team at FoodScience Corporation as the Director of Research and Development. My first project was to research the nutritional and therapeutic benefits of the Aangamik-15® product and to improve the quality control and manufacturing procedures.

I looked though the Russian studies and the Krebs' work and it struck me that no one had elucidated the actual active component behind B_{15}. I identified DMG as the active metabolite behind what was called pangamic acid, calcium pangamate, or the so-called

vitamin B_{15}. I focused my attention on the physiological and therapeutic properties of DMG.

One of the first areas where DMG was found to give significant improvement was in horse racing. Veterinarians and trainers found DMG was effective in reducing lactic acid buildup, resulting in improved racing and recovery times. The same positive effects were found in human athletes. DMG increases resistance to hypoxia by increasing oxygen utilization by tissues and aerobic respiration during muscle activity. It increases stores of glycogen and creatine phosphate in muscles and the liver.

The clinical and nutritional benefits of DMG were quickly recognized, especially in the areas of cardiovascular disease, liver disorders, aging, and stress. DMG was also found to have anti-seizure activity (epilepsy) and to provide major improvement in multiple areas of autism and blood sugar disorders. Later, DMG was shown to enhance the immune response, possess anti-cancer properties, and to protect those who are exposed to infectious disease, carcinogens, and environmental stressors.

DMG HEADLINES

A few months after joining FoodScience Corporation, the B_{15} headlines started. The cover of *New York* magazine read "WONDER DRUG B-15 cures alcoholism, hepatitis, heart disease, allergies, diabetes, schizophrenia, glaucoma, keeps you young, purifies the air you breathe. Maybe." The article entitled "Will Vitamin B-15 Cure What Ails you?" by Philip Nobile was featured in the 1978 issue and increased the demand for what was called B_{15}. The cover story recounted the Russian findings, the Krebs connection, the FDA's attitude, and the involvement of FoodScience Corporation. However, the article did not clear up the misconceptions surrounding the real identity of the active metabo-

lite behind B_{15}; instead it focused on the benefits of B_{15} as reported in the Russian literature.

Within 24 hours of the release of the *New York* magazine article, health food stores in a 100-mile radius of New York were sold out of all B_{15}-related products. When the Orlandis couldn't fill the orders the *New York* article caused, due to technical difficulties, other companies hurried to manufacture products to fill in the gap. Confusion resulted from the sale of products by numerous companies that varied in composition but were all labeled as pangamic acid or "vitamin B_{15}." Many of these products contained little to no DMG (only 15 percent of the products contained ANY DMG). Results of my analysis of all commercial B_{15} products can be found in the study I did for FoodScience Corporation in 1980. In fact, some ingredients in these products couldn't even be identified. Because of this, a lot of the initial enthusiasm over pangamic acid and DMG was lost. Many people who tried a "vitamin B_{15}" product during that time were very disappointed with the lack of results they got from the bogus B_{15} products. It was very ironic at a time when DMG's popularity was the highest, few products containing DMG were available on the market. Letters and testimonials from those who managed to buy the original Aangamik-15® product reported positive effects on a multitude of health problems.

DMG AND THE FDA

In the past, the terms DMG, "vitamin B_{15}," calcium pangamate, and pangamic acid were all used interchangeably, which resulted in widespread public confusion. The Food and Drug Administration (FDA) challenged the "vitamin B_{15}" products on the market, due to the fact that calcium pangamate, pangamic acid, and N,N-dimethyl-glycine are NOT VITAMINS.

In 1980, FoodScience went to court to defend DMG. The key

question before the court was not if DMG worked, but whether DMG in Aangamik-15® was a food additive or a food, according to FDA regulations.

The court ruled that DMG, when combined with other ingredients, was declared an unapproved food additive and would be removed from the market, but the court also recognized DMG as a food when marketed alone as a pure nutrient. This gave FoodScience the opportunity to produce and sell a legal pure DMG product. After six months of research, I was able to produce a pure sublingual DMG product called Aangamik-DMG® and it has been available since 1981. This ruling was reversed in 2000, opening the market for DMG combination products for specific health conditions. DMG can now be combined with other synergistic nutrients to help build wellness on a broader front. This is welcome news and the DMG saga is sure to continue for many years to come.

Glossary

Acetylcholine: a neurotransmitter formed from choline that acts as a vasodilator and is involved in learning and memory.

Active immunity: immunity produced in the body in response to a disease-causing organism or vaccine.

Adaptogen: a substance that helps the body adjust to stresses of various kinds, and causes no side effects. Used to keep the body regulated and in balance, and in the treatment of a variety of illnesses. It provides increased resistance and resilience to stress, enabling the body to adapt.

ADD/ADHD: see attention-deficit/hyperactivity disorder.

AIDS: acquired immunodeficiency syndrome. A viral infection causing a breakdown of the body's immune defenses.

Albumin: the major plasma protein synthesized in the liver that is responsible for maintaining plasma osmotic pressure. It serves as a transport protein for large molecules. It is synthesized in the liver. Decreased serum albumin occurs in active inflammation, and serious hepatic and renal disease.

Alcoholism: a disorder characterized by a pathological pattern of alcohol use that causes a serious impairment in social or occupational functioning.

Allergen: an antigenic substance capable of producing a hypersensitivity or allergy.

Allergy: a state of hypersensitivity induced by exposure to a particular antigen resulting in harmful immunologic reactions. Can be a hypersensitivity to an environmental antigen (atopic allergy or contact dermatitis) or a drug allergy.

Alzheimer's disease: a progressive degenerative disease of the brain of unknown cause, characterized by progressive memory loss, changes in personality, and finally dementia.

Amino acid: any organic compound containing an amino ($-NH_2$) and a carboxyl ($-COOH$) group, which form various substances including proteins, enzymes, hormones, and neurotransmitters. Proteins are synthesized from 20 different amino acids attached together by peptide bonds. Some amino acids must go through a process called posttranslational enzymatic modification of amino acid before being added to proteins, like hydroxyproline.

Anemia: a deficiency of hemoglobin, the oxygen-carrying component of blood, or a reduced level of RBC or erythrocytes, or an abnormal RBC structure causing decreased oxygen-carrying capacity. It also can be due to blood loss or destruction of RBC, or inability to produce more RBC. Symptoms consist of breathlessness, fatigue, and poor resistance to infection.

Angina: any spasmodic, choking, or suffocative pain. Angina is a squeezing pressure-like pain caused by reduced oxygen availability to cells as well as production of toxic metabolites and free radicals.

Angina pectoris: a severe acute attack of cardiac pain. It is most often due to ischemia of the myocardium (reduced blood supply to the heart muscle). Characterized by thoracic pain, often radiating to the arms, sometimes accompanied by a feeling of suffocation.

Antibacterial: a substance that destroys bacteria or suppresses the growth or reproduction of bacteria.

Antibody: proteins produced by specialized B lymphocytes after stimulation by an antigen that act against a specific antigen in an immune response. Also called immunoglobulins.

Anticarcinogenic: inhibiting or preventing the development of cancer.

Anticonvulsant: something that prevents or relieves convulsions.

Antigen: any substance that induces a specific immune response with a specific antibody or specific T lymphocyte, or both. Antigens may be toxins, foreign proteins, bacteria, or tissue cells that combine with an antibody or specific receptors on a lymphocyte.

Anti-inflammatory: works against the inflammatory process counteracting or suppressing inflammation.

Antioxidant: a substance that inhibits oxidation reactions promoted by oxygen, peroxides, or free radicals. A chemical compound or substance that inhibits oxidation like vitamin E, vitamin C, or Coenzyme Q_{10}.

Anti-stress: something that has stress relieving properties. Relieves physical, mental and emotional stress and helps the body to maintain homeostasis.

Anti-tumor: inhibiting or preventing the growth or development of malignant cells.

Antiviral: something that destroys viruses or suppresses their replication.

Apoptosis: programmed cell death of abnormal or unhealthy cells. It is cell death affecting single cells, and is a mechanism for cell deletion and regulation of cell populations.

Arginine: a nonessential amino acid that helps in the synthesis of creatine.

Arrhythmia: an abnormal rhythm or heartbeat, caused by a disturbance in the heart's electrical impulses. It can be an irregularity of force or rhythm of the heartbeat.

Arteriolosclerosis: sclerosis and thickening of the walls of the smaller arteries, by thickening of the connective tissue (hyaline) in the

vessel wall or by a concentric thickening with progressive narrowing of the lumen that may be associated with malignant hypertension.

Arteriosclerosis: any of a group of chronic diseases characterized by thickening, hardening, and loss of elasticity of arterial walls resulting in impaired blood circulation. See also atherosclerosis and arteriolosclerosis.

Arteriosclerotic cardiovascular disease: ischemic heart disease of atherosclerotic arteries to the heart and organs, resulting in debility or death.

Arthritis: inflammation of the joint, also called rheumatism, marked by pain, heat, redness, and swelling, due to inflammation, infection, or trauma.

Arthrosclerosis: stiffening or hardening of the joints.

Asthma: recurrent attacks of dyspnea, with inflammation in airways and wheezing due to contraction of the bronchi. Some cases are allergic, others are provoked by exercise, irritant particles, psychologic stresses, and other causes.

Atherosclerosis: a common form of arteriosclerosis in which deposits of yellowish plaque containing cholesterol and lipids are formed inside the arteries.

ATP: adenosine triphosphate involved in energy metabolism, it occurs in all cells and is used to store energy in the form of high-energy phosphate bonds. The free energy derived from hydrolysis of ATP by ATPase is used to drive metabolic reactions including the synthesis of nucleic acids and proteins, muscle contraction, and movement of electrolytes and other molecules against concentration gradients by active transport.

Attention-deficit/hyperactivity disorder (ADHD): a childhood mental disorder characterized by inattention (such as distractibility, forgetfulness, not finishing tasks, and not appearing to listen), and by hyperactivity and impulsivity (such as fidgeting and squirming,

difficulty in remaining seated, excessive running or climbing, feelings of restlessness, difficulty awaiting one's turn, interrupting others, and excessive talking). Behavior must interfere with academic, social, or work functioning.

Autistic disorder: a severe pervasive developmental disorder with early onset and a biological basis related to neurological factors. It is characterized by an impairment in social interaction (lack of awareness of the existence of feelings of others, failure to seek comfort at times of distress, lack of imitation), in verbal and nonverbal communication, and in capacity for play, and by restricted and unusual activities and interests. Other characteristics sometimes include cognitive impairment, hyper- or hypo- activity, stereotypic behaviors, neurological abnormalities such as seizures or altered muscle tone, sleeping or eating pattern abnormalities, and severe behavioral problems.

Autoimmune disease: any of a large group of diseases characterized by abnormal functioning of the immune system that causes it to produce antibodies against your own tissues. Many diseases, such as lupus (SLE) and rheumatoid arthritis are often classified as autoimmune diseases although their pathogenesis is unclear.

B Cell: a lymphocyte derived from bone marrow that makes immunoglobulins or antibodies.

Betaine: or trimethylglycine (TMG) is an oxidation product of choline, which is a transmethylation intermediate in metabolism, used in the treatment of muscular weakness and degeneration. Shown to have lipotropic activity, it has been used as a lipotropic agent in the treatment of fatty infiltration of the liver.

Bioavailability: the degree to which a drug or other substance becomes available to the target tissue after administration.

Blood: the fluid that circulates through the heart, arteries, capillaries, and veins, carrying nutrients and oxygen to the body cells and carrying away wastes. It consists of the plasma, erythrocytes (red

blood cells), leukocytes (white blood cells), and thrombocytes (platelets).

B lymphocytes: a type of lymphocyte involved in production of antibodies to combat infection. B cells are the cells primarily responsible for humoral immunity, the precursors of antibody-producing cells (plasma cells). B cell maturation occurs primarily in the bone marrow. When stimulated by an antigen, a process that requires the cooperation of helper T cells and macrophages, B cells proliferate and differentiate into plasma cells and memory B cells. A single activated B cell produces immunoglobulins having the same antigen receptor as that of the original cell, so all of the antibodies produced and all of the memory cells are specific for the antigen that induced their formation.

Branched-chain amino acids: leucine, isoleucine, and valine. They are used in proteins or catabolized for energy for muscles.

Bronchitis: inflammation of the bronchi; there are both acute and chronic varieties.

Cancer: a potentially fatal neoplastic disease. Cancer cells exhibit properties of invasion and metastasis. Any malignant growth or tumor cased by abnormal and uncontrolled cell division that may spread to other parts of the body through blood or lymphatic vessels.

Candida albicans: a genus of yeast-like fungi that is part of the normal flora of human skin and mucous membranes but can cause various infections and is the most frequent cause of candidiasis.

Candidiasis: an infection of the skin or mucous membranes, although sometimes it manifests as a systemic infection and any form can become more severe in immunocompromised patients.

Capillary: any of the vessels that connect the arterioles and venules. Their thin walls act as semipermeable membranes for the exchange of nutrients and wastes.

Carcinogen: any cancer-producing substance.

Carcinoma: a malignant growth made up of epithelial cells that infiltrate the surrounding tissues and give rise to metastasis.

Cardiomyopathy: cardiomyopathy is a condition where the heart is so weakened it cannot effectively pump blood to the whole body. It is any disease of the heart muscle, of unknown cause.

Cardiopathy: any disorder or disease of the heart.

Carnitine: compound that transports long chain fatty acids across the inner mitochondrial membrane. It is required for mitochondrial beta-oxidation of fatty acids, carrying fatty acids across the mitochondrial membrane into the matrix where they are used for energy.

Cartilage: a tough, elastic, fibrous connective tissue found in various parts of the body. There are several types, the most important of which are hyaline cartilage, elastic cartilage, and fibrocartilage.

Catalyst: accelerates chemical reactions without being used up or changed in the process.

Cataract: a partial or complete opacity on or in the lens or lens capsule of the eye, impairing vision or causing blindness. Cataracts are classified by their size, shape, location, or cause.

Catecholamine: group of amines having a sympathetic action, examples are dopamine, norepinephrine, and epinephrine.

Catecholaminergic: activated by or secreting catecholamines.

Cell: a cell is the fundamental, structural, and functional unit of living organisms. They make up organized tissues, and consist of a nucleus, which is surrounded by cytoplasm, which contains the various organelles and is enclosed in the cell or plasma membrane.

Cell-mediated immunity: cellular immunity is mediated by T lymphocytes either through release of cytokines or through direct cytotoxicity. It is the immune response produced when sensitized T lymphocytes directly attack foreign antigens and secrete cytokines that initiate an immune response. It includes hypersensitivity reactions, contact dermatitis, and graft rejection, as

well as systemic responses to viral or microbial infections or to tumor cells.

Chelation: chemical process by which molecules surround metal ions to remove them from the bloodstream.

Chelation therapy: introduction of substances into the body that will chelate and remove foreign substances and heavy metals.

Chemotherapy: prevention or treatment of disease by the use of chemical substances. Used specifically for the treatment of cancer using destructive chemicals or drugs that selectively destroy malignant cancer cells.

Cholesterol: a precursor of bile acids and steroid hormones and a key constituent of cell membranes, mediating their fluidity and permeability. Most is synthesized by the liver, but some is absorbed from dietary sources, with each kind transported in plasma by specific lipoproteins.

Choline: a water-soluble compound considered to be a vitamin of the B complex, it is the basic constituent of lecithin and prevents the deposition of fat in the liver. The acetic acid ester of choline (acetylcholine) is essential in synaptic transmission of nerve impulses. Choline is also oxidized to form betaine in methionine biosynthesis.

Cirrhosis: a chronic disease of the liver characterized by the replacement of normal tissue with fibrous tissue and loss of function. It is usually the result of alcohol abuse, nutritional deprivation or infection. The disease has a lengthy latent period, usually followed by the sudden appearance of abdominal swelling and pain, dependent edema, or jaundice, and in advanced stages, ascites, portal hypertension, and central nervous system disorders.

Coenzyme: a molecule that works with an enzyme allowing it to perform. It is also necessary for the utilization of vitamins and minerals.

Collagen: a family of fibrous extracellular proteins that is a major component of connective tissue, giving it strength and flexibility.

Control: a standard against which experimental observations may be evaluated. A patient or group differing from that under study. The controls and treated subjects usually have certain similarities to allow or enhance comparison between them.

Convulsion: a seizure or violent involuntary contraction or series of contractions of the voluntary muscles.

Coronary: encircling term applied to vessels. The term usually denotes the arteries that supply the heart muscle.

Coronary artery disease: a stage of arteriosclerosis involving fatty deposits inside arterial walls of the coronary arteries, which may cause angina pectoris, myocardial infarction, and sudden death. Risk factors that contribute to the disease include hypercholesterolemia, hypertension, smoking, diabetes mellitus, and low levels of high density lipoproteins (HDLs).

Creatinine: produced as the final product of decomposition of phosphocreatine. It is excreted in the urine; measurements of excretion rates are used as diagnostic indicators of kidney function and muscle mass.

Cysteine: a sulfur-containing nonessential amino acid that is easily oxidized to cystine, is sometimes found in the urine, and has limited detoxification properties.

Cystine: an amino acid produced by the digestion of proteins. It is sometimes found in the urine and in the kidneys, frequently forming a cystine calculus in the bladder. Cystine is the chief sulfur-containing compound of the protein molecule and is readily reduced to two molecules of cysteine.

Cytokine: any of a class of immunoregulatory substances (as lymphokines) that are secreted by cells of the immune system. Any of several regulatory proteins, such as the interleukins and lymphokines, that are released by cells of the immune system and act as intercellular mediators in the generation of an immune response. Hormone-like proteins that regulate the function of the immune system.

Cytotoxic: directly toxic to cells preventing reproduction and growth.

Cytotoxic T lymphocytes: killer T cells are differentiated T lymphocytes that can recognize and lyse target cells bearing specific antigens. The cytotoxic activity requires firm binding of the killer cell to the target cell and involves the production of holes in the plasma membrane of the target cell, loss of cell content, and osmotic lysis. Cytotoxic T lymphocytes are important in graft rejection and killing of tumor cells and virus-infected host cells.

Dementia: a permanent intellectual disability resulting in impaired memory, language ability, personality and cognition.

Demethylation: the removal of a methyl group, $—CH_3$, from a compound.

Dependence: a state of relying on or requiring aid, particularly for support or maintenance. A state in which there is a compulsive or chronic need.

Detoxification: reduction of the toxic properties of poisons or the treatment designed to free an addict from his drug habit.

Diabetes mellitus: a chronic syndrome of impaired carbohydrate, protein, and fat metabolism owing to insufficient secretion of insulin (type 1) or insulin resistance (type 2). Type 1 is characterized by abrupt onset of symptoms, insulinopenia, and dependence on exogenous insulin to sustain life. It is due to lack of insulin production by the beta cells of the pancreas, which may result from viral infection, autoimmune reactions, and probably genetic factors; islet cell antibodies are usually detectable at diagnosis. When it is inadequately controlled, lack of insulin causes hyperglycemia, the production of ketone bodies owing to increased fat metabolism, and the hyperglycemia leads to overflow glycosuria, osmotic diuresis, hyperosmolarity, dehydration, and diabetic ketoacidosis. It is accompanied by angiopathy of blood vessels, which affects the retinas, kidneys, and basement membrane of arterioles throughout the body. Other symptoms include polyuria,

polydipsia, polyphagia, weight loss, blurred vision, and irritability. If untreated, diabetic ketoacidosis progresses to nausea and vomiting, stupor, and potentially fatal coma. Type 2 is characterized by gradual onset with few symptoms of metabolic disturbance (glycosuria and its consequences), and no need for exogenous insulin, and dietary control with or without oral hypoglycemics is usually effective. Obesity and genetic factors may also be present. Diagnosis is based on laboratory tests indicating glucose intolerance. Basal insulin secretion is maintained at normal or reduced levels, but insulin release in response to a glucose load is delayed or reduced. Defective glucose receptors on the beta cells of the pancreas may be involved. It is often accompanied by disease of various sizes of blood vessels, particularly the large ones, which leads to premature atherosclerosis with myocardial infarction or stroke.

Dimethylglycine: N,N-dimethylglycine is a tertiary amino acid and an intermediary metabolite occurring as an immediate precursor of sarcosine in the metabolism of choline.

Disease: any deviation from the normal structure or function of a system of the body as manifested by characteristic symptoms, etiology, pathology, and prognosis.

Disulfide bond: a strong covalent bond, —S—S—. This type of bond is important in linking polypeptide chains in proteins.

DMG: N,N-dimethylglycine is an amino acid and an intermediary metabolite occurring as an immediate precursor of sarcosine in the metabolism of choline.

DNA: the cell's genetic blueprint. Deoxyribonucleic acid is the nucleic acid that contains the primary genetic material of all cellular organisms and is found in the nucleus of every cell. It has a backbone composed of sugars that are linked by phosphate groups to bases made of purines or pyrimidines. The strands are twisted to form a double helix. DNA is duplicated by replication, and it

serves as a template for synthesis of mRNA (transcription). mRNA leaves the nucleus and in the cytoplasm of the cell it goes through translation to make proteins that then affect the activity of the cell.

Dopamine: a catecholamine formed in the body from dopa, it is an intermediate product in the synthesis of norepinephrine, and acts as a neurotransmitter in the central nervous system.

Dosage: the determination and regulation of the size, frequency, and number of doses.

Dose: a quantity of something to be administered at one time.

Drug: a chemical substance that affects the processes of the mind or body. Any compound used in humans or animals to aid in the diagnosis, treatment, or prevention of disease. Any substance used for the relief of pain, to control or improve any physiologic condition, or used recreationally, such as a narcotic. Abuse of a drug may lead to dependence or addiction

Edema: the presence of large amounts of fluid in intercellular tissue spaces in the body. It may be localized swelling due to venous or lymphatic obstruction or increased vascular permeability, or systemic, due to heart failure or renal disease.

Efficacy: something's ability to produce a desired beneficial effect. Like the ability of a drug to produce the desired therapeutic effect.

Electrocardiogram: a graphic tracing of the variations in electrical potential caused by the excitation of the heart muscle and detected at the body surface. It shows waves resulting from atrial and ventricular activity. The P wave is due to excitation of the atria, the QRS waves show excitation (depolarization) of the ventricles; and the T wave, the recovery of the ventricles (repolarization).

Emphysema: a pathological condition of the lungs marked by an abnormal increase in the size of the air spaces, resulting in labored breathing and an increased susceptibility to infection.

Energy: power or the capacity to do work or activity. Made possible by the metabolism of food.

Enhancer: something that promotes or augments.

Enzyme: a protein molecule that catalyzes chemical reactions of other substances without itself being used up, destroyed, or altered in the reactions.

Epilepsy: any of a group of syndromes characterized by disturbances of brain function that manifest as episodic impairment or loss of consciousness, abnormal motor movement, psychic or sensory disturbances, or perturbation of the autonomic nervous system. A single episode is called a seizure. Many types of epilepsy are combinations of different kinds of seizures.

Epinephrine: a catecholamine secreted by the adrenal medulla and a neurotransmitter, released by certain neurons and active in the central nervous system. A hormone released into the bloodstream by the adrenal medulla in response to physical or mental stress or from fear or injury. It initiates many bodily responses, including the stimulation of heart action and an increase of blood pressure, metabolic rate, and blood glucose concentration.

Epstein-Barr virus: a herpes virus that causes infectious mononucleosis and is associated with various types of cancers.

Ergogenic: energy enhancing.

Erythrocyte: (red blood cell) is one of the elements found in blood, it is a non-nucleated, biconcave disk that contains hemoglobin, and is involved in the transport of oxygen.

Essential: necessary part of something, giving a substance its necessary qualities. Indispensable as it is required in the diet because the body does not make it in adequate amounts required for health.

Essential amino acids: nine amino acids required for protein synthesis that can only be obtained through the diet: histidine, isoleucine, leucine, lysine, methionine, phenylalanine, threonine, tryptophan, and valine.

Essential nutrients: those nutrients (proteins, minerals, carbohydrates, fats, vitamins) necessary for growth, normal functioning, and maintaining life. They must be supplied by food, since the body cannot synthesize them.

Excitatory amino acids: a group of nonessential amino acids that act as excitatory neurotransmitters in the central nervous system, including glutamic acid or L-glutamate, aspartic acid or L-aspartate, and others.

FDA: food and drug administration of the United States.

Feedback control: a physiological control mechanism operating to regulate the metabolic processes of a cell and maintain a constant internal environment, in which the accumulation of the product of a reaction leads to a decrease in its rate of production, or a deficiency of the product leads to an increase in its rate of production.

Fibromyalgia: a syndrome characterized by chronic pain in the muscles and soft tissues surrounding joints, fatigue, and tenderness at specific sites or trigger points in the body. Accompanied by severe fatigue, sleep disorders, and arthritic symptoms.

Folic acid: a water-soluble vitamin of the B complex essential for the synthesis of nucleic acids and necessary for making red blood cells (hematopoiesis), so a deficiency of folic acid results in anemia. After absorption, it is successively reduced to dihydrofolic acid and then tetrahydrofolic acid, the parent compound of the derivatives that act as coenzyme carriers of one-carbon groups in various metabolic reactions.

Free radical: highly reactive molecule that has unpaired electrons and can cause damage in the body.

Functional foods: foods and supplements marketed for presumed health benefits, such as vitamin supplements and certain herbs also called nutraceuticals.

Gluconeogenesis: a biochemical process where glucose is synthesized from a non-carbohydrate source like amino acids.

Glucose: a simple sugar that is the primary source of energy for the body's cells, and is the principal circulation sugar in the blood. Its utilization is controlled by insulin. Excess glucose is converted to glycogen and stored in the liver and muscles for use as needed, and beyond that it is converted to fat and stored as adipose tissue.

Glutathione: a tripeptide, made of these amino acids—glutamic acid, glycine, and cysteine—that is widely distributed in animal and plant tissues and is involved in various reactions, such as the destruction of peroxides and free radicals, the detoxification of harmful compounds, and activity as a cofactor for enzymes.

Glycosylation: binding of glucose to proteins such as collagen (found in skin, blood vessels, and connective tissues), myelin (the sheath that surrounds nerve cells), and hemoglobin. This forms cross-linked, sugar-damaged proteins. Glycation can accelerate tissue aging and may promote kidney damage, atherosclerosis, and loss of vision.

Glycine: the smallest of the amino acids, a nonessential amino acid occurring as a constituent of many proteins. It is involved in making glycogen (glycogenic), involved in a variety of reactions like purine formation, and is an inhibitory neurotransmitter in the central nervous system.

Glycogen: glucose stored in the body primarily in the muscles and liver that can be converted back to glucose when needed for energy.

Glycolysis: the anaerobic enzymatic conversion of glucose to lactate or pyruvate, resulting in energy in the form of adenosine triphosphate (ATP) that occurs mainly in muscle.

Health: a state of optimal physical, mental, and social well-being, and not merely the absence of disease.

Heart: cardiac muscle that maintains the circulation of the blood. It is divided into four cavities—two atria and two ventricles. The left atrium receives oxygenated blood from the lungs. From there the blood passes to the left ventricle, which pushes it out the aorta

through the arteries to supply the tissues of the body. The right atrium receives the blood after it has passed through the tissues and given up much of its oxygen. The blood then passes to the right ventricle, and then to the lungs, to be oxygenated. The heart tissue itself is nourished by the blood delivered by the coronary arteries.

Heartbeat: a complete cardiac cycle, during which the electrical impulses are conducted and mechanical contraction occurs.

Heart attack: the interruption of blood flow to the heart.

Heart disease: any mechanical or functional abnormality of the heart, its structures, or the coronary arteries.

High-density lipoprotein: HDL cholesterol is a class of lipoproteins that promote the transport of cholesterol from tissues to the liver for excretion in the bile; commonly referred to as "good cholesterol."

High energy phosphate bond: a high energy phosphate bond that occurs in compounds like ATP, phosphocreatine, and some others. The energy released on hydrolysis of the high energy phosphate bond can be transferred, stored, or used to drive metabolic processes such as the synthesis of glycogen from glucose.

Holistic health: preventive medicine that takes into account the whole individual, the total influences—social, psychological, environmental—that affect health, including nutrition, exercise, and mental well-being.

Homeostasis: the body's natural state of balance achieved and maintained through a series of feedback loops. Homeostasis is a state of dynamic equilibrium.

Homocysteine: a sulfur-containing amino acid produced by demethylation of methionine. It can remethylate to methionine, or it can be made into cysteine. An excess level of homocysteine in the blood is considered a risk factor for cardiovascular disease, stroke, dementia, and Alzheimer's.

Homocystine: a disulfide homologous with cystine it is formed by oxidation and subsequent condensation of two molecules of homocysteine. It is a source of sulfur in the body.

Homocystinemia: an excess of homocystine in the blood.

Homocystinuria: excretion of excess homocystine in the urine.

Hormone: an essential substance produced by endocrine glands that regulate body functions.

Humoral immunity: immunity mediated by antibodies, which are produced by B lymphocytes.

Hydrogen bond: a relatively weak bond between a hydrogen atom bound to a highly electronegative element (such as oxygen or nitrogen) in a given molecule.

Hypercholesterolemia: excess of cholesterol in the blood.

Hyperglycemia: abnormally increased glucose in the blood, such as in diabetes mellitus.

Hypertension: chronic high blood pressure.

Hyperinsulinemia: excessively high blood insulin levels.

Hypertension: abnormally and chronically high blood pressure.

Hypoglycemia: an abnormally low level of glucose in the blood.

Hypoxia: low physiological level of oxygen supplied to tissues.

Ig: see immunoglobulin.

Illness: see disease.

Immune: protected against infectious disease by either specific or nonspecific mechanisms, or pertaining to the immune system and immune responses.

Immune compromised: an innate, acquired, or induced inability to develop a normal immune response leaving the body vulnerable to illness and infection.

Immune modulation: adjustment of the immune response to a desired level.

Immune modulator: something that enhances or reduces the immune response.

Immune system: the integrated body system of organs, tissues, cells, and cell products that differentiates self from non-self and neutralizes potentially pathogenic organisms or substances.

Immunity: condition of health that enables a person to resist and overcome disease or infections.

Immunogenic: something with the ability to evoke an immune response.

Immunogenicity: the capacity to provoke an immune response, or the degree to which a substance activates the immune system.

Immunoglobulin: a protein that functions as an antibody in the immune response. They are secreted by plasma cells and are classified based on structure and biological activity. The five classes of immunoglobulins are IgM, IgG, IgA, IgD, and IgE.

INF-α: see Interferon-alpha.

INF-β: see Interferon-beta.

INF-γ: see Interferon-gamma.

Infection: invasion of the body tissues by disease-causing organisms, such as a bacterium, virus, fungus, or parasite.

Infectious disease: a disease caused by a pathogenic microorganism.

Inflammation: an immune system reaction to illness or injury characterized by swelling, pain, heat, redness, and loss of function.

Insulin: a protein hormone secreted by the beta cells in the pancreas that regulates the level of glucose in the blood. It promotes entry of glucose, fatty acids, and amino acids into cells. It promotes glycogen, protein, and lipid synthesis. (Insulin deficiency is the cause of most cases of diabetes.)

Interferon: a protein produced by cells in response to invasion by viral infection, intracellular parasites, by protozoa, by bacteria, and bacterial endotoxins. Interferons also have immunoregulatory functions. They prevent viral reproduction, protect uninfected cells from viral infection, inhibit B cell activation and antibody production, enhance T cell and NK cell activity, and can inhibit the growth of intracellular parasites. All animal cells are able to produce interferons. There are three different types, alpha, beta, and gamma.

Interferon-alpha (INF-α): is the major interferon produced by virus-activated white blood cells; its major activities are antiviral activity and activation of NK cells. Used experimentally in the treatment of some neoplasias (cancers).

Interferon-beta (INF-β): is an interferon produced by fibroblasts, epithelial cells, and macrophages. Its major activity is to stimulate antiviral activity.

Interferon-gamma (INF-γ): is a type of interferon produced by immune activated lymphocytes. One of the primary producers of interferon-gamma is the T lymphocyte. Interferon acts to regulate the immune system. Interferon-gamma expression in cells that don't normally express interferon-gamma has been implicated as a possible cause of some autoimmune diseases.

Interleukin: a major group of multifunctional immune system chemicals or cytokines manufactured by the body to aid in fighting off infection.

Interleukin-1 (IL-1): acts to mediate local inflammation, causing mononuclear phagocytes and endothelial cells to synthesize white blood cell-activating chemicals.

Interleukin-2 (IL-2): acts to regulate the immune response. It stimulates the proliferation of T cells, synthesis of cytokines, stimulates the growth and enhances function of NK cells, and stimulates antibody production. IL-2 is used as an anti-cancer drug in the treatment of some malignant tumors.

Interleukin-3 (IL-3): stimulates the formation of red blood cells and white blood cells.

Interleukin-4 (IL-4): regulates IgE- and eosinophil-mediated immune reactions.

Interleukin-5 (IL-5): stimulates the growth and differentiation of eosinophils and activates mature eosinophils to kill parasites. It may act as a cofactor in the growth and differentiation of B cells.

Interleukin-6 (IL-6): serves as a differentiation factor for B cells and stimulates immunoglobulin production by B cells.

Interleukin-7 (IL-7): serves as a differentiation factor for B cells in the early stages of their development and also supports the growth of some T lymphocytes.

Interleukin-8 (IL-8): acts as an activator for neutrophils and may play a role in inflammation.

Interleukin-9 (IL-9): acts as a growth factor for some T cell populations and mast cells.

Interleukin-10 (IL-10): decreases both innate and T cell-mediated immune inflammation. It inhibits the production of cytokines by activated T cells, plays a role in B cell activation, inhibits production of interferon, and blocks antigen presentation and macrophage formation of IL-1, IL-6, and tumor necrosis factor.

Interleukin-11 (IL-11): stimulates bone marrow cells to proliferation and B cells to differentiate.

Interleukin-12 (IL-12): causes T cells and NK cells to differentiate and secrete interferon enhancing cytotoxic activity.

Interleukin-13 (IL-13): inhibits inflammatory cytokine production in monocytes and may be involved in promoting B cell division.

Interleukin-14 (IL-14): induces B cell proliferation and inhibits immunoglobulin secretion.

Interleukin-15 (IL-15): promotes NK cell proliferation.

Intermediary metabolite: a substance created from the starting components in a chemical process that is essential to the formation of end products.

In vitro: within an artificial environment, in a petri dish or observable in a test tube.

In vivo: within the living body.

Ischemia: the condition of being starved for blood or a deficiency of blood due to constriction or obstruction of a blood vessel.

Islets of Langerhans: congregations of hormone-secreting cells scattered throughout the pancreas. There are three types of cells: alpha, beta, and delta. The alpha cells secrete glucagon, the beta cells secrete insulin, and the delta cells that secret somatostatin. Degeneration of the beta cells is the major cause of type 1 diabetes mellitus.

Lactic acid: an acid that results from anaerobic glucose metabolism. It is a metabolic intermediate involved in many biochemical processes. Glycolysis provides energy to skeletal muscles during anaerobic conditions like heavy exercise, and it can be oxidized aerobically in the heart for energy production or can be converted back to glucose (gluconeogenesis) in the liver. Moderate elevations of blood lactate occur during heavy exercise and can lead to fatigue, muscle pain and cramping, but severe elevations (lactic acidosis) can occur in diabetes mellitus.

LD_{50}: median lethal dose is the amount of a substance required to kill 50 per cent of uniformly susceptible animals inoculated with it. Test to see what amount will kill, within a specified period, 50 per cent of individuals in a large group or population.

Lethal dose: the amount of an agent, such as a toxin or radiation, that is sufficient to cause death.

Leukocyte: white blood cells that are classified into the two groups: granular leukocytes (basophils, eosinophils, and neutrophils) and nongranular leukocytes (lymphocytes and monocytes).

Lipid: any group of organic compounds, including fats, oils, and triglycerides that are insoluble in water but soluble in organic solvents (alcohols). Fats are easily stored in the body, serve as a source of fuel, are an important constituent of cell structure, and serve other biological functions.

Lipoprotein: any of the lipid-protein complexes that function as a lipid transporter in the blood and lymph.

Lipotropic: a substance that prevents accumulation of fat in the liver, controls blood sugar and enhances fat and sugar metabolism.

Low-density lipoprotein (LDL): a class of lipoproteins responsible for transport of cholesterol to tissues. It is commonly referred to as "bad cholesterol."

Liver: a multi-lobed organ responsible for the metabolism of carbohydrates, proteins, and fats, as well as the secretion of bile, and the formation of certain blood proteins. Some of the liver's main functions include detoxification and filtration of blood along with other metabolic functions, including the conversion of sugars to glycogen and storage of glycogen until needed by the body.

Lymphocyte: a type of white blood cell which can be divided into two classes, B and T lymphocytes, responsible for humoral and cellular immunity, respectively. B lymphocytes are responsible for antibody production and T lymphocytes are responsible for direct attack against invading organisms.

Lymphokine: a general term denoting factors produced by cells of the immune system and acting upon them (or on other cell types). Any of various substances released by T cells that have been activated by antigens. They function in the immune response through a variety of actions, including stimulating the production of lymphocytes and activating macrophages. Proteins that modulate cellular immunity.

Macrophage: a type of immune cell that consumes and digests foreign material and cellular debris in the body. Their functions include phagocytosis (ingestion), killing of ingested microorganisms, digestion and presentation of antigens to T and B lymphocytes, and secretion of many different products, including enzymes, prostaglandins, and regulatory molecules such as interferon, tumor necrosis factor, and interleukin-1.

Metabolism: the physical and chemical processes by which substances necessary for living are produced (for structural integrity-anabolism), and also broken down (for energy - catabolism).

Metastasis: the capacity to metastasize, or the transfer of disease from one location to another in the body, is a characteristic of all malignant tumors.

Methionine: a naturally-occurring essential amino acid providing necessary methyl groups and sulfur necessary for metabolism.

Methylation: the process of attaching methyl groups to a compound to produce new compounds or to protect an existing compound from damage. The change in structure usually leads to a change in function as well.

Methyl group: a carbon with three hydrogen atoms CH_3

Microorganism: microscopic organism capable of causing disease, like bacteria, viruses, fungi, and protozoa.

Migraine: periodic attacks of vascular headache commonly associated with nausea, vomiting, and light sensitivity.

Mitochondria: an organelles found in the cytoplasm of cells, where energy is generated (in the form of ion gradients and adenosine triphosphate [ATP] synthesis) resulting from the oxidation of foodstuffs. It contains the enzymes of the Krebs cycle, fatty acid cycles, and the respiratory pathway.

Murmur: a periodic sound of short duration of cardiac or vascular origin being benign or pathologic.

Mutagen: a chemical or physical agent that induces or increases genetic mutations by causing changes in DNA structure.

Myocardial infarction: a heart attack. It is the necrosis (death) of the myocardium (heart muscle) as a result of interruption of the blood supply to the area. It is almost always caused by atherosclerosis or blockage of the coronary arteries.

NAD: nicotinamide adenine dinucleotide is a coenzyme made from niacin that transports electrons.

NADH: reduced form of NAD, which is a potent antioxidant and free radical scavenger.

Negative feedback: the ability of an end product of a pathway to inhibit the pathway to turn it off.

Neoplasm: a tumor, any new abnormal tissue growth. Malignant neoplasms show a greater degree of invasion and metastasis.

Nerve: bundles of fibers made up of neurons that sensory and motor impulses pass through to conduct information throughout the body.

Neuron: any of the impulse-conducting cells of the nervous system. Consisting of a nucleated cell body with one or more dendrites and an axon. The axon together with its covering forms the nerve fiber.

Neuropathy: a disease or abnormality of the nervous system.

Neurotransmitter: a chemical substance produced by nerve cells that can stimulate or inhibit other nerve cells. They are mediators that affect mood, alertness, and sensations.

NK cells: natural killer cells are cells capable of mediating cytotoxic reactions without prior sensitization against the target. NK cells are small lymphocytes without B or T cell surface markers that originate in the bone marrow and develop fully in the absence of the thymus; their cytotoxic activity is not antibody-dependent. They can lyse a wide variety of tumor cells and other cell types and are probably important in natural resistance to tumors. Interferon augments their activity.

NMR: nuclear magnetic resonance spectroscopy is an analytical tool used to determine the composition of organic compounds.

Nonessential amino acids: amino acids that can be synthesized by the human body in sufficient amounts to meet the body's needs, and are not specifically required in the diet.

Nonspecific immunity: immunity that does not involve the recognition of an antigen by lymphocytes and the mounting of a specific immune response. Like the protection afforded by lysosomes, macrophages, interferon, the cells involved in natural immunity, and anatomical barriers to infection.

Nonspecific resistance: innate immunity that results from a person's genetic constitution not from a response to a previous infection or vaccination.

Nucleic acids: RNA or DNA that contain genetic instructions found in viruses, plants, and animals.

Nutraceuticals: see functional foods. A food or naturally-occurring food supplement thought to have a beneficial effect on human health.

Nutrient: any substance of nutritional value to an organism, that maintains life and health, provides energy, and the building materials needed for the growth and repair.

Nutrition: the ingestion and metabolism of nutrients used to maintain life and for growth and replacement of tissues.

Osteoarthritis: a form of arthritis, also called degenerative joint disease, seen mainly in older persons, characterized by chronic degeneration of the articular cartilage and changes in the synovial membrane.

Pathogen: an organism capable of causing disease.

Pathogenesis: the development of abnormal, pathological or diseased conditions.

Placebo: a biologically inactive drug or supplement that is indistinguishable in appearance from the real thing, used to disguise the control and experimental groups in an experiment.

Plaque: unwanted deposits on tissue. In arteries it is associated with heart disease, and in the brain it is associated with Alzheimer's.

Plasma cell: an antibody-producing lymphocyte made from a B cell's reaction with a specific antigen.

Platelet aggregation: a clumping together of platelets, part of a sequential mechanism leading to the initiation and formation of a clot (thrombus).

Positive feedback: the end product of a pathway has a stimulating effect on the pathway, causing an increase in the end product.

Prostaglandin: a hormone-like substance that mediates physiological function, like metabolism, nerve function, blood pressure, contraction of smooth muscle, and modulation of inflammation responses.

Radiation therapy: radiation used to destroy specific areas of tissue used to treat cancer.

RBC (red blood cell): a biconcave disk with no nucleus that contains hemoglobin, which carries oxygen to tissues.

Respiratory insufficiency: a condition in which the lungs cannot provide adequate oxygen intake or carbon dioxide expulsion to meet the needs of the body and its cells.

Rheumatoid arthritis: a chronic systemic disease primarily of the joints, marked by inflammatory changes in the synovial membranes and articular structures and by muscle atrophy.

RNA: ribonucleic acid. The single-stranded nucleic acid found in the cell. There are three types in the cell, messenger RNA, ribosomal RNA, and transport RNA. RNA is used for protein synthesis in the cell and in viruses is used for the carrying of genetic information.

S-adenosylhomocysteine: the compound remaining after the methyl group of S-adenosylmethionine has been transferred to an acceptor molecule; it is a potent inhibitor of transmethylation reactions and is rapidly hydrolyzed.

S-adenosylmethionine: SAMe is a reaction product of ATP and methionine that serves as a methyl donor in transmethylation reactions.

Seizure: a convulsion or sudden brief change in consciousness, perception or muscular motion.

Stress: a state of physiological or psychological strain caused by adverse stimuli (physical, mental, or emotional, internal or external) that tend to disturb the functioning of an organism.

Subclinical: the early stage(s) of an infection, disease, or abnormality before symptoms become detectable by clinical examination or laboratory tests.

T helper cell: a T lymphocyte that "helps" in the process of antigen recognition and antibody production from B cells.

T lymphocytes: are responsible for cell-mediated immunity. When activated by an antigen, T cells proliferate and differentiate into T memory cells and the various types of regulatory and effector T cells.

T suppressor cell: suppresses B lymphocyte activity.

Toxicity: the quality of being poisonous, or the degree of virulence of a toxic microbe or poison.

Transmethylation: transfer of a methyl group (CH_3) from one compound to another.

Triglyceride: the form in which fat is stored in the body.

Tumor: abnormal mass of tissue with no function that can be cancerous.

Tumor necrosis factor (TNF): is an inflammatory cytokine produced by macrophages capable of destroying cancer and tumor cells, but not affecting normal cells; it is being used as an experimental anticancer agent.

Vaccine: a substance that contains antigenic components from an infectious organism. Causes an immune response, but not the disease to protect against subsequent infection by that organism.

Vasodilation: dilation of a vessel, especially dilation of arterioles leading to increased blood flow.

Vitamin: essential in small amounts for life and health, and must be supplied by the diet; deficiencies will result in disease states.

WBC: a white blood cell or leukocyte. Any of the various blood cells that help protect the body from infection and disease: neutrophils, eosinophils, basophils, lymphocytes, and monocytes.

Ask the Doctor

If you want to know where to get DMG locally or would like to send in a testimonial, feel free to contact Dr. Kendall, the DMG doctor. If you have further DMG questions, need more information or need research sent to your doctor, contact Dr. Kendall at: 1-800-671-1163, or check out his website at: www.dmgdoctor.com.

References by Chapter

INTRODUCTION

Graber, C., et al. "Immunomodulation properties of dimethylglycine in humans." *J. Inf. Disease*, 1981; 143:101.

Kendall, R. & Graber, C. "N, N-Dimethylglycine and use in the immune response." U.S. Patent #4,631,189, December 1986.

Lawson, J. & Reap, E. "The effects of dimethylglycine on the immune response of rabbits." Clemson University Presented at the American Society of Microbiologists. Abstract, March 1-6, 1987, Atlanta, Georgia.

Meduski, J., et al. "Decrease of lactic acid concentration in blood of animals given N,N-dimethylglycine." Pacific Slope Biochemical Conference. Abstract, July 7-9, 1980, University of California, San Diego.

Pries, M. "The role of DMG in cardiovascular patients." Report to Food Science Corporation, 1981.

Pries, M. "N,N-dimethylglycine and its use with cardiovascular patients." Report to DaVinci Laboratories, 1980.

Reap, E. & Lawson, J. "Stimulation of the immune response by dimethylglycine, a non-toxic metabolite." *J. Laboratory and Clinical Medicine*, 1990; 115: 481.

Rimland, B. "Dimethylglycine (DMG) in the treatment of autism." Autism Research Institute Publication 110, 1991.

Rimland, B. "Dimethylglycine (DMG), a nontoxic metabolite, and autism." *Autism Research Review International*, 1990; 4(2).

CHAPTER 1 DMG—A Nutrient for the New Millenium

Balch, J. & Balch, P. *Prescription for Nutritional Healing*. New York: Avery Publishing Group, 2000.

Bolton, S. & Null, G. "Vitamin B-15, a review and update." *J. of Orthomolecular Psychiatry*, 1982; 11: 260.

Charles, A. "DMG proving to be a valuable aid in competition." *Horse World*, 1982; 10: 20.

Forman, B. *B-15, The* 'Miracle Vitamin.' New York: Fred Jordan Books/Grosset & Dunlap, 1979: 81-111.

Graber, C., et al. "Immunomodulation properties of dimethylglycine in humans." *J. Inf. Disease*, 1981; 143: 101.

Grannon, J. & Kendall, R. "A clinical evaluation of N,N-dimethylglycine and Diisopropylammonium dichloroacetate (DIPA) on performance of racing greyhounds." *Canine Practice* 1982; 9(6): 7-13.

Hamner, D. & Burr B. *Peak Energy: The High-Oxygen Program For More Energy Now!* New York: G. P. Putnam's sons, 1988: 40-45, 190-191.

Kendall, R. "Research update on dimethylglycine (DMG)." Natural Products Expo West, March 26, 2000.

Levine, S., et al. "Effect of a nutritional supplement containing N,N-Dimethylglycine on the racing standard bred." *Equine Practice*, 1982: 4.

Meduski, J. "N,N-dimethylglycine, a biologically active non-fuel nutrient." Research Paper. University of Southern California Medical School, 1979.

Michlin, E., eds. *Vitamin B-15 (Pangamic Acid): Properties, Functions, and Use*. Naooka, Moscow: "Science" Publishing House, 1965.

Navarro, M. "The therapeutic use of vitamin B-15." *Sto. Tomas J. Med.*, 1954; 9: 376-8.

Navarro, M., et al. "Preliminary observations on the therapeutic effects of vitamin B-15." *J.P.M.A.*, 1956; 32: 671-4.

Passwater, R. "Dimethylglycine update: new studies confirm DMG improves health." *Let's Live Magazine*, February 1987.

Passwater, R. "New findings on vitamin B-15: Soviet Union scientist- and others- are learning about the remarkable versatility of the "sleeper" supplement." *Let's Live*, August 1977.

Sellnow, L. "DMG, properties and proprieties." *The Blood Horse*, 1987: 3855.

Stacpoole, P. "Pangamic acid, a review." *Rev. Nutr. Diet.*, 1977; 27: 145.

Todd, G. *Nutrition, Health and Disease*. Norfolk, Virginia: The Donning Company, 1988: 204-208.

Walker, M. "Some nutri-clinical applications of N,N-Dimethylglycine." *Townsend Letter for Doctors*, June 1988: 226-228.

Walker, M. "Therapeutic benefits of DMG (dimethylglycine)." *Health World*, March 1990: 38-41.

Williams, R. *Biochemical Individuality: the key to understanding what shapes your health*. New Canaan, Connecticut: Keats Publishing, Inc., 1998.

CHAPTER 2 DMG Falls Apart...So You Don't Have To

Balch, J. & Balch, P. *Prescription for Nutritional Healing*. New York: Avery Publishing Group, 2000.

Bolton, S. & Null, G. "Vitamin B-15, a review and update." *J. of Orthomolecular Psychiatry*, 1982; 11: 260.

DeLong, E. "Methylation and its chemical and nutritional importance." *J. of Applied Nutr.*, 1953; 6: 286.

DuVigneaud, V. "DMG as a source of methyl groups." *Research Papers*, 1948-1950.

Hamner, D. & Burr B. *Peak Energy: The High-Oxygen Program For More Energy Now!* New York: G. P. Putnam's sons, 1988: 40-45, 190-191.

Hubber, W. & Parris K. "An in-depth review of its efficacy, safety and action mechanisms. Part III: The clinical efficacy of DMG." Report to FoodScience Corporation by HK Biomedical, Inc., 1989.

Kendall, R. & Lawson, J. "Recent findings on N,N-Dimthylglycine (DMG) a nutrient for the new millennium." *Townsend Letter for Doctors and Patients*, May 2000: 75-85.

MacKenzie, C. & Frisell, W. "Metabolism of Dimethylglycine by Liver Mitochondria." *Journal of Biology and Chemistry*, 1958; 232: 417-427.

MacKenzie, C., et al. "The isolation of formaldehyde from dimethylammoethanol, dimethylglycine, sarcosine, and methyanol." *J. Biol. Chem.*, 1953; 203: 743.

Mathews, M. & VanHolde, K. *Biochemistry*. New York: Benjamin-Cummings, 1996: 747-751.

Meduski, J., et al. "Decrease of lactic acid concentration in blood of animals given N,N-dimethyl-glycine." Pacific Slope Biochemical Conference. Abstract, July 7-9, 1980, University of California, San Diego.

Meduski, J., et al. "Effect of dietary N,N-dimethylglcyine uptake on the molecular oxygen in Sprague-Dawley rats." Research Paper. University of California, San Diego, 1980.

Meduski, J. *Lecture Notes on Nutritional Biochemistry 3rd ed*. Los Angeles: University of South California, 1979.

Meduski, J. "N,N-dimethylglycine, a biologically active non-fuel nutrient." Research Paper. University of Southern California Medical School, 1979.

Michlin, E., eds. *Vitamin B-15 (Pangamic Acid): Properties, Functions, and Use.* Naooka, Moscow: "Science" Publishing House, 1965.

Munro, H. & Crim, M. *The Proteins and Amino Acids. Modern Nutrition in Health and Disease*, 6th ed. Philadelphia: Lea and Febiger, 1980.

Niculescu, M. & Zeisel, S. "Diet, methyl donors, and DNA methylation: interactions between dietary folate, methionine, and choline." *American Society for Nutritional Sciences*, 2002: 2333S-2335S.

Ruch, T. & Fulton, J., eds. *Medical Physiological and Biophysics.* Philadelphia: WB Saunders Co., 1960: 678-679.

Selye, H. *Stress Without Distress.* Philadelphia: Lippincott Williams & Wilkins Publishers, 1974.

Selye, H. *The Stress of Life.* New York: Mc Graw-Hill, 1978.

Sokolova, M. "Pangamic acid as a source of active methyl groups (experimental morphological study.)" *Vitamin B-15 (Pangamic Acid): Properties, Functions, and Use.* Naooka, Moscow: "Science" Publishing House, 1965.

Solovyeva, N. & Garkina, I. "Oxidative demethylation of pangamic acid." *Vitamin B-15 (Pangamic Acid): Properties, Functions, and Use.* Naooka, Moscow: "Science" Publishing House, 1965.

Soloveva, N., et al. "Oxidative demethylation of pangamic acid and some of its derivatives." *Prikadnaya Bio. Khomi. Mikrobiologiya*, 1968; 4(1): 51.

Solovyeva, N. & Garkina, I. "Studies on the methylating properties of pangamic acid." *Vitamin B-15 (Pangamic Acid): Properties, Functions, and Use.* Naooka, Moscow: "Science" Publishing House, 1965.

Todd, G. *Nutrition, Health and Disease.* Norfolk, Virginia: The Donning Company, 1988: 204-208.

Udalov, Y. "Effect of vitamins on blood nucleic acid level during physiologic stress." *Vitamin B-15 (Pangamic Acid): Properties, Functions, and Use.* Naooka, Moscow: "Science" Publishing House, 1965.

Walker, M. "Some nutri-clinical applications of N,N-dimethylglycine." *Townsend Letter For Doctors*, June1988: 228.

White, A., et al. *Principles of Biochemistry 6th ed.* New York: McGraw Hill, 1978.

CHAPTER 3 DMG and Immunity

Altshuler, E. "Changes in condition of connective tissue in middle-aged and elderly patient treated with vitamin B-15." *Vitamin B-15 (Pangamic Acid): Properties, Functions, and Use.* Naooka, Moscow: "Science" Publishing House, 1965.

Anisimov, V. & Salikhov, N. "Use of pangamic acid for internal diseases." *Vitamin B-15 (Pangamic Acid): Properties, Functions, and Use.* Naooka, Moscow: "Science" Publishing House, 1965.

Balch, J. & Balch, P. *Prescription for Nutritional Healing.* New York: Avery Publishing Group, 2000.

Beisel, W., et al. "Single nutrient effects on immunologic functions." *J. of Amer. Med. Assoc.*, 1981; 245: 53.

Epshtein, A. "Treatment of psoriasis with methotrexate in combination with pyrogenal, calcium pangamate, and chelators." *Vest. Demat. Venerol.*, 1973; 47: 48.

Forman, B. *B-15, The 'Miracle Vitamin.'* New York: Fred Jordan Books/Grosset & Dunlap, 1979: 81-111.

Graber, C., et al. "Immunomodulation properties of dimethylglycine in humans." *J. Inf. Disease,* 1981; 143: 101.

Graber, C., et al. "DMG as an immuno-adjuvant." Annual Meeting Southeastern and South Caroline branches of American Society for Microbiology. November 9-10th, 1979, Atlanta Georgia.

Hamner, D. & Burr, B. *Peak Energy: The High-Oxygen Program for More Energy Now!* New York: G. P. Putnam's sons, 1988: 40-45,190-191.

Hariganesh, K. & Prathiba, J. "Effect of dimethylglycine on gastric ulcers in rats." J. Parm. *Pharmacology*, 2000; 52: 1519-22.

Kendall, R. & Lawson, J. "Recent findings on N,N-Dimthylglycine (DMG) a nutrient for the new millennium." *Townsend Letter for Doctors and Patients*, May 2000: 75-85.

Kolosova, A., et al. "Effect of pangamic acid on the vascular-tissue permeability and osmotic resistance of erythrocytes in middle-aged and old patients." *Vitamin B-15 (Pangamic Acid): Properties, Functions, and Use.* Naooka, Moscow: "Science" Publishing House, 1965.

Kendall, R. & Graber, C. "N,N-dimethylglycine and use in the immune response." U.S. Patent #4,385,068, May 1882.

Kendall, R. & Graber, C. "N, N-dimethylglycine and use in the immune response." U.S. Patent #4,631,189, December 1986.

Kendall, R. & Lawson, J. "Dimethylglycine enhancement of antibody production." U.S. Patent #5,118,618, June 1992.

Kendall, R. & Lawson, J. "Treatment of melanoma using N,N-dimethylglycine." U.S. Patent #4,994,492, February 1991.

Lawson, J. & Recap, E. "The effects of dimethylglycine on the immune response of rabbits." The American Society of Microbiologists. Abstract, March 1-6, 1987, Atlanta, Georgia.

Michlin, E., eds. *Vitamin B-15 (Pangamic Acid): Properties, Functions, and Use.* Naooka, Moscow: "Science" Publishing House, 1965.

Muona, M. & Virtanen, E. "Effect of dimethylglycine and trimethylglycine (Betaine) on the response of Atlantic salmon (Salmon salar L.) smolts to experimental Vibrio anguillarum infection." *Fish and Shellfish Immunology*, 1993; 3: 439-449.

Navarro, M. "The therapeutic use of vitamin B-15." *Sto. Tomas J. Med.*, 1954; 9: 376-8.

Navarro, M., et al. "Preliminary observations on the therapeutic effects of vitamin B-15." *J.P.M. A.*, 1956; 32: 671-4.

Nizametidinova, G. "Effectiveness of calcium pangamate introduced into vaccinated and x-irradiated animals." *Reports of the Kazan Veterinary Institute*, 1972; 112: 100-104.

Passwater, R. "B-15- New ally in the fight against major disease." *The Health Quarterly*, 3(5):16, 17, 85.

Pickering, L., et al. "Epstein-Barr virus infections (infectious mononucleosis)." *Red Book: Report of the Committee on Infectious Disease 25th ed.* Elk Grove Village, IL: American Academy of Pediatrics, 2000: 238-240.

Reap, E. & Lawson, J. "Stimulation of the immune response by dimethylglycine, a non-toxic metabolite." *Journal of Laboratory and Clinical Medicine*, 1990; 115: 481.

Reap, E. & Lawson, J. "The effects of dimethylglycine on B-16 melanoma in mice" Annual Meeting of the American Soc. of Microbiology, October 1988.

Schooley, R. "Epstein-Barr virus (infectious mononucleosis)." *Mandell, Douglas, and Bennett's Principles and practice of infectious diseases*, 5th ed. Philadelphia: Churchill Livingstone, 2000: 1559-1613.

Shpirt, Y. "Indications for use and efficacy in internal disease." Municipal Clinical Hospital #60 Moscow: V/O Medexport, 1967.

Stoodnitsin, A. & Maslov, P. "The therapeutic efficacy of calcium pangamate in dermatologic-venerological practice." *Vitamin B-15 (Pangamic Acid): Properties, Functions, and Use.* Naooka, Moscow: "Science" Publishing House, 1965.

Todd GP. *Nutrition, Health and Disease.* Norfolk, Virginia: The Donning Company, 1988: 204-208.

Vedrova, I. & Chamaganova, A. "Use of vitamin B-15 for treatment of certain skin diseases." *Vitamin B-15 (Pangamic Acid): Properties, Functions, and Use.* Naooka, Moscow: "Science" Publishing House, 1965.

Walker, M. Some nutri-clinical applications of N,N-dimethylglycine." *Townsend Letter for Doctors*, June 1988.

Wang, C. & Lawson J. "The effects on the enhancement of monoclonal antibody production." Annual Meeting of the American Society of Microbiology. October 1988.

Yakovlyeva, I. "Pangamic acid treatment for middle-aged and elderly people." *Vitamin B-15 (Pangamic Acid): Properties, Functions, and Use.* Naooka, Moscow: "Science" Publishing House, 1965.

CHAPTER 4 DMG and Cardiovascular Disease

Andreyev, C., et al. "Effect of pangamic acid on heart and brain hypoxia." *Vitamin B-15 (Pangamic Acid): Properties, Functions, and Use.* Naooka, Moscow: "Science" Publishing House, 1965.

Anisimova, V., et al. "The effects of Vitamin B-15 (Pangamic Acid) on clinical symptoms and humoral disorders in cases of coronary atherosclerosis." *Kazansk Med. Zh.,* 1964; 5: 36-40.

Apanaseko, A. "The influence of vitamin B-15 on myocardial contractility and cardiotonic effects of Strophanthidin in ischemic heart disease." *Cor. Vasa.,* 1973; 15: 20.

Aspit, S. "Effect of pangamic acid on tissue respiration of the myocardium in patients suffering from mitral heart stenosis of rheumatic etiology." *Vitamin B-15 (Pangamic Acid): Properties, Functions, and Use.* Naooka, Moscow: "Science" Publishing House, 1965.

Balch, J. & Balch, P. *Prescription for Nutritional Healing.* New York: Avery Publishing Group, 2000.

Baranova, L. "Influence of vitamin B-15 on blood lipids in patients with hyperlipemia." *Kardiologia,* 1968; 8: 62.

Bobrova, O. & Oleinik, N. "Use of pangamic acid in the treatment of patients suffering from atherosclerosis of the coronary vessels and the vessels of the lower extremities" *Vitamin B-15 (Pangamic Acid): Properties, Functions, and Use.* Naooka, Moscow: "Science" Publishing House, 1965.

DeLong, E. "Methylation and its chemical and nutritional importance." *Journal of Applied Nutr.,* 1953; 6: 286.

Dukukin, A., et al. "The effects of vitamin B-15 (pangamic acid) on the resistance of the organism and its cardiovascular system to hypoxia." *Dokl, Akad, Nuak, SSSR,* 1962; 144: 675-681.

DuVigneaud, V. "DMG as a source of methyl groups." *Research Papers,* 1948-1950.

Fizdyel, E., et al. "Use of pangamic acid in the treatment of patients with coronary and cardiopulmonary insufficiency." *Vitamin B-15 (Pangamic Acid): Properties, Functions, and Use.* Naooka, Moscow: "Science" Publishing House, 1965.

Forman, B. *B-15, The 'Miracle Vitamin.'* New York: Fred Jordan Books/Grosset & Dunlap, 1979: 81, 99-102.

Giloonova, N. "Use of pangamic acid with patients suffering from coronary atherosclerosis." *Vitamin B-15 (Pangamic Acid): Properties, Functions, and Use.* Naooka, Moscow: "Science" Publishing House, 1965.

Hamner, D. & Burr B. *Peak Energy: The High-Oxygen Program For More Energy Now!* New York: G. P. Putnam's sons, 1988: 40-45, 190-191.

Hubber, W. & Parris K. "DMG: an in-depth review of its efficacy, safety and action mechanisms. Part III: the clinical efficacy of DMG." Report to FoodScience Corporation by HK Biomedical, Inc., 1989.

Kang, S., et al. "Hyperhomocysticanemia as a risk factor for occlusive vascular disease." *Annual Review of Nutrition,* 1992; 12: 279-98.

Kolosov, A., et al. "Effect of pangamic acid on the vascular-tissue permeability and osmotic resistance of erythrocytes in middle-aged and old patients." *Vitamin B-15 (Pangamic Acid): Properties, Functions, and Use.* Naooka, Moscow: "Science" Publishing House, 1965.

Kolesnichenko, A. "The effect of different dose regimens of vitamin B-15 on cholesterol metabolism." *Vop. Pitan.,* 1967; 26(1): 7-12.

Meduski, J., et al. "Effect of dietary N,N-dimethylglcyine uptake on the molecular oxygen in Sprague-Dawley rats." Research Paper. University of California, San Diego, 1980.

Meduski, J., et al. "Decrease of lactic acid concentration in blood of animals given N, N-dimethylglycine." Pacific slope Biochemical Conference. Abstract, July 7-9, 1980, University of California, San Diego.

Michlin, E., eds. *Vitamin B-15 (Pangamic Acid): Properties, Functions, and Use.* Naooka, Moscow: "Science" Publishing House, 1965.

Mikhailova, L. & Solovyeva, T. "Use of pangamic acid in cardiovascular diseases and cirrhosis of the liver." *Vitamin B-15 (Pangamic Acid): Properties, Functions, and Use.* Naooka, Moscow: "Science" Publishing House, 1965.

Milimovka, M., et al. "Clinical use of vitamin B-15 in cardiovascular diseases." *Vitamin B-15 (Pangamic Acid): Properties, Functions, and Use.* Naooka, Moscow: "Science" Publishing House, 1965.

O'Leary G. "Using DMG on experimentally induced arteriosclerosis in sea quail." Private Research Study. 1979.

Pettigrew, A. "Transmethylation in cardiopathies: the role of pangamic acid." *Journal Amer. Osterop. A.,* 1961; 59: 968.

Pries, M. "The role of DMG in cardiovascular patients." Report to Food Science Corporation, 1981.

Pries, M. "N,N-dimethylglycine and its use with cardiovascular patients." Report to DaVinci Laboratories, 1980.

Todd, G. *Nutrition, Health and Disease.* Norfolk, Virginia: The Donning Company, 1985: 204-208.

Trofimova, Z. "Effect of pangamic acid, B-complex vitamins and steroid hormones in experimental myocarditis." *Vitamin B-15 (Pangamic Acid): Properties, Functions, and Use.* Naooka, Moscow: "Science" Publishing House, 1965.

Walker, M. "Some nutri-clinical applications of N,N-dimethylglycine." *Townsend Letter For Doctors,* June 1988: 228.

Yakovlev, N., et al. "Effect of pangamic acid, methionine, or a gluconate-glycine mixture on myocardial metabolism and EKG during muscular activity." *Ukr. Biokhun. Zh.,* 1965; 37(5): 818-835.

Yegorov, M., et al. "Clinical use of calcium pangamate for cardiovascular diseases." *Vitamin B-15 (Pangamic Acid): Properties, Functions, and Use.* Naooka, Moscow: "Science" Publishing House, 1965.

CHAPTER 5 DMG and Cancer

American Cancer Society "Cancer Facts & Figures 2003." Atlanta: American Cancer Society, Inc., 2003.

Balch, J. & Balch, P. *Prescription for Nutritional Healing.* New York: Avery Publishing Group, 2000.

Baylin, S., et al. "Alteration in DNA methylation: a fundamental aspect of neoplasia." *Adv. Cancer Res.,* 72: 141-196.

Beisel, W., et al. "Single nutrient effects on immunologic functions." *J. Amer. Med. Assoc.,* 1981; 245: 53.

Christman, J., et al. "Reversibility of changes in nucleic acid methylation and gene expression induced in rat liver by severe dietary methyl deficiency." *Carcinogenesis,* 1993; 14: 551-557.

Collin, J. "Preventing and treating cancer with vitamins." *Townsend Letter for Doctors,* 1989: 668-670.

DeLong, E. "Methylation and its chemical and nutritional importance." *J. of Applied Nutr.,* 1953; 6: 286.

Dizik, M., et al. "Alterations in expression and methylation of specific genes in livers of rats fed a cancer promoting methyl-deficient diet." *Carcionogenesis,* 1991; 12: 1307-1312.

Forman, B. *B-15, The 'Miracle Vitamin.'* New York: Grosset & Dunlap, 1979: 112-129.

Holden, R., et al. "An immunological model connecting the pathogenesis of stress, depression and carcinoma." *Medical Hypotheses,* 1989; 51: 309-314.

Hubber, W. & Parris K. "DMG: An in-depth review of its efficacy, safety and action mechanisms Part III: The clinical efficacy of DMG." Report to FoodScience Corporation by HK Biomedical, Inc., 1989.

Jones, P. & Takai, D. "The role of DNA methylation in mammalian epigenetics." *Science,* 2001; 293: 1068-1070.

Kendall, R. & Lawson, J. "Recent findings on N,N-Dimthylglycine (DMG) a nutrient for the new millennium." *Townsend Letter for Doctors and Patients,* May 2000: 75-85.

Kugler, H. "Disease prevention and treatment tumor therapy via potentiation of immune functions— an animal case history." May 14, 1990: 2-3.

Landrum, C. "Clemson professor's work on cancer shows promise." *Anderson Independent Greenville News.* January 11, 1988: 1A, 6A.

Lawson, J. & Reap, E. "The effect of dimethylglycine on the antibody production, cell-mediated immune responses, and growth and development of B-16 melanoma cells." Ph.D. Thesis, *Clemson University,* 1990; 51(10B): 4768-4876.

Liotta, L. "Cancer cell invasion and metastasis." *Scientific American,* February 1992: 54-63.

Locker, J., et al. "DNA methylation and hepatocarcinogenesis in rats fed a choline devoid diet." *Carcinogenesis*, 1986; 7: 1309-1312.

Lopatina, N., et al. "Elevated expression and altered pattern of activity of DNA methyltransferase in liver tumors of rats fed methyl-deficient diets." *Carcinogenesis*, 1998; 19: 1777-1781.

Lu, S., et al. "Methionine adenosyltransferase 1A knockout mice are predisposed to liver injury and exhibit increased expression of genes involved in proliferation." *Pro. Nat. Acad. Sci.*, 2001; 98: 5560-5565.

MacKenzie, C. & Frisell, W. "Metabolism of dimethylglycine by liver mitochondria." *Journal of Biology and Chemistry*, 1958; 232: 417.

Mani, S., et al. "Role of dimethylglycine (DMG) in melanoma inhibition." 9th Annual Research Conference for the American Institute for Cancer Research. Nutrition and Cancer Prevention: New Insights into the Role of Phytochemicals. Abstract, September 2 & 3, 1999.

Mani, S. & Lawson, J. "Partial fractionation of perna and the effect of perna and dimethylglycine on immune cell function and melanoma cells." South Carolina Statewide Research Conference. January 3- 5, 1999, Charleston, SC.

Mani, S., et al. "Role of perna and dimethylglycine (DMG) in modulating cytokine response and their impact on melanoma cells." 99th General Meeting of the American Society for Microbiology. May 30-June 3, 1999, Chicago, IL.

Nizametidinova, G. "Effectiveness of calcium pangamate introduced into vaccinated and x-irradiated animals." *Reports of the Kazan Veterinary Institute*, 1972; 112: 100-104.

Niculescu, M. & Zeisel, S. "Diet, methyl donors, and DNA methylation: interactions between dietary folate, methionine, and choline." *American Society for Nutritional Sciences*, 2002: 2333S-2335S.

No authors listed. "Dietary methyl groups and cancer." *Nutritonal Reviews*, 1986; 44(8): 278-280.

No author listed. "Cancer treatment." *The Merck Manual—Home Edition*, Sec. 15, Ch. 166, Information gathered of the internet on 2/20/03 at http://www.merck.com/mrkshared/mmanual_home/section15/166.jsp

Reap, E. & Lawson, J. "Effects of dimethylglycine on B-16 melanoma in mice." Annual meeting of the American Society of Microbiology. October 6-8, 1988.

Reap, E. & Lawson, J. "Stimulation of the immune response by dimethylglycine, a non-toxic metabolite." *Journal of Laboratory and Clinical Medicine*, 1990; 115: 481.

Rogers, A. "Methyl donors in the diet and responses to chemical carcinogens." *Am. J. Clin. Nutri.*, 1995; 61: 659S-65S.

Shivapurkar, N. & Poirier, L. "Tissue levels of S-adenosylmethioine and S-adenolsyl-homocysteine in rats fed methyl-deficient, amino acid-deficient diets for one to five weeks." *Carcinogenesis*, 1983; 4: 1051-1057.

Slattery, M., et al. "Are dietary factors involved in DNA methylation associated with colon cancer?" *Nutr. Cancer*, 1997; 28: 52-62.

Svardal, A., et al. "Effect of methotrexate on homocysteine and other compounds in tissue of rats fed a normal or defined, choline-deficient diet." *Cancer Chemother. Pharmacol.*, 1988; 21: 313-318.

Swetlikoff, G. "The current state of cancer: what will the future bring?" WWW.ALIVEPUBLISHING.COM April 2003: 39-43.

Varela-Moreiras, G., et al. "Choline deficiency and methotrexate treatment induces marked but reversible changes in hepatic folate concentration, serum homocysteine and DNA methylation rates in rats." *J. Am. Coll. Nutr.*, 1995; 14: 480-485.

Vojdani, A., et al. "Minimizing cancer risk using molecular techniques: A review- part 2." *Townsend Letter for Doctors and Patients*, November, 1999: 97-102

Wagner, J. ed. "Ongoing cancer research." *Nutritional Outlook*, October, 2002: 51-59.

Wainfan, E., et al. "Rapid appearance of hypomethylated DNA in livers of rats fed cancer promoting, methyl-deficient diets. *Cancer Res.*, 1989; 49: 4094-4097.

Wainfan, E. & Porier, L. "Methyl groups in carcinogenesis: effects on DNA methylation and gene expression." *Cancer Res.*, 1992; 52: 2071S-2077S.

Walker, M. "Boost endurance and immunity with DMG." Bestways, 1988: 64-65.

Walker, M. "Some nutri-clinical applications of N,N-dimethylglycine." *Townsend Letter For Doctors*, June 1988: 228.

Woodard, J. "Effects of deficiencies in labile methyl groups on the growth and development of fetal rats." *J. Nutriton*, 1970; 100: 1215-1226.

Zeisel, S., et al. "Effect of choline deficiency on S-adenocylmethioine and methionine concentrations in rat liver." *Biochem. J.*, 1989; 259: 725-729.

Zhu, K. & Williams, S. "Methyl-deficient diets, methylated ER genes and breast cancer: a hypothesized association." *Cancer Causes Control*, 1998; 9: 615-620.

CHAPTER 6 DMG Provides Clarity

Andreyev, C. et al. "Effect of pangamic acid on heart and brain hypoxia." *Vitamin B-15 (Pangamic Acid): Properties, Functions, and Use*. Naooka, Moscow: "Science" Publishing House, 1965.

Balch, J. & Balch, P. *Prescription for Nutritional Healing*. New York: Avery Publishing Group, 2000.

Balazs, L. & Leon, M. "Evidence of an oxidative challenge in the Alzheimer's brain." *Neurochem. Res.*, 1994; 19(9): 1131-7.

Benzi, G. & Moretti, A. "Are reactive oxygen species involved in Alzheimer's disease?" *Neurobiol. Aging*, 1995; 16(4): 661-674.

Blyumina, M. & Belyakova, T. "Experience in use of vitamin B-15 on preschool-age children suffering from oligophrenia." *Vitamin B-15 (Pangamic Acid): Properties, Functions, and Use*. Naooka, Moscow: "Science" Publishing House, 1965.

Floyd, R. "Antioxidants, oxidative stress, and degenerative neurological disorders." *Proc. Soc. Exp. Biol. Med.*, 1999; 222(3): 236-45.

Freed, W. "Prevention of strychnine-induced seizures and death by the N-methylated glycine derivative betaine, dimethylglycine and sarcosine." *Pharmacology, Biochemistry and Behavior*, 1985; 22: 641.

Gascon, G., et al. "N,N-dimethylglycine and epilepsy." *Epilepsia*, 1989; 30(1): 90-93.

Jenner, P. "Oxidative stress in Parkinson's diease and other neurodegenerative disorders." *Pathol. Biol.*, 1996; 44(1): 57-64.

Jenner, P. "Oxidative stress in Parkinson's disease." *Ann. Neurol.*, 2003; 53 (3 suppl 1): S26-38.

Kolosov, A., et al. "Effect of pangamic acid on the vascular-tissue permeablity and osmotic resistance of erythrocytes in middle-aged and old patients." *Vitamin B-15 (Pangamic Acid): Properties, Functions, and Use*. Naooka, Moscow: "Science" Publishing House, 1965.

Lohr, J. & Browning, J. "Free radical involvement in neurophsyciatric illnesses." *Psychopharmacol. Bull.*, 1995; 31(1): 159-65.

Roach, E. & Carlin, L. "N,N-dimethylglycine for epilepsy." *New England Journal of Medicine*, 1982; 307: 1081-1082.

Seiler, N. et al. "Treatment of seizure disorders and pharmaceutical compositions useful therein." U.S. Patent # 4,540,582, September 1985.

Ward, T. et al. "Dimethylglycine and reduction of mortality in penicillin-induced seizures," *Annals of Neurology*, 1985; 17(2): 213.

CHAPTER 7 DMG and Autism

Andreyev, C. et al. "Effect of pangamic acid on heart and brain hypoxia." Vitamin B-15 (Pangamic Acid): Properties, Functions, and Use. Naooka, Moscow: "Science" Publishing House, 1965.

Autism Research Institute, 4182 Adams Avenue, San Diego, CA 92116.TEL:+(619) 281-7165 Bernard Rimland, Director. http://www.autism.com/ari/

Balch, J. & Balch, P. *Prescription for Nutritional Healing*. New York: Avery Publishing Group, 2000.

Blyumina, M. & Belyakova, T. "Experience in use of vitamin B-15 on preschool-age children suffering from oligophrenia." *Vitamin B-15 (Pangamic Acid): Properties, Functions, and Use*. Naooka, Moscow: "Science" Publishing House, 1965.

Bolton, S. & Null, G. "Vitamin B-15: a review and update." *J. of Orthomolecular Psych.*, 1982; 11: 260.

Brue, A. & Oakland, T. "Alternative treatments for attention-deficit/hyperactivity disorder: does evidence support their use?" *International Journal of Integrative Medicine*, 2002; 4: 4.

Canna, I. & Gillberg, C. "Asperger syndrome-some epidemiological considerations: a research note." *Journal of Child Psychology and Psychiatry,* 1989; 30(4): 631-638.

Cave, S. "Autism in children." *International Journal of Pharmaceutical Compounding,* 2001; 5: 1..

Cott, A. "Pangamic acid." *Journal of Orthomolecular Psychiatry,* 1975; 4: 2.

Courchesne, E., et al. "Abnormality of cerebellar vermain lobules VI and VII in patients with infantile autism: identification of hypoplastic and hyperplastic subgroups with MR imaging." *AJR,* January, 1994: 162.

Courchesne, E., et al. "Parietal lobe abnormalities detected with MRI in patients with infantile autism." *AJR,* February, 1994: 160.

Courchesne, E., et al. "The brain in infantile autism: posterior fossa structures are abnormal." *Neurology,* February, 1994.

Courchesne, E., et al. "Impairment in shifting attention in autistic and cerebellar patients." *Behavior Neuroscience,* 1994; 108(5): 848—65.

Courchesne, E., et al. "A new role for the cerebellum in cognitive operations." *Behavior Neuroscience,* 1992; 106.

Defeat Autism Now! "Mercury detoxification consensus group position paper." *Autism Research Institute,* May 2001.

Edelson, S. & Rimland, B. *Treating Autism, Parent Stories of Hope and Success.* San Diego: Autism Research Institute, 2003.

Ellaway, C., et al. "Rett Syndrome: Randomized controlled trial of L-carnitine." *J. of Child. Nerurology,* 1999; 14(3): 162-167.

Floyd, R. "Antioxidants, oxidative stress, and degenerative neurological disorders." *Proc. Soc. Exp. Biol. Med.,* 1999; 222(3): 236-45.

Freed, W. "Prevention of strychnine-induced seizures and death by the N-methylated glycine derivative betaine, dimethylglycine and sarcosine." *Pharmacology, Biochemistry and Behavior,* 1985; 22: 641.

Gascon, G., et al. "N,N-dimethylglycine and epilepsy." *Epilepsia,* 1989; 30(1): 90-93.

Garvey, J. "Diet in autism and associated disorders." *Journal of Family Health Care,* 2002; 12(2): 34-38.

Gedye, A. " Anatomy of self-injurious, stereotypic, and aggressive movements: evidence for involuntary explanation." *Journal of Clinical Psychology,* 1992; 48(6): 766-778.

Gupta, S., et al. "Brief report: dysregulated immune system in children with autism: beneficial effects of intravenous immune globulin on autistic characteristics." *Journal of Autism and Developmental Disorders,* 1996; 26: 4.

Jung, S. & Lee, Y. "A double blind study of dimethylglycine treatment in children with autism." T*ZU CHI Medical Journal,* 2000; 12: 111-121.

Kern, J., et al. "Effectiveness of N,N-dimethylglycine in autism and pervasive developmental disorder." *J. Child Neurol.,* 2001; 16(3): 169-173.

Kidd, P. "Autism, and extreme challenge to integrative medicine. Part II: Medical management." *Alternative Medicine Review,* 2002; 7(6): 472-499.

Lelord, G., et al. "Effects of pyridoxine and magnesium on autistic symptoms- initial observations." *Journal of Autism and Developmental Disorders,* 1981; 11: 2.

Mènage, P., et al. "CD4+ CD4RA+ T lymphocyte deficiency in autistic children: effect of a pyridoxine-magnesium treatment." *Brain Dysfunct.,* 1992; 5: 326-333.

Navarro, M. "The therapeutic use of vitamin B-15." *Sto. Tomas J. Med.,* 1954; 9: 376-8.

Navarro, M., et al. "Preliminary observations on the therapeutic effects of vitamin B-15." *J. P.M. A.,* 1956; 32: 671-674.

Oommen, T. "Dimethylglycine: New horizon in therapeutics." *Indian Journal of Pharmaceutical Science,* 1998; 60(4): 189-190.

Piöchl, E., et al. "Carnitine deficiency and carnitine therapy in a patient with Rett's Syndrome." *Klin. Pädiatr.,* 1996; 208: 129-134.

Plioplys, A., et al. "Lymphocyte function in autism and Rett syndrome." *Neuropsychobiology,* 1994; 29: 12-16.

Rimland, B. *Autism Research Review International,* 2001; 15(2).

Rimland, B. "The autism epidemic, vaccinations, and mercury." *Journal of Nutritional and Environmental Medicine*, 2000; 10: 261-266.

Rimland, B. *Autism Research Review International*, 2000; 14(4).

Rimland, B. *Autism Research Review International*, 2000; 14(1).

Rimland, B. *Autism Research Review International*, 1999; 13(3).

Rimland, B. *Autism Research Review International*, 1999; 13(2).

Rimland, B. *Autism Research Review International*, 1998; 12(1).

Rimland, B. *Autism Research Review International*, 1997; 11(4).

Rimland, B. *Autism Research Review International*, 1996; 10(4).

Rimland, B. *Autism Research Review International*, 1996; 10(3).

Rimland, B. *Autism Research Review International*, 1996; 10(1).

Rimland, B. *Autism Research Review International*, 1995; 9(3).

Rimland, B. *Autism Research Review International*, 1995; 9(2).

Rimland, B. *Autism Research Review International*, 1995; 9(1).

Rimland, B. *Autism Research Review International*, 1994; 8(4).

Rimland, B. *Autism Research Review International*, 1994; 8(3).

Rimland, B. *Autism Research Review International*, 1994; 8(2).

Rimland, B. *Autism Research Review International*, 1993; 7(1).

Rimland, B. *Autism Research Review International*, 1992; 6(3).

Rimland, B. "Dimethylglycine (DMG) in the treatment of autism." *Autism Research Institute Publication* 110, 1991.

Rimland, B. "Dimethylglycine (DMG), a nontoxic metabolite, and autism." *Autism Research Review International*, 1990; 4(2).

Rimland, B. "Controversies in treatment of autistic children: vitamin and drug therapy." *J Child Neurol.*, 1988; 3: S68-S72.

Rimland, B., et al. "The effects of high doses of vitamin B_6 on autistic children. A double-blind cross-over study." *American Journal of Psychiatry*, 1978; 135: 472-75.

Rimland, B. *Infantile Autism: The Syndrome and its Implications for a Neural Theory of Behavior.* New York: Appleton Century Crofts, 1964.

Roach, E. & Carlin, L. "N,N-dimethylglycine for epilepsy." *New England Journal of Medicine*, 1982; 307: 1081-1082.

Seiler, N. et al. "Treatment of seizure disorders and pharmaceutical compositions useful therein." U.S. Patent # 4,540,582, September 1985.

Stralton, K., et al. "Adverse events associated with childhood vaccines other than pertussis and rubella: summary of a report from the institute of medicine." *Journal of the American Medical Association*, 1994; 271(20): 1602-1605.

Walker, M. "Some nutri-clinical applications of N,N-dimethylglycine." *Townsend Letter For Doctors*, June 1988: 228.

Ward, T. et al. "Dimethylglycine and reduction of mortality in penicillin-induced seizures," *Annals of Neurology*, 1985; 17(2): 213.

Waring, R., et al. "Biochemical parameters in autistic children." *Developmental Brain Dysfunction*, 1997; 10: 40-43.

Warren, R., et al. "Deficiency of suppressor-inducer (CD4+CD45RA+) T cells in autism." *Immunological Investigations*, 1990; 19(3): 245-251.

Warren, R., et al. "Increased frequency of the null allele at the complement C4b locus in autism." *Clinical Exp. Immunol.*, 1991; 83: 438-440.

Yonk, L., et al. "CD4+ helper T cell depression in autism." *Imunology Letters*, 1990; 25: 344-346.

Zucker, M. "Fighting autistic syndrome with nutrition." *Let's Live*, August 1983.

CHAPTER 8 DMG and Sports

Barnes, L. "B-15: the politics of ergogenicity." *Physician and sports medicine*, 1979; 7(11): 17-18.

Bishop, P., et al. "Effects of N,N-dimethylglycine on physiological response and performance in trained runners." *J. of Sports Med.*, 1987; 27: 53-56.

Black, D. & Sucec, A. "Effects of calcium pangamate on aerobic and endurance parameters, a double blind study." *Med. Sci. Sports Exercise*, 1981; 13: 93.

Charles, A. "DMG proving to be a valuable aid in competition." *Horse World*, Oct., 1982: 20.

Eamodanova, G. & Yakoviev, N. "Effect of pangamic acid on the efficiency of experimental training." *Ukr. Biokhim. Zh.*, 1967; 26(1): 7-12.

Forman B. *B-15, The 'Miracle Vitamin.'* New York: Fred Jordan Books/ Grosset & Dunlap, 1979: 42-80.

Girandola, R., et al. "Effects of pangamic acid ingestion on metabolic response to exercise." *Biochemical Medicine*, 1980; 24: 218-222.

Grannon, J. & Kendall, R. "A clinical evaluation of N,N-dimethylglycine and Diisopropylammonium dichloroacetate (DIPA) on performance of racing greyhounds." *Canine Practice* 1982; 9(6): 7-13.

Gray, M. & Titlow, L. "The effect of pangamic acid on maximal treadmill performance." *Med. Sci. Sport Exercise*, 1982; 14: 424-7.

Gray, M. & Titlow, L. "B_{15}: myth or miracle?" *Phys. and Sports Med.*, 1982; 10: 107-112.

Hamner, D. & Burr, B. *Peak Energy: The High-Oxygen Program for More Energy Now!* New York: G.P. Putnam and Sons, 1988: 40-45 & 190-191.

Jones, W. "Lactic acid and DMG." *The Quarter Racing Journal*, June 1988; 46.

Karpuchina, Y., et al. "Effect of pangamic acid, methionine, and a combination of calcium gluconate and glycine on biochemical changes that occur in the blood of athletes performing physical exercises." *Vep. Pitan.*, 1967; 26: 3.

Kendall, R. & Lawson, J. "Recent findings on N,N-dimethylglycine (DMG) a nutrient for the new millennium." *Townsend Letter for Doctors & Patients*, May 2000.

Kleinkopf, K. "N,N-dimethylglycine and calcium gluconate and its effects on maximum oxygen consumption (max VO_2) on highly conditioned athletes." Private report. College of Southern Idaho, July 1980.

Leshkevich, L. & Kolomeitseva, V. "Effects of pangamic acid on lipid metabolism during muscular activity." *Vop. Pitan.*, 1967; 26(1): 7-12.

Levine, S., et al. "Effect of a nutritional supplement containing N, N-dimethylglycine (DMG) on the racing standardbred." *Equine practice*, March 1982: 4.

Lytle, L. "Nutritional and selected supplemental effects on energy levels on selected athletes." Ph.D. Thesis. College of Nutrition, Donsbach University, 1979.

Meduski, J., et al. "Effect of dietary N,N-dimethylglcyine uptake on the molecular oxygen in Sprague-Dawley rats." Research Paper. University of California, San Diego, 1980.

Meduski, J., et al. "Decrease of lactic acid concentration in blood of animals given N, N-dimethyl-glycine." Pacific slope Biochemical Conference. Abstract, July 7-9, 1980, University of California, San Diego.

Michlin, E., eds. *Vitamin B-15 (Pangamic Acid): Properties, Functions, and Use.* Naooka, Moscow: "Science" Publishing House, 1965.

Moffitt, P., et al. "Venous lactic acid levels in exercising horses fed N,N-Dimethylglycine." Proceedings of the 9th Equine Nutrition and Physiology Symposium. 1985, Lansing, Michigan.

Navarro, M. & Prudencio, P. "An animal study on the somatic motor activity and a review on the biological effects and therapeutic uses of vitamin B-15." The Annual Convention of the Philippine Society of Endocrinology and Metabolism. October 31, 1984, Quezon City Sports Club.

Null, G. Personal Communication to Roger Kendall, June 29,1983.

Null, G. Personal Communication to Roger Kendall, June 29,1989

Orlandi, D. Personal Communication to Roger Kendall, 1980.

Pipes, T. "The effects of pangamic acid on performance in trained athletes." *Med. and Sci. in Sports and Exercise*, 1980; 12: 98.

Richardson, J. & Fuller, N. "The effects of vitamin B-15 on contraction of striated muscle." *J. Sports Med., 1979*; 19: 129-131.

Samodanova, G. & Yakovlev, N. "Effect of pangamic acid on the efficiency of experimental training." *Biokhim. Zh.*, 1967: 39.

Sellnow, L. "DMG, properties and proprieties." The Blood Horse, June 1987: 3855.

Udalov, Y. & Chernyakov, I. "The effect of calcium pangamate on animals under hypoxic conditions." *Vitamin B-15 (Pangamic Acid): Properties, Functions, and Use.* Naooka, Moscow: "Science" Publishing House, 1965.

Walker, M. "Some nutri-clinical applications of N,N-dimethylglycine." *Townsend Letter For Doctors,* June 1988: 228.

Walker, M. "The love pill." *Gallery,* August 1983: 40, 42, 109.

Walker, M. "Nutridisiacs: Nutrients that have you feeling sexual." *Health Foods Business,* August 1990:39-40.

Walker, M. "Boost endurance and immunity with DMG." *Bestways,* 1988: 64-65.

Yakovlev, N. "Influence of vitamin B-15 on biochemical processes under muscular activity." *Vop. Med. Khim.,* 1965; 11: 44.

Yakovlev, N., et al. "Effect of pangamic acid, methionine, or a gluconate-glycine mixture on myocardial metabolism and EKG during muscular activity." *Ukr. Biokhun. Zh.,* 1965; 37(5): 818-835.

Yakovlyev, N., et al. "The effect of pangamic acid (vitamin B-15) on metabolism during physical exercise of varying duration." *Vitamin B-15 (Pangamic Acid): Properties, Functions, and Use.* Naooka, Moscow: "Science" Publishing House, 1965.

CHAPTER 9 DMG and Diabetes

Aurtuori, M. & Rancho, M. "Effects of N,N-Dimethylglycine on diabetic mice." University of Bridgeport, 1981.

Balch, J. & Balch, P. *Prescription for Nutritional Healing.* New York: Avery Publishing Group, 2000.

Bertelli, A, & Casentini, S. "Suprarenal stimulation by combinations of pangamic acid and salicylic acid." *Boll. Soc. it. Biol. Sper.,* 1957; 33: 907.

Bobrova, O. & Oleinik, N. "Use of pangamic acid in the treatment of patients suffering from atherosclerosis of the coronary vessels and the vessels of the lower extremities." *Vitamin B-15 (Pangamic Acid): Properties, Functions, and Use.* Naooka, Moscow: "Science" Publishing House, 1965.

Cherntsova, T., et al. "Use of vitamin B-15 in certain hematologic diseases." *Vitamin B-15 (Pangamic Acid): Properties, Functions, and Use.* Naooka, Moscow: "Science" Publishing House, 1965.

Cunningham, J. *Micronutrients as Nutriceutical Interventions in Diabetes Mellitus. Journal of the American College of Nutrition,* 1998; 8(17): 7-10.

Challem, J., et al. *Syndrome X: The Complete Nutritional Program to Prevent and Reverse Insulin Resistance.* John Wiley & Sons, 2000.

Fizdyel, E., et al. "Use of pangamic acid in the treatment of patients with coronary and cardiopulmonary insufficiency." *Vitamin B-15 (Pangamic Acid): Properties, Functions, and Use.* Naooka, Moscow: "Science" Publishing House, 1965.

Hamner, D. & Burr B. *Peak Energy: The High-Oxygen Program For More Energy Now!* New York: G. P. Putnam's sons, 1988: 40-45,190-191.

Hubber, W. & Parris K. "DMG: an in-depth review of its efficacy, safety and action mechanisms. Part III: the clinical efficacy of DMG." Report to FoodScience Corporation by HK Biomedical, Inc., 1989.

Jones, W. "Lactic acid and DMG." *The Quarter Racing Journal,* June, 1988; 46.

Kandel, J., et al. "The Effects of three topical agents on subscapular cataract progression in Royal College of Surgeon Rats." *Doctor of Optometry Thesis.* March 20, 1982.

Kolosov, A., et al. "Effect of pangamic acid on the vascular-tissue permeability and osmotic resistance of erythrocytes in middle-aged and old patients." *Vitamin B-15 (Pangamic Acid): Properties, Functions, and Use.* Naooka, Moscow: "Science" Publishing House, 1965.

Kutty, N. & Ananthalakshmi, J. "Comparison of the hypoglycemic effects of dimethylglycine and glibenclamide in normal and diabetic rats." *Indian Journal of Pharmacology,* 2001; 33(4): 300.

MacKenzie, C. & Frisell, W. "Metabolism of dimethylglycine by liver mitochondria." *J. Biol. Chem.,* 1958; 232: 412.

Mason, C. *The Methyl Approach to Hypoglycemia.* Suma, Washington: Botanical Laboratories, 1981.

Meduski, J., et al. "Effect of dietary N,N-dimethylglcyine uptake on the molecular oxygen in Sprague-Dawley rats." Research Paper. University of California, San Diego, 1980.

Meduski, J., et al. "Decrease of lactic acid concentration in blood of animals given N, N-dimethylglycine." Pacific slope Biochemical Conference. Abstract, July 7-9, 1980, University of California, San Diego.

No Author. "The diabetes control and complications trial research group: the effect of intensive treatment of diabetes on the development and progression of long-term complications in insulin dependent diabetes mellitus." *N. Engl. J. Med.,* 1993; 329: 977-986.

Rancho, M. "A comparative study of the effects of N,N-dimethylglycine (DMG) on genetically diabetic and non-diabetic mice as metabolic enhancer." Private Report. University of Bridgeport, Connecticut. November 7, 1980.

Selmonsk, G. "The effects of derivatives of pangamic acid on mitosis in the lens epithelium of frogs." Private Report. University of Vermont.

Shpirt, Y. "The use and efficacy of calcium pangamate in the treatment of internal diseases." *Vitamin B-15 (Pangamic Acid): Properties, Functions, and Use.* Naooka, Moscow: "Science" Publishing House, 1965.

Walker, M. "Some nutri-clinical applications of N,N-dimethylglycine." *Townsend Letter For Doctors,* June 1988: 228.

CHAPTER 10 DMG for Respiratory Disorders

Andreyev, C., et al. "Effect of pangamic acid on heart and brain hypoxia." *Vitamin B-15 (Pangamic Acid): Properties, Functions, and Use.* Naooka, Moscow: "Science" Publishing House, 1965.

Andreyev, C. & Rode, A. "The effects of pangamic acid on gaseous exchange in rats." *Vitamin B-15 (Pangamic Acid): Properties, Functions, and Use.* Naooka, Moscow: "Science" Publishing House, 1965.

Balch, J. & Balch, P. *Prescription for Nutritional Healing.* New York: Avery Publishing Group, 2000.

Braude, A., et al. "Some manifestation of the biological activity of calcium pangamate." *Vitamin B-15 (Pangamic Acid): Properties, Functions, and Use.* Naooka, Moscow: "Science" Publishing House, 1965.

Dukukin, A., et al. "The effects of vitamin B-15 (pangamic acid) on the resistance of the organism and its cardiovascular system to hypoxia." *Dokl. Akad. Nuak.,* SSSR, 1962; 144: 675-681.

Forman, B. *B-15, The 'Miracle Vitamin.'* New York: Fred Jordan Books/Grosset & Dunlap, 1979: 81, 83, 92, 102-104.

Graber, C. & Kendall, R. "N,N-dimethylglycine and use in immune response." U.S. Patent #4,631,189, December 1986.

Graber, C, et al. " Immunomodulating properties of dimethylglycine in humans." *J. Inf. Disease,* 1981; 143: 101.

Hamner, D. & Burr B. *Peak Energy: The High-Oxygen Program For More Energy Now!* New York: G. P. Putnam's sons, 1988: 40-45, 190-191.

Hubber, W. & Parris K. "DMG: an in-depth review of its efficacy, safety and action mechanisms. Part III: the clinical efficacy of DMG." Report to FoodScience Corporation by HK Biomedical, Inc., 1989.

Jones, W. "Lactic acid and DMG." *The Quarter Racing Journal,* 46, June 1988.

Kleinkopf, K. "N,N-dimethylglycine and calcium gluconate and its effects on maximum oxygen consumption (max VO$_2$) on highly conditioned athletes." Private report. College of Southern Idaho, July 1980.

Meduski, J., et al. "Effect of dietary N,N-dimethylglcyine uptake on the molecular oxygen in Sprague-Dawley rats." Research Paper. University of California, San Diego, 1980.

Meduski, J., et al. "Decrease of lactic acid concentration in blood of animals given N, N-dimethylglycine." Pacific slope Biochemical Conference. Abstract, July 7-9, 1980, University of California, San Diego.

Udalov, Y. & Chernyakov, I. "The effect of calcium pangamate on animals under hypoxic conditions." *Vitamin B-15 (Pangamic Acid): Properties, Functions, and Use.* Naooka, Moscow: "Science" Publishing House, 1965.

Walker, M. "Some nutri-clinical applications of N,N-Dimethylglycine." *Townsend Letter for Doctors,* June 1988: 226-228.

Walker, M. "Therapeutic benefits of DMG (dimethylglycine)." *Health World,* March 1990: 38-41.

CHAPTER 11 DMG for a New Life

Balch, J. & Balch, P. *Prescription for Nutritional Healing.* New York: Avery Publishing Group, 2000.

Bertelli, A. & Casentini, S. "Pangamic acid action on some tests of antirheumatic activity." *Boll. Soc. it. Biol. Sper.,* 1967; 33: 885.

Forman, B. *B-15, The 'Miracle Vitamin.'* New York: Fred Jordan Books/Grosset & Dunlap, 1979: 93-94.

Hamner, D. & Burr B. *Peak Energy: The High-Oxygen Program for More Energy Now!* New York: G. P. Putnam's sons, 1988: 40-45, 190-191.

Mani, S. & Lawson, J. "Partial fractionation of Perna and the effect of perna and dimethylglycine on immune cell function and melanoma cells." South Carolina Statewide Research Conference. January 3- 5, 1999, Charleston, South Carolina.

Meduski, J., et al. "Effect of dietary N,N-dimethylglcyine uptake on the molecular oxygen in Sprague-Dawley rats." Research Paper. University of California, San Diego, 1980.

Meduski, J., et al. "Decrease of lactic acid concentration in blood of animals given N, N-dimethyl-glycine." Pacific slope Biochemical Conference. Abstract, July 7-9, 1980, University of California, San Diego.

Walker, M. "Some nutri-clinical applications of N,N-dimethylglycine." *Townsend Letter for Doctors,* June 1988: 226-228.

Yakovlyev, N., et al. "Effects of pangamic acid on exchange of substances during various periods of muscular activity." *Vitamin B-15 (Pangamic Acid): Properties, Functions, and Use.* Naooka, Moscow: "Science" Publishing House, 1965.

CHAPTER 12 DMG for Arthritis, Lupus, and Other Autoimmune Conditions

2002 American Lung Association. All rights reserved. October 2002. http://www.lungusa.org/disease/lung/pneumoni.html

Ahsan, H., et al. "Oxygen free radicals and systemic autoimmunity." *Clin. Exp. Immunol.,* 2003; 131(3): 398-404.

Anderson, N., Peiper, H., et al. *Super-Nutrition for Animals! Birds Too!!* East Canaan: Safe Goods, 1996: 129-130.

Balch, J. & Balch, P. *Prescription for Nutritional Healing.* New York: Avery Publishing Group, 2000.

Belkowski, S. "The humoral response to collagen and the effects of dimethylglycine and perna canaliculus on collagen induced arthritis in rats." Ph.D. Theseis, Clemson University, August 1991.

Bertelli, A. & Casentini, S. "Pangamic acid action on some tests of antirheumatic activity." *Boll. Soc. it. Biol. Sper.,* 1967; 33: 885.

Forman, B. *B-15, The 'Miracle Vitamin.'* New York: Fred Jordan Books/Grosset & Dunlap, 1979: 93-94.

Hamner, D. & Burr B. *Peak Energy: The High-Oxygen Program for More Energy Now!* New York: G. P. Putnam's sons, 1988: 40-45, 190-191.

Kendall, R., *Methods and Compositions for Modulating Immune Response and for the Treatment of Inflammatory Disease.* US Patent # 7,229,646B2, June 2007.

Kendall, R. & Lawson, J. "Recent findings on N,N-Dimthylglycine (DMG) a nutrient for the new millennium." *Townsend Letter for Doctors and Patients,* May 2000: 75-85.

Kendall, R. & Lawson, J. "Treatment of arthritis and inflammation using N,N-dimethylglycine." U.S. Patent #5,026,728, June 1991.

Lahita, R. & Phillips, R. *Lupus – Everything you need to know.* New York: Avery Publishing, 1998.

Lawson, B., Belkowski , S., Whitesides, J. , Davis, P., and Lawson, J. Immunomodulation of murine collagen-induced arthritis by N,N-dimethylglycine and a preparation of *Perna canaliculus*. BMC *Complementary and Alternative Medicine*, 2007;7:20.

Lawson, J. "Effects of dimethylglycine on collagen II induction of arthritis in rats." Annual Meeting of the American Society of Microbiology. October 6-8, 1988.

Mani, S. & Lawson, J. "Partial fractionation of Perna and the effect of perna and dimethylglycine on immune cell function and melanoma cells." South Carolina Statewide Research Conference. January 3- 5, 1999, Charleston, South Carolina.

Mani, S., Whitesides, J., et al. "Use of Perna and dimethylglycine as immunotherapeutic agents in autoimmune disease and melanoma." *Critical Reviews in Biomedical Engineering*, 2000; 26(5): 405-6.

Meduski, J., et al. "Effect of dietary N,N-dimethylglcyine uptake on the molecular oxygen in Sprague-Dawley rats." Research Paper. University of California, San Diego, 1980.

Meduski, J., et al. "Decrease of lactic acid concentration in blood of animals given N, N-dimethyl-glycine." Pacific slope Biochemical Conference. Abstract, July 7-9, 1980, University of California, San Diego.

Walker, M. "Some nutri-clinical applications of N,N-dimethylglycine." *Townsend Letter for Doctors*, June 1988: 226-228.

CHAPTER 13 DMG and Detoxification

Anisimov, V. & Salikhov, N. "Use of pangamic acid for internal diseases." *Vitamin B-15 (Pangamic Acid): Properties, Functions, and Use.* Naooka, Moscow: "Science" Publishing House, 1965.

Balch, J. & Balch, P. *Prescription for Nutritional Healing.* New York: Avery Publishing Group, 2000.

Braude, A., et al. "Some manifestation of the biological activity of calcium pangamate." *Vitamin B-15 (Pangamic Acid): Properties, Functions, and Use.* Naooka, Moscow: "Science" Publishing House, 1965.

Forman, B. *B-15, The 'Miracle Vitamin.'* New York: Fred Jordan Books/Grosset & Dunlap, 1979: 81, 83, 92, 102-104.

Graber, C. & Kendall, R. "N,N-dimethylglycine and use in immune response." U.S. Patent #4,631,189, December 1986.

Graber, C, et al. " Immunomodulating properties of dimethylglycine in humans." *J. Inf. Disease*, 1981; 143: 101.

Goodkova, N. & Sinkevich, Z. "The effect of vitamin B-15 on higher nervous activity of patients suffering from chronic alcoholism." *Vitamin B-15 (Pangamic Acid): Properties, Functions, and Use.* Naooka, Moscow: "Science" Publishing House, 1965.

Hubber, W. & Parris K. "DMG: an in-depth review of its efficacy, safety and action mechanisms. Part III: the clinical efficacy of DMG." Report to FoodScience Corporation by HK Biomedical, Inc., 1989.

Jones, W. "Lactic acid and DMG." The Quarter Racing Journal, 46, June 1988.

Leshkevich, L. & Kolomeitseva, V. "Effects of pangamic acid on lipid metabolism during muscular activity." *Vop. Pitan.*, 1967; 26(1): 7-12.

Lu, S, et al. "Methionine adenosyltransferease 1A knockout mice are predisposed to liver injury and exhibit increased expression of genes involved in proliferation." *Pro. Nat. Acad. Sci.*, 2001; 98: 5560-5565.

MacKenzie, C. & Frisell, W. "Metabolism of dimethylglycine by liver mitochondria." *Journal of Biology and Chemistry*, 1958; 232: 417-427.

Mikhailova, L. & Solovyeva, T. "Use of pangamic acid in cardiovascular diseases and cirrhosis of the liver." *Vitamin B-15 (Pangamic Acid): Properties, Functions, and Use.* Naooka, Moscow: "Science" Publishing House, 1965.

Navarro, M., et al. "Preliminary observations in the treatment of cyanide poisoning with pangametin (vitamin B-15)." Sto. Tomas J. Med., 1954; 12: 38-42.

Navarro, M. "The therapeutic use of vitamin B-15." *Sto. Tomas J. Med.*, 1954; 9: 376-8.

Navarro, M., et al. "Preliminary observations on the therapeutic effects of vitamin B-15." *J.P.M.A.*, 1956; 32: 671-4.

Orlandi, C. "The effects of N,N-dimethylglycine on ethanol withdrawal in mice." Private Research Paper. Univesity of Vermont, 1984.

Posokhova, E. "Effect of ortic acid, calcium pangamate, and lipamide on ultrastructural changes in hepatocytes in toxic hepatitis." *Morphology and Pathomorphology*, 1981: 95-97.

Strelchuk, I. "Treatment of chronic alcoholism and other drug addictions by vitamin B-15." *Vitamin B-15 (Pangamic Acid): Properties, Functions, and Use.* Naooka, Moscow: "Science" Publishing House, 1965.

Udalvo ,Y. & Sokolova, M. "Preventative effects of vitamin B-15 in experimental fatty infiltration of the liver." *Fed. Proc. Fed. Am. Socs. Exp. Biol. Suppl.*, 1964; 23: T863.

Walker, M. "Some nutri-clinical applications of N,N-Dimethylglycine." *Townsend Letter for Doctors*, June 1988: 226-228.

Walker, M. "Therapeutic benefits of DMG (dimethylglycine)." *Health World*, March 1990: 38-41.

Ziemlanski, S., et al. "Effect of long-term diet enrichment with selenium, vitamin E and B-15 on the degree of fatty infiltration of the liver." *Acta. Physiol. Pol.*, 1984; 35(4): 382-397.

CHAPTER 14 DMG and Veterinary Medicine

Anderson, N. & Peiper, H., et al. *Super-Nutrition for Animals! Birds too!!* East Canaan: Safe Goods, 1996:129-130.

Cator, R. & Halliburton, J. "The effects of N,N-Dimethylglycine on blood lactate levels and speed in racing thoroughbreds." Spearman, Texas: Panhandle Regional Veterinary Clinic with Texas A&M Medical Veterinary Diagnostic Labratory, Unpublished, 1983.

Grannon, J. & Kendall, R. "A clinical evaluation of N,N-dimethylglycine and Diisopropylammonium dichloroacetate (DIPA) on performance of racing greyhounds." *Canine Practice* 1982; 9(6): 7-13.

Jones, W. "Lactic acid and DMG." *The Quarter Racing Journal*, June 1988: 46.

Levine, S., et al. "Effect of a nutritional supplement containing N,N-dimethylglycine on the racing standardbred." *Equine Practice*, March 1982.

Meduski, J., et al. "Effect of dietary N,N-dimethylglcyine uptake on the molecular oxygen in Sprague-Dawley rats." Research Paper. University of California, San Diego, 1980.

Meduski, J., et al. "Decrease of lactic acid concentration in blood of animals given N, N-dimethyl-glycine." Pacific slope Biochemical Conference. Abstract, July 7-9, 1980, University of California, San Diego.

Messonnier, S. *The Arthritis Solution for Dogs.* Roseville, California: Prima Publishing, 2000: 116-117.

Messonnier, S. *The Allergy Solution for Dogs.* Roseville, California: Prima Publishing, 2000:126-127.

Messonnier, S. *Natural Health Bible for Dogs and Cats.* Roseville, California: Prima Publishing, 2001: 194-195, 57, 65, 71, 78, 81, 84, 98.

Moffitt, P., et al. "Venous lactic acid levels in exercising horses fed N,N-dimethylglycine." Proceedings of the 9th Equine Nutrition and Physiology Symposium. 1985, Lansing, Michigan.

Nizametidinova, G. "Effectiveness of calcium pangamate introduced into vaccinated and x-irradiated animals." Reports of the Kazan Veterinary Institute, 1972; 112: 100-104.

Scanlan, N. "Compromised hepatic detoxification in companion animals and its correction via nutri-tional supplementaiton and modified fasting." *Altern. Med. Rev.*, 2001; 6: s24-s37.

Schoen, A. & Wynn, S. eds. Complementary and Alternative Veterinary Medicine: Principles and Practice. New York: Mosby, 1998: 36-37, 54-58, 62.

Sellnow, L. "DMG, properties and proprieties." *The Blood Horse*, June 1987: 3855.

Yanez,J. et.al., Pharmaceutical Evaluation of Glyco-Flex III and Its Constituents on Canine Chondrocytes. *Journal of Medical Sciences*, 1, 2008.

CHAPTER 15 What Kind of DMG User Can I Be?

Balch, J. & Balch, P. *Prescription for Nutritional Healing*. New York: Avery Publishing Group, 2000.

Blendon, R., et al. "Americans' views on the use and regulation of dietary supplements." *Arch. Intern. Med.*, 2001; 161: 805-810.

Epshtein, A. "Treatment of psoriasis with methotrexate in combination with pyrogenal, calcium pangamate, and chelators." Vest. Demat. Venerol., 1973; 47: 48.

Forman, B. *B-15, The 'Miracle Vitamin.'* New York: Fred Jordan Books/Grosset & Dunlap, 1979: 81-111.

Hubber, W. & Parris K. "DMG: An in-depth review of its efficacy, safety and action mechanisms Part III: The clinical efficacy of DMG." Report to FoodScience Corporation by HK Biomedical, Inc., 1989.

Kendall, R. & Lawson, J. "Recent findings on N,N-Dimthylglycine (DMG) a nutrient for the new millennium." *Townsend letter for doctors and patients*, May 2000: 75-85.

Meduski, J. "Nutritional evaluation of the results of the 157-day sub-chronical estimation of N,N-dimethylglcine toxicity." Research paper. University of South California, 1979.

Meduski, J. "N,N-dimethylglycine, a biologically active non-fuel nutrient." Research Paper. University of Southern California Medical School, 1979.

Michlin, E., eds. *Vitamin B-15 (Pangamic Acid): Properties, Functions, and Use*. Naooka, Moscow: "Science" Publishing House, 1965.

Navarro, M. "The therapeutic use of vitamin B-15." Sto. Tomas J. Med., 1954; 9: 376-8.

Navarro, M., et al. "Preliminary observations on the therapeutic effects of vitamin B-15." *J.P.M. A.*, 1956; 32: 671-4.

Passwater, R. "B-15- New ally in the fight against major disease." *The Health Quarterly*, 3(5): 16, 17, 85.

Passwater, R. "Dimethylglycine update: new studies confirm DMG improves health." *Let's Live*, February 1987.

Passwater, R. "New findings on vitamin B-15: Soviet Union scientist- and others- are learning about the remarkable versatility of the "sleeper" supplement." *Let's Live*, August 1977.

Passwater, R. "Vitamin B-15: will it become as important as vitamin E? Part I." *Let's Live*, January 1976.

Passwater, R. "Vitamin B-15: will it become as important as vitamin E? Part II." *Let's Live*, February 1976.

Shpirt, Y. "Indications for use and efficacy in internal disease." Municipal Clinical Hospital #60 Moscow: V/O Medexport, 1967.

Todd GP. *Nutrition, Health and Disease*. Norfolk, Virginia: The Donning Company, 1988: 204-208.

Vedrova, I. & Chamaganova, A. "Use of vitamin B-15 for treatment of certain skin diseases." *Vitamin B-15 (Pangamic Acid): Properties, Functions, and Use*. Naooka, Moscow: "Science" Publishing House, 1965.

Walker, M. "Some nutri-clinical applications of N,N-dimethylglycine." Townsend Letter for Doctors, June 1988: 226-228.

Walker, M. "Therapeutic benefits of DMG (dimethylglycine)." *Health World*, March 1990: 38-41.

HISTORY OF DMG

Bolton, S. & Null, G. "Vitamin B-15, a review and update." *Journal of Orthomolecular Psychiatry*, 1982; 11: 260.

Bukin, L. & Garkina, I. "Methods of producing calcium pangamate," U.S. Patent #3,907,869. September 1975.

Cott, A. "Pangamic acid." *Journal of Orthomolecular Psychiatry*, 1975; 4: 2.

Forman, B. *B-15, The 'Miracle Vitamin.'* New York: Fred Jordan Books/Grosset & Dunlap, 1979: 7-41.

Garkina, I. "Pangamic acid, its nature, properties, and preparation." *Veprosy Med. Khim.*, 1962; S(3): 236-238.

Girandola, R., et al. "Effects of pangamic acid ingestion on metabolic response to exercise." *Biochemical medicine*, 1980; 24: 218-222.

Handler, P., et al. *J. of Biol. Chem.*, 1941; 138: 211.

Herbert, V. "Pangamic acid." *Am. J. Clin. Nutr.*, 1979; 32: 1534-40.

Karpuchina, Y., et al. "Effect of pangamic acid, methionine, and a combination of calcium gluconate and glycine on biochemical changes that occur in the blood of athletes performing physical exercises." *Vep. Pitan.*, 1967; 26: 3.

Kemp, G. "A clinical study and evaluation of pangamic acid." *JAOA*, 1959; 58: 714-8.

Kendall, R. *The 1981 Buyers Guide 4th ed. for DMG and the so-called "Vitamin B-15."* South Burlington, Vermont: FoodScience Corporation, 1981.

Kendall, R. *N,N-Dimethylglycine NMR Comparative Report.* Essex Jct., Vermont: DaVinci Laboratories Inc., 1980: 1-5, 38-39.

Kendall, R. *NMR Comparative Report. N,N-Dimethylglycine, An IR (infrared) comparative report examines and catalogues the FoodScience product with 23 other "B-15 " products.* Study conducted at the State University of New York. South Burlington, VT: FoodScience Laboratories, 1978.

Krebs, E. & Krebs, E. U.S. Patent #2,464,240. 1949.

Krebs, E., et al. "Pangamic acid sodium: a newly isolated crystalline water-soluble factor. A preliminary report." *Int. Red. Med.*, 1951; 163: 18.

Leshkevich, L. & Kolomeitseva, V. "Effects of pangamic acid on lipid metabolism during muscular activity." *Vop. Pitan.*, 1967; 26(1): 7-12.

MacKenzie, C. & Frisell, W. "Metabolism of dimethylglycine by liver mitochondria." *J. Biol. Chem.*, 1958; 232: 412.

Marshall, F., et al. "Some pharmacologic properties of pangamic acid." *Pro. Soc. Exp. Bio. Med.*, 1961; 107: 420-422.

Navarro, M., et al. "Preliminary observations in the treatment of cyanide poisoning with pangametin (vitamin B-15)." *Sto. Tomas J. Med.*, 1954; 12: 38-42.

Navarro, M. "The therapeutic use of vitamin B-15." *Sto. Tomas J. Med.*, 1954; 9: 376-8.

Navarro, M., et al. "Preliminary observations on the therapeutic effects of vitamin B-15." *J.P.M.*, 1956; 32: 671-4.

Navarro, M. & Prudencio, P. "An animal study on the somatic motor activity and a review on the biological effects and therapeutic uses of vitamin B-15." The Annual Convention of the Philippine Society of Endocrinology and Metabolism. October 31, 1984.

Nobile, P. "Will B-15 cures what ails you?" *New York*, March 1978: 38-41.

Passwater, R. "New findings on vitamin B-15: Soviet Union scientist- and others- are learning about the remarkable versatility of the "sleeper" supplement." *Let's Live*, August 1977.

Passwater, R. "Vitamin B-15: will it become as important as vitamin E? Part I." *Let's Live*, January 1976.

Passwater, R. "Vitamin B-15: will it become as important as vitamin E? Part II." *Let's Live*, February 1976.

Richardson, J. & Fuller, N. "The effects of vitamin B-15 on contraction of striated muscle." *J. Sports Med.*, 1979; 19: 129-131.

Stacpoole, P. "Pangamic acid." Wld. Rev. Nutr. Diet, 1977; 27: 145-63.

Tomijama, T. & Vone, V. Proc. *Japan, Acad.*, 1953; 29: 178.

Udalvo, Y. & Sokolova, M. "Preventative effects of vitamin B-15 in experimental fatty infiltration of the liver." *Fed. Proc. Fed. Am. Socs. Exp. Biol. Suppl.*, 1964; 23: T863 or Farmakol, I Toksikol., 1963; 269(3): 355-358.

Udalov, Y. "Mechanism of action of vitamin B-15 (pangamic acid)." *Doklady Akad. Nauk. SSR.*, 1962; 143(3): 734-736.

RUSSIAN LITERATURE

Michlin, E., eds. *Vitamin B-15 (Pangamic Acid): Properties, Functions, and Use.* Naooka, Moscow: "Science" Publishing House, 1965. (Contents listed below)

Alpatov, I., et al. "The effect of pangamic acid in experimental poisoning with dichlorethane."

Altshuler, E. "Changes in condition of connective tissue in middle-aged and elderly patient treated with vitamin B-15."

Andreyev, C., et al. "Simultaneous use of cyanocobalamin and pangamic acid in treatment of patients suffering from traumatic factors."

Andreyev, C. et al. "Effect of pangamic acid on heart and brain hypoxia."

Andreyev, C. & Rode, A. " The effects of pangamic acid on gaseous exchange in rats."

Anisimov, V. & Salikhov, N. "Use of pangamic acid for internal diseases."

Aspit, S. "Effect of pangamic acid on tissue respiration of the myocardium in patients suffering form mitral stenosis of rheumatic etiology."

Blyumina, M. & Belyakova, T. "The use of vitamin B-15 for oligophrenic children."

Bobrova, O. & Oleinik, N. "Use of pangamic acid in the treatment of patients suffering from atherosclerosis of the coronary vessels and the vessels of the lower extremities."

Braude, A., et al. "Some manifestation of the biological activity of calcium pangamate."

Bukin, V. "Instructions for use of calcium pangamate."

Cherntsova, T., et al. "Use of vitamin B-15 in certain hematologic diseases."

Fizdyel, E., et al. "Use of pangamic acid in the treatment of patients with coronary and cardiopulmonary insufficiency."

Garkina, I. "Pangamic acid and its derivatives."

Giloonova, N. "Use of pangamic acid with patients suffering from coronary atherosclerosis."

Goodkova, N. & Sinkevich, Z. "The effect of vitamin B-15 on higher nervous activity of patients suffering from chronic alcoholism."

Karpuchina, Y., et al. "Effect of pangamic acid on biochemical changes in the blood of athletes during performance of exercises."

Kolosov, A., et al. "Effect of pangamic acid on the vascular tissue permeability and osmotic resistance of erythrocytes in middle and old age."

Kyulyan, G. & Trufanov, A. "On the minimal amounts of pangamic acid required for the eliminatation of disturbances caused by anti-vitamin B-12 in guinea pigs."

Mikhailova, L. & Solovyeva, T. "Use of pangamic acid in cardiovascular diseases and cirrhosis of the liver."

Milimovka, M., et al. "Clinical use of vitamin B-15 in cardiovascular diseases."

Shpirt , Y. "The use and efficacy of calcium pangamate in the treatment of internal diseases."

Sokolova, M. "Pangamic acid as a source of active methyl groups (experimental morphological study)."

Solovyeva, N. & Garkina, I. "Oxidizing demethylation of pangamic acid."

Solovyeva, N. & Garkina, I. "Studies on the methylating properties of pangamic acid."

Stoodnitsin, A. & Maslov, P. "The therapeutic efficacy of calcium pangamate in dermatologic-venerological practice."

Strelchuk, I. "Treatment of chronic alcoholism and other drug addictions by vitamin B-15."

Trofimova, Z. "Effect of pangamic acid, B-complex vitamins and steroid hormones in experimental myocarditis."

Udalov, Y. "The effect of vitamins on the level of nucleic acids in the blood in physiologic stresses."

Udalov, Y. "Data on the use of pangamic acid in the clinic."

Udalov, Y. & Chernyakov, I. "The effect of calcium pangamate on animals under hypoxic conditions."

Vedrova, I. & Chamaganova, A. "Use of vitamin B-15 for treatment of certain skin diseases."

Yakovlyev, N., et al. "The effect of pangamic acid (vitamin B-15) on metabolism during physical exercise of varying duration."

Yakovlyeva, I. "Pangamic acid treatment for middle-aged and elderly people."

Yegorov, M., et al. "Clinical use of calcium pangamate for cardiovascular diseases."

Index

ABOUT THE AUTHORS

Roger V. Kendall, Ph.D., has worked for over 25 years in the area of nutritional research and product development in the health field. He is considered to be the leading expert in the biochemistry and therapeutic applications of DMG. Dr. Kendall lectures widely, and is currently serving as head of the research committee for the National Animal Supplement Council (NASC). He has authored numerous articles in both peer reviewed journals and leading magazines on the therapeutic role of nutrients as immune modulators, antioxidants, and metabolic enhancers that promote healing and optimum health. Dr. Kendall holds a Ph.D. in organic biochemistry from Penn State University, and has held teaching positions at the University of Bridgeport and Ambassador University. He presently holds seven U.S. Patents and two European Patents, six of them on DMG.

Adena Therrien has a Bachelor's of Science from Trinity College of Vermont in biology. She attended the Graduate School at the University of Vermont's Department of Animal Science, where in addition to taking nutritional biochemistry classes, Adena worked as a faculty assistant and taught Animal Anatomy and Physiology Lab for three semesters and one semester of Lab Animal Medicine. Because of her love for animals, especially cats, she spent five years working as a veterinary technician. She currently works as a technical writer and researcher where she is putting to use her scientific background and love of research.